GRAPHIC WORLDS OF PETER BRUEGEL THE ELDER

GRAPHIC WORLDS OF PETER BRUEGEL THE ELDER

Reproducing 63 engravings and a woodcut

after his designs

by

H. ARTHUR KLEIN

DOVER PUBLICATIONS, INC.
NEW YORK

For M. C. K.

Published in Canada by General Publishing Company, Limited, 30 Lesmill Road, Don Mills, Toronto, Ontario.
Published in the United Kingdom by Constable and Company, Limited, 10 Orange Street, London WC 2.

Graphic Worlds of Peter Bruegel the Elder is a new work, first published in 1963 by Dover Publications, Inc.

International Standard Book Number: 0-486-21132-0
Library of Congress Catalog Card Number: 63-17907
Manufactured in the United States of America
Dover Publications, Inc. 180 Varick Street, New York, N.Y. 10014

CONTENTS

FOREWORD

This book is largely a labor of love.

The affair has been going on a long time—between the author and the works of Bruegel—but in art as in amour what matters is intensity of experience rather than mere duration.

Bruegel's works have held for me an unfailing and unfading, yet not an unchanging, fascination. New aspects have unfolded, year by year. The latest, though not necessarily the last, has been discovery and exploration of his worlds of graphic art—the engravings made from his drawings and the original drawings themselves.

This book is an explanation in which I seek to reveal to myself and others just what makes this artist seem wonderful.

The best of Bruegel engravings are in the following pages, yet not all of them could be included. Space was limited, and the time came when each inclusion had to be balanced by a deletion. To any readers whose favorites have been excluded, I apologize, and assure them that my disappointment is probably little less than their own.

In compiling and writing this book, it was not my idea that the Bruegel "fine prints" are superior to the Bruegel paintings. On the other hand, the graphic works are not incidental to or unimportant alongside the paintings. Who would want to give up either? It is good fortune that modern methods of reproduction make it possible for those who are interested to have copies of both, for their bookshelves and walls.

Good fortune, too, has attended the labors on the project in many ways. As usual, it took the form of people. First, my wife. . . . She shares my persistent Bruegelism and Bruegelizing, even to the extent of agreeing that home wouldn't be quite the same without reproductions of paintings such as "Return of the Herd," "Hunters in the Snow," and "The Corn Harvest" on our walls, where just a glance can quickly answer the inner question "Are they as good now as they were?"; and the answer remains always, "Yes, probably even better. . . ." This book is hers in ways too numerous to mention.

The many acknowledgments within will show that the volume is in itself a bound compilation of evidence of the help and good will of our long-time friends, Jake Zeitlin and Josephine Ver Brugge Zeitlin, ardent Bruegelers both. Their great collection of Bruegel engravings is surpassed only by their generosity in sharing it all—

prints, books, information, encouragement. (My only problem, I confess, in arranging photographic reproduction of prints belonging to the Zeitlins has been an unmistakable internal gnawing sensation, whose nature I understood when studying Bruegel's analysis of the Sin of *Envy*, reproduced here. . . .) Abundant thanks to the Zeitlins!

Good fortune also took the form of the superb exhibition of Bruegel prints and drawings at the Los Angeles County Museum in the spring of 1961 under the direction of Ebria Feinblatt, Curator of Prints and Drawings. Her kindness and cooperation helped much; so too did the splendid catalog she compiled. It is referred to repeatedly here. Every art library should have a copy, in my opinion.

My indebtedness to the writings of such scholars as Fritz Grossmann, C. G. Stridbeck, Adriaan J. Barnouw, etc., is repeatedly acknowledged in the text, and often implied even when not specifically stated.

Thanks for permission to photograph and reproduce illustrations are here given gladly to many people, including E. Gunter Troche, Director, Achenbach Foundation for Graphic Arts, California Palace of the Legion of Honor, San Francisco; Gertrude D. Howe, Assistant Curator in Charge of Loans, Metropolitan Museum of Art, New York; Eleanor A. Sayre, Museum of Fine Arts, Boston; Perry B. Cott, Chief Curator, and Katharine Shepard, Assistant Curator of Graphic Art, National Gallery of Art, Washington, D.C. Also to Lt. Colonel William Stirling of Keir, Scotland, and London, England.

Special gratitude goes also to Dr. Martin Grotjahn, superlative walker and talker, for sharing fascinating insights regarding the meanings-within-meanings in the paintings of Jerome Bosch, spiritual ancestor of so much in the Bruegel engravings. Had not this book, by plan, been devoted solely to engravings based on Bruegel originals, it would have included also several engravings based on originals by Bosch, or by Bosch-via-Bruegel, or Bruegel-based-on-Bosch. In fact, sometime in the future I hope to do for that intriguing group of engravings and for surviving Bosch drawings something comparable to this Bruegel presentation.

It is quite literally a privilege to be able to express appreciation for the reference material made available by the Library of the

University of California at Los Angeles; the Los Angeles Public Library; and, most abundantly, by that peregrinating Parnassus on wheels, the rolling research center and cruising cultural asset of our community: the Bookmobile of the Los Angeles County Library, and all those who have staffed it!

My free translations of Flemish verses inscribed under engravings were kindly checked, in some cases, by Andries Deinum, and had it been possible to submit all the rest to him, they might have been more faithful, if not so free. The onus for anything misleading in the translations rests naturally on me.

Translations of many of the Latin captions to the engravings were supplied by Stanley Appelbaum of the Dover editorial staff.

My thanks go to Mr. Hayward Cirker, President of Dover Publications, for his decision to make this book physically large enough to permit reproduction of the prints in size suitable for framing as well as for more satisfactory enjoyment in bound form.

Finally, a most personal acknowledgment for help from David Klein, best skindiver among sandwich-makers, or sandwich-maker among skindivers. . . .

And now for the graphic worlds of engravings after Peter Bruegel the Elder. . . .

H.A.K.

Malibu, California, 1963

AIDS IN ADVANCE

The following pages present some aids to easier enjoyment and use of what follows. This is material which might have been placed, appendix-fashion, in the rear; however, it seems better to acquaint the reader with its presence and nature in advance. It is not necessarily intended to be read first, but rather to be referred to whenever need or desire arises.

The aids comprise six sections in the following order:
1. Title and Arrangement of this Book
2. Spelling the Name of the Artist
3. Pronouncing "Bruegel"
4. A Brief List of References, by Way of Bibliography
5. Abbreviations and Symbols
6. A Chronology of the Creative Life of Peter Bruegel the Elder

A general introduction follows these aids, an introduction designed to lead directly into Bruegel's wonderful worlds, beginning with the landscapes, and continuing through seven other sections, with a total of 64 reproductions of prints from engravings.

1. Title and Arrangement of this Book

Graphic Worlds of Peter Bruegel the Elder was chosen as title in order to emphasize the diversity of subject matter in the drawings by Bruegel from which were made the engravings here reproduced. This diversity is here presented in eight sections, an arrangement based solely on the writer's considered judgment and not on any indications deriving from Bruegel or his publishers.

Within most of those sections the order of the individual pictures follows the sequence of their numbering in *Les Estampes de Peter Bruegel l'Ancien*, the basic catalog of Bruegel prints compiled early in this century by René van Bastelaer, the Curator of Prints at the Royal Library of Belgium and a scholar whose memory deserves a grateful salute from every lover of the graphic art of Bruegel.

In the two sections entitled "The World of the Seven Deadly Sins or Vices" and "The World of the Gospels" it has seemed best—for what may be called "psychological," or perhaps simply "logical," reasons—to depart from the order of Bastelaer's identifying numbers.

In the comments which precede the reproductions, the Bastelaer numbers are given in an abbreviated form—as B.6, etc.—in order that there may be complete identification at all times, even when titles of individual prints may differ from those which appear elsewhere.

In arrangements as well as in commentary the editor's effort has been to let the prints speak for themselves, to supply what background information seems likely to increase enjoyment and understanding, and to share his opinions—persistent or tentative— only when they are clearly indicated as opinions. If the written word at any time appears to get in the way of the graphic message, forget the former and cleave only to the latter. That is the editor's earnest advice and personal plea.

2. Spelling the Name of the Artist

There may seem some inconsistency in the pages that follow. The title and comments refer to *Bruegel*, yet some references clearly read *Brueghel*, and many readers probably will recall that sometime, somewhere, they have encountered also *Breughel*. Actually, all were used. Bruegel himself signed his pictures *Brueghel*—when he signed them—until about 1559; thereafter, and until his death in 1569, he consistently used *Bruegel*. And that simpler form, identified with his mature masterpieces, is preferred in this book. However, when quoting from works which used the "earlier" form, that spelling has been respected.

Also, the more familiar *Peter* is used in this book rather than the correct Dutch *Pieter* for his first name, just as *Jerome*, rather than its Latin fancification *Hieronymus*, has been used as the first name for such eminent incidental persons as Bruegel's print publisher, Jerome Cock, and Bruegel's spiritual ancestor, that enigmatic genius, Jerome Bosch.

Concerning the spelling *Breughel*: When Peter Bruegel died he left a widow and two sons, mere boys. Both of them grew up to become painters of some repute, and both spelled their names with the u and e reversed and the silent h included, as *Breughel*. Thus, since it should be the right of any individual to be addressed by the name of his own choice, they are correctly called Peter Breughel

the Younger and Jan Breughel. Each gained a nickname—"Hell" Breughel and "Velvet" Breughel, respectively, based—be it said—on their styles and subject matter, not on their personalities or characters. . . .

After all, in the sixteenth century, spelling consistency did not matter much, even to quite literate people. Cross the Channel and consider the case of one William Shakespeare (who will be mentioned again in comparison or contrast with Bruegel). Several spellings of his name are found in his own era, and he himself when signing it did not always use the same form. It is perhaps evidence of the cowardice that attends the passion for mere "correctness," as well as a sort of shabby compromise, that the prevalent standard has become the most cumbersome form of all—the 11-letter S-h-a-k-e-s-p-e-a-r-e. It might better have been Shakspere, as he seems usually to have written; or Shakspeare, as he signed that strange will of his; or even Shaxpere, as with others in the Stratford region.

3. Pronouncing "Bruegel"

It would be too bad if this book did not lead readers to talk about the artist it seeks to honor. It would be worse if they remained silent because of uncertainty how to pronounce his name. Practice here varies even more widely than with regard to spelling.

Perhaps the most frequently encountered is the pronunciation with a diphthong: *Broy-gell*. Then again one will hear *Bree-gell* and sometimes also *Broo-gell*. A subsidiary school or persuasion makes the first vowel into the German Umlaut u, like the vowel in *über* or *üppig*, which is sounded approximately by shaping the lips as if to utter a nice round o as in rose, but instead vocalizing a long e, as in free.

Correctness, like consistency, is sometimes a virtue of small minds, but if one wants to follow the lead of the lexicographers, whose profession it is to know such things, then the pronunciation should be that of the German Umlaut o, as in *schön* or *möchte*, or the French eu as in *jeu, seul, feu*, etc. To achieve this, round the lips again, as for the o of rose, but seek to utter the sound of long a, as in fate or plate or—O vagaries of impossible English spelling!—weight!! What comes out should be closer to the ā than the ō sound.

Neither the German ö nor the French eu is native to our vocal organs. It may help those to whom German is somewhat familiar to visualize the artist's name as if it were spelled *Brögel*, and those to whom French comes handier, to think of it as if it were *Breuguel*. This is all, however, merely incidental. After all, what really matters here is not how you pronounce his name, but how you enjoy his engravings.

4. A Brief List of References, by Way of Bibliography

A complete Bruegel bibliography today would be enormous, unwieldy, and possibly even ridiculous. The following brief list is limited to works most likely to be found useful or readily accessible or—whenever possible—both. For convenience, the references are grouped according to the language in which they are written, and in the case of English, according to whether they

appear in book form, or in periodicals and journals. Order is reverse chronological, the latest being first.

Those interested in more detailed bibliography are referred to pages 648–49 of the Grossmann article in the *Encyclopedia of World Art*, Vol. II, the third item in the list below.

In English. Books and Catalogs

MÜNZ, LUDWIG. *Bruegel, the Drawings* (Complete Edition). Greenwich, Conn., 1961. 247 pp., including 163 pp. of plates, reproducing 157 drawings accepted as genuine and 53 listed as apocryphal.

FEINBLATT, EBRIA (ed.). *Pieter Bruegel the Elder, Exhibition of Prints & Drawings*. Los Angeles County Museum, 1961. 68 pp. The readable, handsome, and amply illustrated catalog of a great exhibition held during the spring of 1961.

GROSSMANN, FRITZ. "Pieter Bruegel the Elder," *Encyclopedia of World Art*, pp. 631–51. Vol. II, 1960.

GROSSMANN, FRITZ. *Bruegel, the Paintings* (Complete Edition). London, 1955. 206 pp., including 38 pp. preliminary text and 155 plates.

TOLNAY, C. DE. *The Drawings of Pieter Brueghel the Elder*. New York, 1952. 95 pp. text and notes; 96 pp. of plates, reproducing 123 drawings accepted as genuine and 40 listed as apocryphal.

GLÜCK, GUSTAV. *The Large Bruegel Book* (with notes by Fritz Grossmann). Vienna, 1952.

COX, TRENCHARD. *Pieter Bruegel*. London, 1951. 24 pp., 10 color plates.

BARNOUW, ADRIAAN J. *The Fantasy of Pieter Brueghel*. New York, 1947. Unfortunately out of print. 106 pp. with some 30 reproductions of authentic Bruegel engravings, plus 12 from engravings not now regarded as based on Bruegel originals.

BENESCH, OTTO. *The Art of the Renaissance in Northern Europe*. Cambridge, Mass., 1945. Pages 90 ff. for discussion of Bruegel's place in history of ideas.

VIDEPOCHE, JEAN. *The Elder Peter Bruegel*. New York, 1938. With a 14-page essay by Aldous Huxley; the 31-page "Note" by Videpoche, however, contains more of interest to students of Bruegel and his time. 55 pp., 30 reproductions, 6 color plates.

In English. Periodicals, Publications, and Journals

CALMANN, G. "The Picture of Nobody," *Journal of the Warburg Institute*, Jan.–June, 1960, 60–104.

GROSSMANN, FRITZ. "New Light on Bruegel . . .," *The Burlington Magazine*, 1959, 341–46.

STRIDBECK, C. G. "Combat between Carnival and Lent," *Journal of the Warburg Institute*, 1956, 96–109.

BERGSTROM, I. "The Iconological Origins of 'Spes' by P. Bruegel the Elder," *Nederlands Kunsthistorisch Jaarboeck* 1956, 53–63.

GROSSMAN, FRITZ. "The Drawings of P. Bruegel the Elder in the Museum Boymans and Some Problems of Attribution," *Bulletin Museum Boymans*, Rotterdam, 1955, 41–63.

In English. Motion Picture

Bruegel's Seven Deadly Sins, a 20-minute soundfilm, completed 1962, by H. Arthur Klein (editor-author of present book) and Thomas T. Taylor, III. Commentary spoken by eminent actor Dan O'Herlihy. Musical background.

Information regarding sale or rental in United States and Canada from TOP Films, Post Office Box 3, Malibu, California 90265; and for United Kingdom, Europe, etc., by Contemporary Films, Ltd., 14 Soho Square, London, W.1, England. Available in 16mm and 35mm prints.

Photographed entirely from Bruegel prints in the *Sins* series, all of which are reproduced and discussed in this book. Camera motion "animates" these engravings. Enlargements permit entire screen to be filled by details which occupy only an inch or two in width on the original engravings.

Shown at Edinburgh Film Festival of 1962. Also shown to invited audiences at Stedelijk (Municipal) Museum of Amsterdam and the Bibliothèque Royale (Royal Library) of Brussels, Belgium, in 1962.

Sequence of episodes in film: Introduction, with Bruegel portrait; *The Sins*: Avarice, Pride, Envy, Anger, Gluttony, Lust, and Sloth; Conclusion.

In French and German

STRIDBECK, C. G. *Bruegelstudien* (Stockholm Studies in History of Art), Stockholm, 1956. 380 pp. and 109 plates. Subtitled in part *Untersuchungen zu den ikonologischen Problemen bei Pieter Bruegel d. A.*, this solid and almost overwhelming work comprises a series of essays. It deserves to be translated into English, soon.

JEDLICKA, GOTTHARD. *Pieter Bruegel, der Maler in seiner Zeit*. Erlenbach-Zurich, 1947.

FRIEDLÄNDER, M. J. Study of Bruegel in Vol. XIV of his series *Die Altniederländische Malerei*. Leyden, Holland, 1937.

FRIEDLÄNDER, M. J. *Pieter Bruegel*. Leyden, Holland, 1937.

TOLNAY, C. DE. *Pierre Bruegel L'Ancien*. Brussels, 1935.

MICHEL, EDOUARD. *Bruegel*. Paris, 1931.

GLÜCK, GUSTAV. *Die Kunst der Renaissance in Deutschland, den Niederlanden, Frankreich. . . .* Berlin, 1928.

BASTELAER, RENÉ VAN, and G. HULIN DE LOO. *Peter Bruegel l'Ancien, son oeuvre et son temps*. Brussels, 1907.

BASTELAER, RENÉ VAN. *Les Estampes de Peter Bruegel l'Ancien*. Brussels, 1907. The monumental catalog of the prints, with reproductions in line and invaluable information regarding plate states and all relevant formal details.

5. Abbreviations and Symbols

Individual prints are identified by their "Bastelaer numbers"—as mentioned above. This refers to the number given the corresponding print in the volume which appears as the last entry in the preceding list of references, namely, the 1907 *Les Estampes de Peter Bruegel l'Ancien*. These numbers are given simply preceded by a capital B.; i.e., B.7, etc.

Original drawings, as contrasted with the engravings based

upon them, we identify by means of the catalog numbers assigned by Ludwig Münz in *Bruegel, the Drawings*, which appears as a 1961 item in the English part of the preceding list of references. Here, the identifying number is merely preceded by a capital M.; i.e., M.52. For many an engraving no original drawing has survived; however, where such a drawing is known, readers may wish to consult it either by looking up the reproduction among the plates in the Münz volume or—if they have the good fortune—by visiting the museum or collection where it is on display.

Finally, in the immediately following "Chronology of the Creative Life of Peter Bruegel the Elder," a number of references are made to paintings by Bruegel, including three in monochrome (grisaille) which served as originals for engravings reproduced in this volume. In order positively to identify the paintings mentioned and to assist readers in finding reproductions, we make use of the numbers of the corresponding plates in the work by Fritz Grossmann, *Bruegel, the Paintings*, which appears as the fourth item in the English part of the preceding list of references. A single painting may be illustrated by more than one plate, and in such case will be indicated by a range of numbers. The abbreviation is simply the identifying number or numbers following the capital letter G.; i.e., G.4 or G.122–24.

Certain other abbreviations are used to save space in the "Chronology" which follows immediately. These are c. (circa, approximately); PB (Peter Bruegel the Elder); vdH (Pieter van der Heyden, who made so many engravings from PB's originals); and finally, ? (to indicate doubtful or uncertain dates, etc.).

6. A Chronology of the Creative Life of Peter Bruegel the Elder

The following year-by-year summary of highlights deliberately omits mention of surviving PB drawings for which no corresponding engravings are known. To include such a listing of the individual drawings—however worthwhile for an understanding of the artist's over-all creative development—would go beyond the scope of this book, which is necessarily restricted to prints from engravings based on Bruegel originals. However, it has seemed best to include mention of major authentic paintings to permit comparison with drawings of the same or near date which *were* engraved and printed.

1525–30	PB born during one of these six years; site uncertain, but very likely village of Breda in province of Brabant, now Holland.
c. 1542	PB starts study with Peter Coeck van Aelst, a leading Flemish artist and decorator.
1550	Coeck having died, PB studies with Jerome Cock, a painter turned engraver and publisher, proprietor of print-publishing house Aux Quatre Vents, founded Antwerp, 1548.
1551	PB admitted to master status in Painters' Guild of Antwerp.
1552–53	PB in Italy on trip then customary, almost mandatory, for Flemish masters.

c. 1552–53 "Landscape with Sailing Boats and a Burning Town" (painting, G.1), now in a private collection.

1553 Drawing, now lost; an etching by George Hoefnagel survives, known as "Landscape with Abduction of Psyche by Mercury" (B.1).

Another drawing, now lost; etching by Hoefnagel survives, known as "Landscape with Winding River and Fall of Icarus" (B.2).

"Landscape with Jesus Appearing to Apostles at the Sea of Tiberias" (painting, G.2), now in a private collection.

1555 "Mountain Ravine (drawing, M.13), original for engraving known as "Alpine Landscape with Deep Valley" (B.9), engraved by Jerome Cock. Drawing in Louvre, Paris.

1555–58 Engraving and publication by Jerome Cock from now lost original drawings, of eleven other subjects in series known as *The Twelve Large Landscapes*.

1556 "The Temptation of St. Anthony" (drawing, M.127), now in Ashmolean Museum, Oxford. Engraved, probably by vdH, in same year (B.119).

"The Ass at School" (drawing, M.129), now in Kupferstichkabinett, Berlin. Engraved by vdH, dated 1557 (B.142).

"Big Fish Eat Little Fish" (drawing, M.128), now in Albertina, Vienna. Engraved by vdH, dated 1557 (B.139).

"Avarice" or "Avaritia" (drawing, M.130), now in British Museum, London. Engraved by vdH (B.128).

"The Adoration of the Kings" (painting, G.4), now in Musées Royaux des Beaux-Arts, Brussels.

1557 "Gluttony" or "Gula" (drawing, M.131), now in the collection of Frits Lugt, Paris. Engraved by vdH (B.129).

"Pride" or "Superbia" (drawing, M.132), in above collection, Paris. Engraved by vdH (B.127).

"Lechery" or "Luxuria" (drawing, M.133), in Royal Library, Brussels. Engraved by vdH (B.131).

"Anger" or "Ira" (drawing, M.134), in Uffizi Gallery, Florence. Engraved by vdH (B.125).

"Envy" or "Invidia" (drawing, M.135), in collection of R. von Hirsch, Basel, Switzerland. Engraved by vdH (B.130).

"Sloth" or "Desidia" (drawing, M.136), in Albertina, Vienna. Engraved by vdH (B.126).

"Landscape with the Parable of the Sower" (painting, G.5).

Engraving by vdH, "Patience" (B.124), from lost original by PB.

Engraving by vdH, "The Fight of the Money-Bags and Strong-Boxes" (B.146), from lost original by PB.

1558 "The Last Judgment" (drawing, M.137), in Albertina, Vienna. Engraved by vdH (B.121).

"Everyman" or "Elck" (drawing, M.138), in British Museum, London. Engraved by vdH (B.152).

"The Alchemist" (drawing, M.139), in Kupferstichkabinett, Berlin. Engraved probably by Philippe Galle (B.197).

1558 or 59 Engraving by Frans Huys of "Skaters before the Gate of St. George in Antwerp" (B.205) from drawing M.140.

1559 "Faith" or "Fides" (drawing, M.142), now in Rijksmuseum, Amsterdam. Engraved probably by P. Galle (B.132).

"Hope" or "Spes" (drawing, M.145), in Kupferstichkabinett, Berlin. Engraved probably by P. Galle (B.133).

"Charity" or "Charitas" (drawing, M.143), in Boymans Museum, Rotterdam. Engraved probably by P. Galle (B.134).

"Prudence" or "Prudentia" (drawing, M.144), in Musées Royaux des Beaux-Arts, Brussels. Engraved probably by P. Galle (B.136).

"Justice" or "Justicia" (drawing, M.146), in Royal Library, Brussels. Engraved probably by P. Galle (B.135).

"The Combat between Carnival and Lent" (painting, G.6–12), in Kunsthistorisches Museum, Vienna.

"The Netherlandish Proverbs" (painting, G.13–14), in Kaiser Friedrich Museum, Berlin.

1560 "Fortitude" or "Fortitudo" (drawing, M.147), in Boymans Museum, Rotterdam. Engraved by P. Galle (B.137).

"Temperance" or "Temperantia" (drawing, M.148), Boymans Museum, Rotterdam. Engraved probably by P. Galle (B.138).

"Children's Games" (painting, G.15–19), in Kunsthistorisches Museum, Vienna.

1561 "Castle with Round Towers; at the Left a River" (drawing, M.38), in Kupferstichkabinett, Berlin. Etched in 1598 by Jacob de Gheyn (B.94). This etching is also known as "River Landscape with Castle."

1561 or 62 "Mad Meg" or "Dulle Griet" (painting, G.36–44), in Musée Mayer van den Bergh, Antwerp.

c. 1562 "The Resurrection" (grisaille, G.30–31), Boymans Museum, Rotterdam. Engraved very likely by P. Galle (B.114).

1562 "Two Monkeys" (painting, G.45), in Kaiser Friedrich Museum, Berlin.

"The Suicide of Saul" (painting, G.46–47), in Kunsthistorisches Museum, Vienna.

"The Triumph of Death" (painting, G.20–29), in Prado, Madrid.

"The Fall of the Rebel Angels" (painting, G.32–35), in Musées Royaux des Beaux-Arts, Brussels.

"The Peddler Pillaged by Apes" (B.148), engraved by vdH from original by PB now lost.

1562 or 63 "View of Naples" or "The Harbor of Naples" (painting, G.48–49), in Galleria Doria, Rome.

1563 Bruegel married Mayken, daughter of Pieter Coeck,

his former teacher, in Brussels. From this time until his death six years later, Bruegel lived in Brussels, where he created his greatest, most mature paintings.

"The Poor Kitchen" (B.154) and "The Rich Kitchen" (B.159), engravings by vdH from PB originals now lost.

"The Tower of Babel" (painting, G.50, etc.), in Kunsthistorisches Museum, Vienna.

"The Flight into Egypt" (painting, G.60–62), in Antoine Seilern collection, London.

c. 1564 "The Death of the Virgin" (grisaille, G.77), in Upton House, National Trust, Banbury, England. Engraved in 1574 by P. Galle (B.116).

1564 "The Fall of the Magician" (drawing, M.150), in Rijksmuseum, Amsterdam. Engraved in 1565 by vdH (B.118).

"The Procession to Calvary" (painting, G.63–74), in Kunsthistorisches Museum, Vienna.

"The Adoration of the Kings" (painting, G.75–76), in National Gallery, London.

1565 "Spring" (drawing, M.151), in Albertina, Vienna. Engraved by vdH (B.200).

"Jesus and the Woman Taken in Adultery" (grisaille, G.78), in Antoine Seilern collection, London. Engraved by Pieter Perret (B.111).

"The Hunters in the Snow" or "January" (painting, G.79–84), in Kunsthistorisches Museum, Vienna.

"The Gloomy Day" or "February" (painting, G.85–90), in Kunsthistorisches Museum, Vienna.

"Hay-Making" or "July" (painting, G.91–98), in National Gallery, Prague.

"The Corn Harvest" or "August" (painting, G.99–103), in Metropolitan Museum of Art, New York City.

"The Return of the Herd" or "November" (painting, G.104–9), in Kunsthistorisches Museum, Vienna.

"Winter Landscape with Skaters and a Bird-Trap" (painting, G.114), in F. Delporte collection, Brussels.

"Man of War with Inscription 'Die Scip 1564'" (B.98), engraved by Frans Huys. Original drawing does not survive for this or other engravings in the *Ship* series.

"The Parable of the Good Shepherd" (B.122), engraved by P. Galle. Original does not survive.

c. 1565–67 "The Massacre of the Innocents" (painting, G.111–13), in Hampton Court, England, collection of the British Crown.

c. 1566 "The Masquerade of Orson and Valentine" (B.215),

woodcut by unknown artist. Original does not survive.

"The Numbering at Bethlehem" or "Enumeration of the People at Bethlehem" (painting, G.115–19), in Musées Royaux des Beaux-Arts, Brussels.

"The Wedding Dance in the Open Air" (painting, G.121), in the Institute of Arts, Detroit.

"The Sermon of St. John the Baptist" (painting, G.122–24), in the Museum of Fine Arts, Budapest.

"Landscape with Rabbit Hunters" (B.I), etched by PB himself.

1567 "The Land of Cockaigne, or Plenty" (B.147), engraved by vdH from PB's painting of same year and title (G.138–39), now in Alte Pinakothek Museum, Munich.

"The Adoration of the Kings in the Snow" (painting, G.120), in Oskar Reinhart collection, Winterthur, Switzerland.

"The Conversion of St. Paul on the Road to Damascus" (painting, G.125–28), in Kunsthistorisches Museum, Vienna.

1567? "The Wedding Banquet" or "Peasant Wedding" (painting, G.129–33), in Kunsthistorisches Museum, Vienna.

"The Peasant Dance" (painting, G.134–37), in Kunsthistorisches Museum, Vienna.

1568 "Summer" (drawing, M.152), in the Kunsthalle, Hamburg. Engraved by vdH (B. 202).

"The Cripples" (painting, G.140), in the Louvre, Paris.

"The Peasant and the Bird-Nester" or "Proverb of the Bird-Nest" (painting, G.141–45), in Kunsthistorisches Museum, Vienna.

"The Misanthrope" (painting, G.146), in Galleria Nazionale, Capodimonte, Naples.

"The Parable of the Blind" (painting, G.147–51), in Galleria Nazionale, Capodimonte, Naples.

"The Magpie on the Gallows" or "The Dance under the Gallows" (painting, G.153–54), in the Museum, Darmstadt.

"The Drunken Peasant Locked into a Pigsty" (B.164), engraved by Jean Wiercix from an unknown original.

1568–69? "The Storm at Sea" (painting, G.155), in Kunsthistorisches Museum, Vienna. Condition of painting indicates it was uncompleted when PB died.

1569 Death of PB. He was survived by his widow and two sons: P. Breughel the Younger, and Jan Breughel, aged five and one or two years, respectively.

GRAPHIC WORLDS
OF PETER BRUEGEL
THE ELDER

INTRODUCTION

Peter Bruegel the Elder had two principal activities as an artist; he worked as a designer for engravings and he also painted.

That order is in conformity with the facts, and does not imply that the paintings were less important to the artist's heart than the engravings. Bruegel in his own day was known, in the Netherlands and elsewhere, largely as a leading "inventor" of designs intended for copperplate engraving. He was the first link in a chain that produced prints intended for his day and age—prints that increasing numbers of burghers bought, studied, and discussed. Probably for every man or woman who saw a Bruegel painting during the master's lifetime (or a long time after), there were hundreds familiar with prints like those reproduced here.

The difference between the scope of the paintings and the prints is not merely one of quantity; there were qualitative differences, too. The drawings and paintings were conceived with different publics in mind.

Like many another artist of his era and later, Bruegel produced art with at least three different "audiences" in mind. Seldom was a single work oriented toward more than one of these audiences.

1. The "Private" Drawings

The first and smallest audience was simply the artist himself, or himself plus an inner circle of artists and intimate friends. For this most select audience he produced those marvelous sketches and studies—a sort of graphic memorandum book—which Bruegel himself labeled in Flemish *naer het leven*, or "drawn from life." More than fifty such drawings have survived, carefully and lovingly done with pen and brownish ink over preliminary sketches in black chalk. They are attributed to the years between 1557 and 1569, the year Bruegel died. All but a few bear detailed annotations in Bruegel's own handwriting, indicating colors and materials of the garments worn by the men and women pictured.

These were the artist's own contemporaries—figures he saw in the streets of Antwerp or Brussels. Fidelity radiates like a bright light from these drawings. Using them, we can today recreate the costume, the posture, and, it seems, even the state of mind of the pictured peasants, woodcutters, shepherds, pilgrims, beggars, and burghers.

In one of the last-drawn of these, we have two Jewish rabbis, no doubt seen in Brussels, to which city Bruegel moved after his marriage in 1564. Their prayer shawls, robes, and headgear are recorded with the same verisimilitude and detail which characterize the other drawings from life.

Then there are also, among Bruegel's surviving drawings, a number of landscapes, river scenes, and the like, for which no corresponding engravings have survived. It seems evident from the character of these drawings that they were not intended originally to serve as models for an engraver. They may have been "private" studies, a pictorial diary for the artist and his intimates.

In any case, neither these nor the drawings from life are included in the subject matter of this book. Some day soon, let us hope, they may appear as reproductions in a popular and inexpensive volume, for they deserve it.

Finally, related to such "private" productions are at least two pictures, all in black and gray, embodying Bruegel's most sensitive expression of religious feeling and humanitarian sentiment. These grisailles were subsequently engraved, and so the prints are reproduced in this book; yet it seems most likely that Bruegel himself did not mean them for engraving when he painted "Jesus and the Woman Taken in Adultery" (a picture he never parted with during his lifetime) or "The Death of the Virgin" (which he presented to his personal friend, the eminent geographer Abraham Ortelius).

2. The Paintings for Patrons

Quite different was the social destination of the great paintings on which, until quite recently, Bruegel's growing fame has been almost exclusively based.

These paintings were executed for wealthy or aristocratic patrons. Once delivered, they adorned fine residences or palaces and were largely inaccessible and virtually unknown to the masses of Bruegel's fellow Flemings. So far as scholars have found, no Bruegel works were prominently displayed in churches or other places open to the public. There might have been a group of such pictures, had not Bruegel's untimely death at the age of about 44 intervened (September 9, 1569). According to the writer Karel van

Mander in his book of painters, the *Schilder-Boeck* of 1604, the City Council of Brussels honored Bruegel with a commission to execute a group of paintings commemorating the construction of the canal connecting that city with Antwerp. From Mander's narrative we cannot even be certain whether these had been begun when Bruegel died.

We do know, however, that many of the masterpieces painted by Bruegel during his concluding nine years of life in Antwerp became possessions of the most prominent art parton of the city, Niclaes Jonghelinck. Jonghelinck acquired at least sixteen Bruegel paintings! Some of these have survived to our time. Others, including many of the superlative *Months* cycle, seem to have vanished. One can only hope that somehow, somewhere, one or more will be discovered, even now.

It is even possible that Bruegel's removal from Antwerp to Brussels may be related to the artist's immemorial "patronage problem." Grossmann has suggested that he might have moved because of the presence in Brussels of Cardinal Granvelle, minister of the Spanish king, Philip II, and head until 1564 of the Council of State for the Netherlands.

Now, nearly 400 years after Bruegel's death, fewer than thirty paintings survive which, in the opinion of all or most authorities, are authentic works of his. We can hardly expect, however much we might hope, that this number ever will be much increased. There is, nevertheless, another and more numerous body of Bruegel work, no less authentic.

3. The Engravings and Prints

Approximately three times as many authentic Bruegel print subjects as paintings are known today. Sixty-four are reproduced in this volume, and that number might have been made larger but for considerations of space and desire to avoid repetition of theme or treatment.

Actually, the number of "authenticated" Bruegel engravings is smaller in the opinion of the experts today than it was half a century ago. At that time more than 250 different print subjects were attributed to Bruegel originals. Bastelaer's great catalog, which truly deserves to be called monumental, listed some 278 subjects and reproduced most of them. However, later and more sophisticated scholarship has excluded many, holding them to be engraved rather from originals by one among a variety of other and lesser artists including Cornelis Cort, Hans Bol, Pieter van der Borcht, and Cornelys Matsys. This fact need not cause surprise: there was only one Peter Bruegel the Elder, but there were a variety of other competent craftsmen who worked in styles and on subject matter similar to his.

The importance of the engravings does not, in any case, depend on how many are now extant, but on what they now represent. Fritz Grossmann, a truly great Bruegel authority, considers them "no less important for an understanding of Bruegel's art than the paintings."

It is the prime purpose of this book to justify and illustrate that conclusion.

Bruegel began to draw for engraving at a most significant period in the development of human culture and communications (inextricably intertwined as they are). A new graphic mass medium was coming to the fore. It, too, was a child of the printing press which, less than a century earlier, had given birth to the first Gutenberg Bible. Copperplate engraving was not new; but new was the combination of artistic copperplate engraving and the printing press to produce superb independent prints of pictorial subjects—"independent" because they were not mere book illustrations, but graphic works in, of, and for themselves. The text, if any, would be subsidiary to the picture, as we shall see in many of the reproductions in this volume.

New, too, was the mode and extent of distribution of this new "mass medium." The day of the fine print publisher, the popular art editor and vendor, was at hand.

It was a remarkable artist-entrepreneur, Jerome Cock, who helped Antwerp to shine especially in that new light. In 1548 Cock launched his publishing shop, naming it elegantly Aux Quatre Vents. Then forty-one years old, Cock was no starry-eyed newcomer to art. He, like Bruegel after him, had visited Italy for the desirable two years of study and prestige-building. Doubtless he saw much that turned his mind to thoughts of print publishing, and by the time he returned to the Netherlands he seems to have had his future course in mind—to become an aggressive impresario and publisher of prints.

Cock was himself a competent etcher and engraver. These skills were beginning to come into their own. In 1551 the artists' "union"—known as the Guild of St. Luke—accepted metal engravers with the status of "free masters," the same as the master painters. During the following years a really good engraver could expect much better pay and perhaps even higher esteem than the artist whose original designs he transferred to metal. (This situation should be remembered when one encounters a print which shows the name or initials of its engraver and publisher but makes no mention of the artist responsible for the original design.)

Cock began as his own designer and engraver. His first published prints seem to have been a series of large Roman ruins—relics from the classic age, with which any cultivated burgher could easily identify. Also there were landscapes in the Venetian manner. At this early stage, the emphasis was always on the world beyond the Alps.

Next came a series of landscape etchings after designs by Jerome Cock's brother, Mathys, who had died some time prior to 1548.

Bruegel traveled in Italy in 1552–53. Then, with his drawings, sketches, and memories, he returned to Antwerp. He must have formed his first connection with Cock some time prior to 1555, for by that year Cock had engraved and begun to publish the first of a series of imposing Bruegel landscapes. More were issued during the several years following. Today the group is known as *The Twelve Large Landscapes*. Cock had worked the copperplates, first with acid as etchings, then by accenting with the dry burin, as in orthodox engraving style.

The series seems to have met with approval from the patrons of Aux Quatre Vents, or there hardly would have been a dozen issued. There was also another and still larger print known now as "Large Alpine Landscape."

Even while the *Landscapes* were being published and sold, Bruegel undertook something quite new, yet old. About 1557,

"abruptly and without any transition," as noted by Ebria Feinblatt, "he began to provide satirical-moralistic drawings with such themes as *Big Fish Eat Small Fish*, the *Ass at School*, the *Temptation of S. Anthony*, *Patience*, the *Seven Deadly Sins*, the *Last Judgment*." (All these are reproduced and interpreted on following pages.)

Thus the leap—which art historians are still explaining—from the imposing landscapes to "the human and sub-human world of the grotesque and monstrous, the abnormal and distorted. . . ." And in this sudden leap "Bruegel shows himself the conjurer and equal of the most unique artist in history, Hieronymus Bosch."

However tempting, it is not practical here to consider closely the Bosch-to-Bruegel influences. That could well be the subject of another book, richly illustrated, with symbols traced and cross-indexed: a sort of concordance of iconography. The two artists, destined to be linked in history more closely then even Beethoven and Brahms, were not even contemporaries. Bosch died in 1516, a decade or more before the uncertain date of Bruegel's birth. By 1551, when Bruegel was admitted as a master in the Antwerp painters' guild, Bosch had been dead thirty-five years.

To be sure, the fame and tradition of that great original had not disappeared in the Netherlands. And even prior to Bosch there was a rich tradition of the demonic-didactic—the art, so to speak, of scaring folks into avoiding evil, or of enjoying the thought of such a scare being administered to others, who needed it more.

The fantasies of Bosch and Bruegel inevitably suggest one another. Yet there are important differences, as Ebria Feinblatt has pointed out: "Bruegel emphasized morality as an instructive program for reform of human character. Bosch's world is superterrestrial. . . ." And again, "man and God are the subject of Bosch; man and behavior, of Bruegel." (The present writer is admittedly attracted to and all but convinced by the bold and ingenious Bosch interpretation in Wilhelm Fränger's *The Millennium of Hieronymus Bosch*; but since this is a book about Bruegel, not Bosch, that must remain a mere obiter dictum.)

It is noteworthy that Bruegel's "Bosch-like" prints did circulate widely through the art world of their day. Their "primary emphasis upon humor and instruction" doubtless was a help, as was the presence of the sentiment voiced by the fat boy in *Pickwick Papers*: "I wants to make your flesh creep." At any rate, records survive to show that not long after publication in Antwerp, such prints reached Italy; fitted with French inscriptions they won success in Paris; and in Germany they received the high tribute of being copied. (What greater praise than such piracy?)

On the other hand, as Miss Feinblatt observes, the master's paintings, which had proportionally fewer infusions of Boschian spookery, did not leave the Netherlands until after Bruegel's death, and then only as the private treasures of royalty—in particular of the Hapsburg clan, which thus acquired a historical justification otherwise rather difficult to discern.

In Bruegel's "diabolical–didactic" paintings, meanings were often veiled and dubious. So too were the meanings in the comparable prints, but Cock, as publisher, took especial care to see that acceptable morals, usually rhymed in Flemish and Latin, were engraved underneath, so that the salutary sentiments of the *Sin* and *Virtue* prints could not be mistaken. (After all, there was even then arising on the horizon a non-imaginary monster of most horrendous aspect—the Spanish-sponsored Inquisition, some of whose most sanguinary excesses were vented in the Netherlands during the decades to follow.)

Today the interpretation of "what Bruegel really meant" has become a fascinating game, relatively free from risk of anything more serious than disagreement from the specialists. It is a pastime combining scholarship, detective work, keen eyesight, and sheer conjecture. It is a game that many can play and have played. They have not all, by any means, reached identical conclusions. A consensus is difficult to formulate.

In the comments at the beginning of each section and preceding individual reproductions, the writer has tried to summarize the interpretations that seem most plausible. Some contradictions or gaps are inevitable, and there is much that cannot even be guessed at.

One idea deserves mention. In the prints, such as the *Sins*, that are diabolical–didactic, Bruegel sought to do something rather different from what was done in the allegorical–didactic prints, such as all the *Virtue* series but one. Even more marked is the difference in the approach that should be made to the prints in which, without devils or monsters anywhere, he recorded events in the lives of his fellow Flemings.

It is, however, the fantastic and fiendish which intrigues most viewers when they first begin to survey the full range of Bruegel's engraved work. What then shall be said to them in short summary regarding Bruegel as graphic teacher and moralist?

In the words of Ebria Feinblatt, Bruegel's basic attitude toward the world and man—or perhaps better, the world of man—may be summed up as being "moral, and critical of (a) man's foolishness and sinfulness, (b) religious dissension and intolerance, (c) the formalistic elements of the Counter-Reformation."

With respect to men's foolishness and sinfulness, we note that Bruegel is placed at the peak or culmination of a long tradition of art which pillories and laments "the folly of man" and the perversity of "the world"—a tradition which can be traced back through Erasmus, far into the Middle Ages.

With respect to religious dissension and intolerance, additional insights will be suggested in comments at appropriate points later in this book.

And with respect to the formalistic elements of the Counter-Reformation, we will see that certain prints, such as "The Temptation of St. Anthony," show sharp and scarce-concealed criticisms of the state of the Church and the conduct of its hierarchy.

Now is the time to turn from preliminaries to the graphic work itself, divided into subject matter sections which help to make clear the range and variety of Bruegel engravings. The complexity and even contradiction abundant in this body of work will be apparent. Such complexity constitutes an important part of its remarkable fascination. Had the Bruegel of the prints been an artist ever sweet and simple, there probably would have been no such book as this, which seeks to explore the various worlds his genius illuminated.

I.
Outer Worlds—

Nature and Man

The
World
of
Landscapes

Bruegel's landscape drawings and the engravings based on these drawings are worth study for themselves, but it is doubtful whether they would now receive such attention were it not for the impact of the artist's other works outside the landscape category.

In Bruegel's day, a tradition of landscape painting and drawing was still being defined and developed. A landscape as a background or setting for a religious picture was one thing; but quite another was concentrating on a vista or panorama as a subject in and for itself. . . . Throughout the Middle Ages the spectacle of large masses of "Nature" was likely to be fearsome and repellent. Travelers forced to journey through rugged mountains and dizzy valleys took good care to look away, insofar as they could safely do so.

It was not until the fourteenth century was well under way that a bold soul in Italy first took the drastic step of deliberately climbing a hill for the sake of "the view." The primal forests, the unpeopled wastes, the "great open spaces" lacking all signs of humanity or security—these existed, unfortunately, but they were not suitable subjects either for enjoyment at first hand or through the medium of art. They stimulated uneasiness, if not outright fear. And even in Bruegel's imposing landscapes reproduced here, the habitations and habits of men are abundantly represented.

Bruegel's special contribution to the art of landscape can probably be best assessed by setting his engraved landscapes alongside those of other artists whose works were probably familiar to the more informed patrons of Aux Quatres Vents, in and out of Antwerp. For example, the landscapes of Joachim Patinir, who died about 1524, and those of Mathys Cock (brother of Jerome), who died some time before 1548.

Patinir seems the more important as a standard of comparison. He merits, indeed, designation as one of the "first" Flemish landscape artists, in the senses both of priority in time and in stature. His similarity to Bruegel is striking. . . . In Patinir's works, contrary to the practice prevalent in his day, human figures are small and relatively subordinate; the vista is pre-eminent, the people within it are incidental. His landscapes usually are seen as if from an elevation, and they include extensive and hilly terrain. Foliage in the foreground is faithfully rendered, while in the middle distances abrupt and melodramatic rocky masses assert themselves, interspersed with heavy, dense configurations of trees and bushes. Often some other artist supplied the human figures. These, despite the dominance of the vista, were seldom static or lacking in "business"; small action and incident are abundant. The age's attitude was still that a landscape in and of itself did not deserve a picture; hence religious themes were incorporated by way of justification, decoration, and edification. In the same way, we see

in the following Bruegel prints, the subordinate figures of St. Jerome, Mary Magdalene, etc. And among Patinir's surviving paintings we may note parallel subjects. One of his St. Jerome paintings is at Karlsruhe, another at Madrid.

Charles de Tolnay, in his *Drawings of Pieter Brueghel the Elder*, speaks of Patinir's handling of landscape as "a sort of display of natural curiosities for the appeasement of wanderlust"—the wanderlust of the flatland Flemings, apparently. Tolnay also refers to Patinir as a "merely external delineator and collector of 'natural objects'" in contrast to Bruegel as landscapist.

Regarding Mathys Cock, Tolnay labels his landscape as "the Utopian world-home for poetic gratification"; and refers to both this Cock—as well as to Cornelys Matsys (1513–79)—as an artist "arranging and balancing his requisites."

Bruegel, as revealed in his surviving drawings and in engravings from no longer surviving original drawings, created landscapes more vital, more autonomous, and more expressive than these others. Ebria Feinblatt writes of "the immense, palpitating mountain ranges with their concentrated minutiae of foliage, their delicate feathery flecking. . . ." This latter effect is far more evident in the drawings than the engravings. Among surviving prints, one comes closest to it through a print from the one plate which Bruegel himself prepared: his remarkable etching of "Landscape with Rabbit Hunters."

Without doubt, Bruegel's landscapes convey suggestions—sometimes striking, sometimes subtle—of the dynamics of "inanimate" nature. The forces which shaped the upthrusting rocks and molded the "immense, palpitating mountain ranges" can be felt. Whether consciously or not, Bruegel took the first steps along the road which Van Gogh pursued to its expressionistic ultimate in his last-period paintings and drawings. There an entire scene—trees, fields, clouds, and all—writhes and gyrates in a frenzy and ecstasy of animation. This is in art a parallel to what John Ruskin deplored in literature as the "pathetic fallacy"—the imputing to unconscious nature of sentiments or emotional states relevant only to the conscious human who observes it. The pictorial artist need not say in words—for he can *show*—that one scene is caught up in birth agonies, or another is broodingly malignant, or still another dreams dimly but in peace. . . . In literature, use of the "pathetic fallacy" *may* be a shabby, deplorable device; but in pictorial art—as the best of expressionist landscapes demonstrate—it has attained successes secure against any critical attack.

Completely neutral "realistic" reporting of external nature is virtually unknown in art worth looking at. The assumption that such objective realism is an end which should be sought by individual artists, is a fallacy perhaps more pathetic, in its deepest implications, than the convention associated with such clichés as "the sad sea waves," "the patient oaks," "the angry flood," and the like. Even a fine landscape photograph, insofar as it is expressive and

individual, makes a commentary, offers an interpretation, conveys a mood.

Response to a given work of art exists, however, not in the work itself, but in the beholder of that work. And Beholder One brings a different mind and mood than Beholder Two.

Sixty or seventy years later, Beholders Ten-Thousand-and-One and Ten-Thousand-and-Two are looking. Their pre-conditioning differs from that of their grandparents; they have grown up in a different world, read different books, taken different courses, etc. The individual as well as the period differences are still operative.

These are obvious observations. They would be inexcusably trivial, were it not for the character of much writing on art history. It is unjustifiably dogmatic; it seeks to elevate the subjective to a status of universal objectivity, to codify personal impressions, communicate the essentially incommunicable, and—even, as the story has it—"unscrew the inscrutable."

This relates to (but is not meant as a defense for) the present writer's inability to accept in full Tolnay's far-reaching interpretation of the Bruegel landscapes. Tolnay declares that even the earliest of them are "separated by a chasm from all the world-landscapes of his [Bruegel's] predecessors and cannot be comprehended on the basis of the latter." He contends that Bruegel's landscapes are in fact examples of "reality conceived as a creature." It is a sort of cosmic or at least terrestrial animism, in Tolnay's extreme view, which he reiterates in varying formulations: "the world as a creature," "the chain of mountains as a society of creatures," "Nature as a living being," etc.

Tolnay even interprets a mountain by Bruegel as "a sort of tumor of the earth." The trees and bushes on the mountain become its "hair," which is thicker where the body is concave, sparser where the body "arches outward." And even beyond, "The breathing of the clumsy creature [the mountain] is overheard as it lies in a phlegmatic digesting state"—the mountain, that is, is taking its "afternoon nap." No humor is intended by Tolnay.

Bruegel's landscapes, though they form only one part of his work perpetuated and disseminated through engravings, can stand on their own merits, thanks to their beauty, scope, and grandeur, without benefit of such an elaborate and far-fetched *mystique*.

From his trip to Italy during 1552 and 1553, Bruegel returned to Antwerp a master of landscape drawing. His works are called by Ebria Feinblatt "the greatest corpus of landscape drawings in the history of Flemish art." Italian influences were not absent—notably those of Titian and Domenico Campagnola, but, says the same critic, "he far surpassed them in the breathing mountainous infinity which he was the first to convey in art."

It was as a landscape artist that Bruegel made his debut in the new world of reproduction through engravings; and his designs, transferred to copper plates by his publisher, Jerome Cock, produced the prints which follow, as well as a number of others, not included here for lack of space.

1. *ALPINE LANDSCAPE WITH DEEP VALLEY (Paysage alpestre, B.9, M.13)*

This is one of a series of twelve prints, commonly known as *The Large Landscapes* (*Suite des Grands Paysages*). Their publisher, Jerome Cock, was most likely also their engraver.

This imposing, detailed, and eventful engraving is the only one of the twelve for which one of Bruegel's original drawings survives —in this case at the Louvre, Paris. It is reproduced as "Mountain Ravine" in Charles de Tolnay's *The Drawings of Pieter Brueghel the Elder*. Tolnay considers it to be the sole surviving original working drawing of the series; a couple of other drawings of subjects from among the twelve he believes were merely copies, not from the hand of Bruegel. The drawing is dated 1555. Probably it was completed as one of the two or three first, among the twelve, the last of which must have been ready for the engraver before the end of 1558.

This book, for lack of space, does not include two surviving prints whose dates indicate they derive from still earlier original drawings—as early, in fact, as 1553, in Rome, during Bruegel's Italian travels. One of these prints is "Landscape with Abduction of Psyche by Mercury" (B.1), the other, "Landscape with Winding River and Fall of Icarus" (B.2). Both prints show many interesting elements, but seem inferior in power and scope to the landscape engravings selected for reproduction in this book.

This sweeping vista overlooking an Alpine ravine teems with evidences of humanity. Literally scores of human figures are engaged in varied activities, scattered from the foreground at lower right to the far distances at left center. Men are plowing, hunting, driving burdened horses, plodding along with agricultural implements on their shoulders—all purposeful and busy. Everywhere we find the artist concerned with recording "the essential reality of creatures going about their business among the equally earnest elements of nature" (Robinson Jeffers—"Boats in a Fog").

Habitations and shelters of the human creatures belong also to this essential reality. Houses and a church nestle in the ravine, above the bridge; along the hillcrest halfway up at the left stands a church, partly concealed by a protective wall. The church has an "onion dome" such as is still seen in the Tirol and southern Bavaria. Houses and towers stretch to the right of the church. Across the ravine another cluster of houses perches precipitously on a hilltop. Below and to the left an arched gate appears to guard the access road. At right, slightly above the center of the print, the round pointed tower of another church rises above a grove of evergreens.

A wayside cross leans a little crazily on the crest of a hill, toward left center, which runs down toward the three-arched bridge spanning the rock-studded stream in the gorge.

The sky, too, is filled with the reality of creatures going about their business among the elements of nature. Long-necked migratory birds fly, two by two, from left to right. One group includes four birds.

Animate life abounds as far as the eye can see, to the very limits of the horizon and the engraver's skill. The multiplicity deserves mention, for this scene—like so many others created by Bruegel in his later paintings as well as in his drawings—is clearly a composite. It contains elements observed by the artist at different times and in different places. Identifiable portions of this engraving can be found not only in the previously mentioned drawing known as "Mountain Ravine," but also in another surviving drawing of the same year called "Mountainous Landscape" (M.12). Specifically from this latter drawing came the dominant massive group of rocks just right and above the center of the print, and also the large boulder rising up out of the water near the bottom edge, just right of center.

Selection and synthesis of this sort is characteristic of the other landscapes in this series and—it cannot be doubted—of the great paintings of the six years preceding Bruegel's death in 1569 (notably the paintings in the series of *The Months*: "Hunters in the Snow," "Gloomy Day," "Return of the Herd," "Corn Harvest"—all of 1565).

One would search in vain in Italy or elsewhere for an actual landscape corresponding completely with this. Yet it is "true to life." The one possibly romanticized element in this engraving— the wreath of mist swirling around the topmost peak at upper right —is by no means improbable.

Concerning this and other drawings, an outstanding Bruegel authority has written that they "convey the grandiose character of the high Alpine scenery with a forcefulness not attained by any earlier artist except perhaps Leonardo" (Fritz Grossmann, "Bruegel" in *Encyclopedia of World Art*, II, 1960).

It is interesting to compare the original drawing (or drawings) and the engraving from which the print here reproduced was made. Tolnay accuses the engraver of having "arbitrarily transformed the lines of the model." Bruegel, he pointed out, had "modeled the masses of the mountains" with "long parallel wavy lines"; but "the engraver used cross-hatching, emphasizing instead of the plastic effect the effect of light-shadow."

A remarkable feature of the working drawing (M.13), not carried over into this engraving, is the appearance of a huge face in profile, open-mouthed and wild-eyed, formed by the configuration of the rocks, just left of center and about a quarter of the way down from the top edge. This "great stone face," had it been carried over, would have appeared about where we now see the rocky cliff toward which the central pair of birds are headed, just right of center.

This cliff is, however, as mentioned, part of the configuration of rocks taken from the other drawing (M.12). The possible motive for this "borrowing," like so much else concerning the works and life of Bruegel, can be at best mere conjecture. It is not even certain that the face effect in the M.13 drawing is intentional. Yet it seems far too definitely "facial" to have been unnoticed by both original artist and engraver. The subject has not been mentioned by Tolnay or other Bruegel students, so far as this writer knows.

The impact may be surmised from the fact that the boulder and shrub components which make up the face would measure well over 100 feet from top to bottom, with a countenance staring aghast into the depths of the ravine as if amazed or enraged by what it sees.

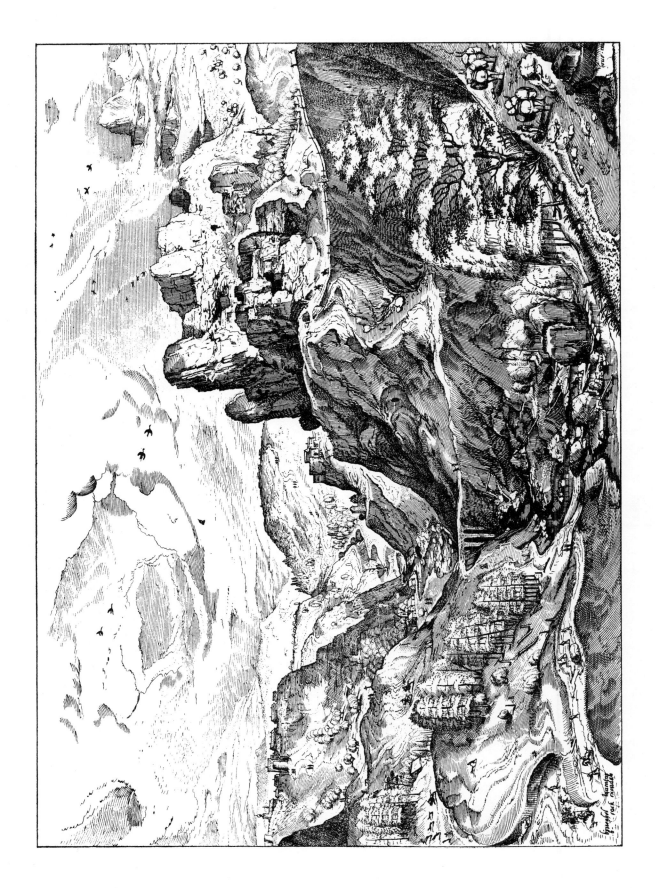

2. SAINT JEROME IN THE DESERT (S. Hieronymus in Deserto, B.7)

The man for whom this print is named crouches in a near corner at the right. He is Saint Jerome—"Hieronymus" in the Latin form. Apparently engrossed in a book, he turns his back on the eloquent and fluid-flowing landscape which fills the rest of the frame.

Behind him lies a tame lion, like a large cat; his companion, not a menace. Dürer's 1514 copper engraving, "St. Jerome in His Study" (Metropolitan Museum of Art, New York) shows a similar lion peacefully dozing at the feet of the sainted scholar, while on the wall hangs a wide-brimmed hat, much like the one which here hides the face of the holy man. The lion is a frequent companion of this Saint in Renaissance art.

In this print a circle is inscribed above Saint Jerome's hat, serving as a "radiance" to symbolize his sanctity.

The hiding of the face is a "Bruegelism" both recurrent and puzzling. Again and again, in drawings and paintings, Bruegel hid the facial features of central or subsidiary characters. Quite commonly they are submerged behind hats, hoods, helmets or other head coverings, which often seem to fuse directly to the bulk of the body below. A fine Bruegel scholar, Fritz Grossmann, remarks that Bruegel not only "liked to show his sitters from the back" but "even in a frontal view he often hid the face . . . under a hat or head scarf"; thus "without giving up the realistic appearance, he was . . . able to endow a figure with anonymity." Grossmann says further that "to Bruegel character was revealed in the whole person, not just in the face." Whether or not this be regarded as a reason, the frequency of facelessness in Bruegel cannot be gainsaid, and constitutes one of several striking characteristics.

The historical Jerome was Eusebius Sophronius Hieronymus, born about A.D. 340, to Christian parents on the border of Dalmatia. His education in Rome emphasized intensive study of rhetoric and literature. He immersed himself in Latin and Greek classics, and became, in fact, better versed in "pagan" letters than any other Church Father. Later he learned Hebrew also. After traveling widely throughout the Roman Empire, he fell ill in Antioch. The story is told that in a dream Jesus appeared and chided him for wishing more to be a Ciceronian than a Christian. Jerome, who had thought the style of the Scriptures crude, now resolved to turn to Bible studies. "Henceforth," he said, "David is to be my Simonides, my Pindar, my Catullus."

He then went as a hermit into the wasteland of Chalcis, south and east of Antioch.

And so we see him in this engraving, immersed in the studies on which his Latin translation of the Scriptures, later known as the Vulgate, was based. From Jerome, too, derives the distinction between canonical (or included) and apocryphal (or excluded) scriptural writings.

In a work devoted to this Netherlands master, Bruegel, it is worth mentioning that Erasmus of Rotterdam edited Jerome's complete works in nine volumes (Basel, 1516–20).

In the increasing humanistic influence and enthusiasm of Bruegel's age, Jerome, as the first great Christian scholar, was especially esteemed. His name, indeed, was current, other Jeromes being important in Flemish art, among them Jerome (Hieronymus) Bosch, whose fantastic symbols and monsters Bruegel was to revive in his own form, and Jerome (Hieronymus) Cock, artist-turned-publisher, who probably engraved this copperplate and sold its prints to an ever-growing clientele of Flemish burghers.

Human and animal figures are not absent in this landscape. Four deer and three rabbits feed beside the small stream flowing past the forest to the left of the foreground trees. On a height above that forest, in the middle distance, a man leads a burdened horse, while another man appears to drive forward an unsaddled horse.

Above, on a commanding position, stand an extensive castle and fortifications system. Below the castle, along the ridge, a man's figure is silhouetted. Over his shoulder rests a shepherd's staff or perhaps a weapon. Slightly to the left, in the valley beyond, a carter, astride his horse, cracks his whip. Somewhat higher and farther, a teamster whips up two horses who are drawing a boat ashore. Near them are other sailing boats, their sails furled, seemingly anchored in the stream.

Larger vessels—sailing ships—are driven by the breeze across the river estuary or an inreaching arm of the sea. And on the far horizon, diagonal "loops" of line indicate nearly a score of sailing vessels bending before the wind.

The valley merges with the horizon in a fertile configuration of farmlands, village dwellings, and church.

A pair of birds are in flight, just left of the large tree.

In the lower left-hand corner stands a squat, strangely modern figure. He holds something like a walking stick in his right hand as he stands, his back toward us, facing the water. A trio of ducks glides there, and, looking lower, on a slight promontory we see balanced an animal, perhaps a goat.

Truly a strange "desert"! It is the Netherlands of Bruegel mixed with his Alpine memories—not the wasteland near Antioch where Jerome changed his way of life and the future of the sacred literature of the Christian West.

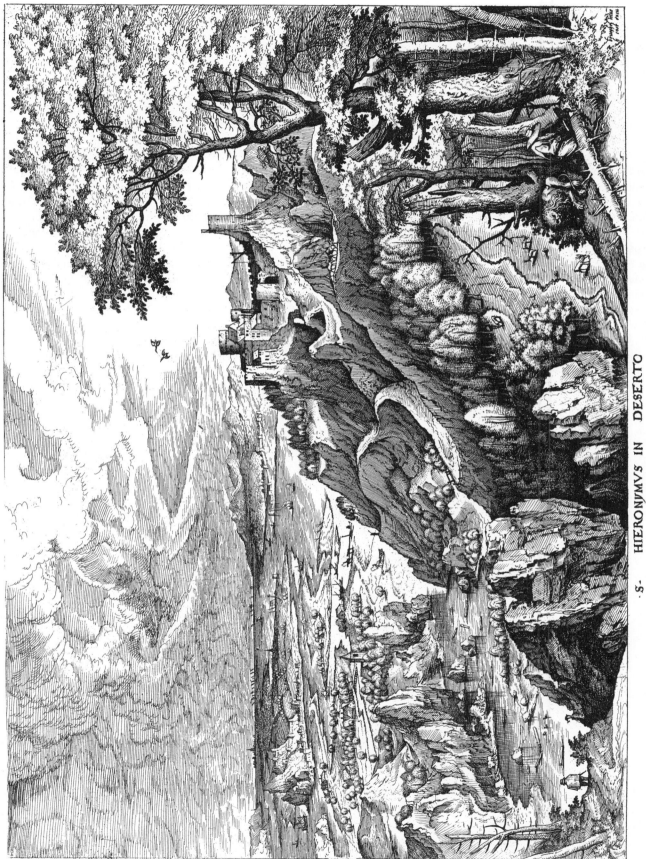

HIERONYMVS IN DESERTO

3. PENITENT MARY MAGDALENE (*Magdalena Poenitens, B.8*)

Once more the traditional personality whose name appears in the title appears obscurely and almost incidentally in the print. The Magdalene is in the foreground corner at right. The landscape again unfolds a panorama with mountains, valley, stream, town, castle, and the like.

White radiance arises from the head of the penitent. A crucifix is before her, as well as a skull, an ever-present reminder of mortality. She meditates, in all probability, a scriptural passage. Her "lean-to" shelter is formed by stripped tree trunks with large thorns like those on the fallen tree before Jerome (in the preceding print).

In the sky above the hill (at right, top) the Mother of Jesus hovers in a radiance. She appears to be attended by a quintet of angels. Farther left, along the summit, stands a cross; and still farther left, across a road, a gallows on which a body hangs. A road winds over the hill between cross and gallows. Two men climb it bearing heavy burdens. Lower on the road (just beyond the walled town) three burdened mules are led or driven by two men.

Men and mules move along other roads above a crevasse or defile to the left.

On the road near at hand, just above the Magdalene's retreat, two men and two burdened mules make their way up the slope.

On the surface of the river floats a sort of houseboat or barge bearing a tent—possibly a ferry? And on an island below stands a small house. A boat is tied up nearby.

In the lower left-hand corner appear the "credits." They declare that Brueghel (as he then spelled his name) "invented," or drew, the original; while H. Cock published it.

According to Tolnay, this engraving combines elements from at least two surviving Bruegel drawings. One, from about 1554, he calls "Landscape with River Valley and Mountains of Medium Height" (M.6). It is in the Kupferstichkabinett, Dresden. The mountain at the left of that drawing appears here in reversed position and somewhat altered form as the tallest mountain on the skyline, slightly left of center. This same mountain, with its rather characteristic "cutaway" shape, is also similar to the mountain at the upper right of another drawing titled simply "River Valley" (M.7), likewise in the Kupferstichkabinett, Dresden.

These are similarities, not identities. Often a little imagination is needed. But it is part of a fascinating game of detection.

In any case there exists no working drawing corresponding completely or even largely to this engraving.

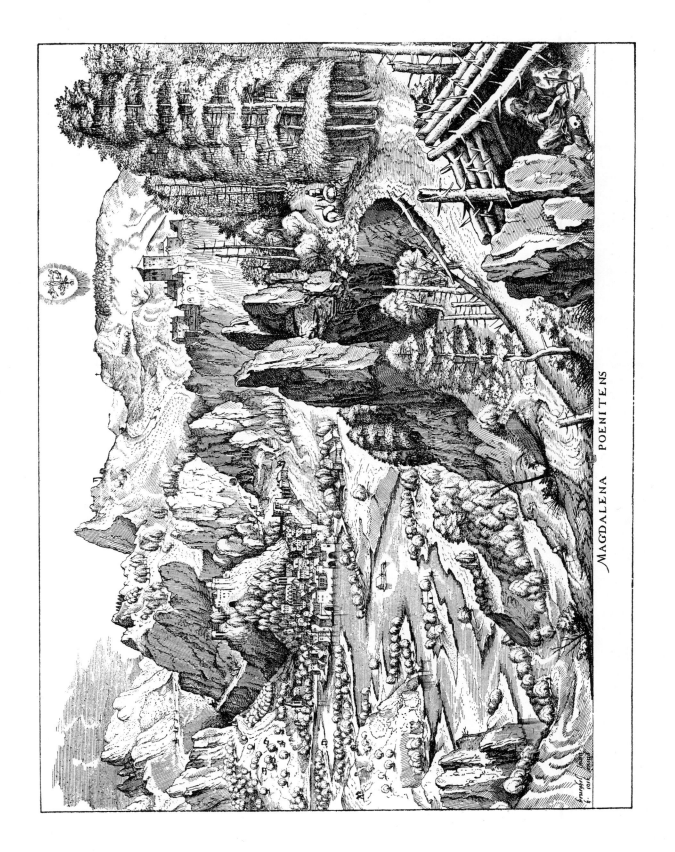

MAGDALENA POENITENS

4. *THE CUNNING BIRD CATCHER* (*Insidiosus Auceps, B.10*)

The cunning, or insidious, bird catcher himself stands in the extreme right-hand corner. We see again this apparently paradoxical or perverse subordination of the title personality or event. Such ironical "throwing away" of the title element is striking in such paintings as "The Fall of Icarus" (1554–58?), "The Procession to Calvary" or "Jesus Carrying the Cross" (1564), and "The Conversion of St. Paul on the Road to Damascus" (1567). Obviously, this is no accident. Rather, it is typical of Bruegel's approach to his chosen subject matter, human and natural. Other instances appear elsewhere in this book.

The bird catcher holds a frame bearing eight captives. Another is in his gauntleted hand. At his feet a poodle-like dog barks excitedly. This little foreground triangle constitutes the "first plane." A second plane, immediately behind, is formed by a terraced field. There (just above the bird catcher's hand) stands a richly dressed lady (at right). She seems to have come from the castle or manor house behind and to be inspecting preparation of the field with her overseer. At the moment she looks at a worker on a horse. Behind, and at the other side, a sower scatters seed and reaches into the bag slung from his belt. Every action seems definite, purposeful, serious.

Meanwhile, down in the valley, the activities and evidences of life—animal and human—multiply abundantly. Four ducks swim in the stream, near bottom, at the left. Along the far river bank a figure walks next to another riding a horse. Farther right a man pushes a wheelbarrow. Along the road behind him is another couple, one afoot, the other mounted. Their road has come past buildings, including a church. An arched bridge spans the stream. On the near side stands an arched gate, possibly a village entrance or tollgate.

Back above the stream near the left edge, two deer and two rabbits graze on the slope. The hill to the left of the church is dotted with animals and birds feeding. A worker stands still higher.

The village farther up the valley clusters around another church, and on a hill far up the valley still another church tower is silhouetted. Somewhat to the right and below it we see a wayside cross on a slope on the opposite side of the valley. Higher up *that* slope is still another church or towered castle. Small orchards are suggested. Trees dot the terrain. The valley is clearly fertile.

The entire vista might illustrate Gerard Manley Hopkins's vivid lines in "Pied Beauty": "Landscape plotted and pieced—fold, fallow, and plough;/And all trades, their gear and tackle and trim. . . ."

In the sky at right two birds fly. Bruegel seldom left a sky birdless. If no bird flies, one or more will perch high in a tree.

The river obviously flows toward us. Its continuity of motion matches the continuity in the lives of the valley dwellers.

Yet this picture is neither idealization or idyll-ization. It is free from the pretty-pretty pastoralism that later on was to become an aristocratic fad. It is free, too, of any element of parody or contempt for the rural life.

Peter Bruegel the Elder, we know now, was no "peasant." He was a sophisticated city dweller, a cosmopolite, a companion and friend of cultured men of letters, philosophers, and liberal religious and ethical reformers.

Thus far, the *Large Landscape* prints show neither condescension, denunciation, parody, nor false pathos. They are marked rather by sobriety, scope, sense of space, and real detail, recorded abundantly and devotedly.

As to the original drawings from which this engraving was derived, scholars have found some elements in a drawing designated as "River Valley," made in 1554–55, now in the Kupferstichkabinett, Dresden (M.7). Other elements are traced to the drawing dated 1555, "Landscape with Range of Mountains" in the Library of the Duke of Devonshire, Chatsworth, England (M.16).

The actual site represented by the M.7 drawing was identified by Tolnay as the valley of the Ticino River seen from the Italian side, with the castles of Castello Grande (Uri) and Castello Montebello (Schwyz) both visible. The M.16 drawing represents the same area from a quite different point of view.

Generally speaking, the pictorial material on the left of the print derives from the M.16 drawing, that on the right from the M.7, according to Tolnay.

However, he points out, "the mountain in the center of the engraving has an affinity with both drawings, resembling no. 18 [M.7] so far as the general form on the right is concerned, but recalling the Chatsworth drawing as regards its outline on the left."

Again, as in other significant Bruegel instances, the engraved print emphasizes, far more than do the drawings from which it derives, the height of the observer's standpoint over the scene he surveys.

In this connection, the print also illustrates an achievement of Bruegel which Fritz Grossmann typifies as utterly novel and "exciting": namely, "the view into the mountains from above and the impression of movement conveyed by the undulating terrain, by the position and attitude of the figures, and often by the addition of a winding river."

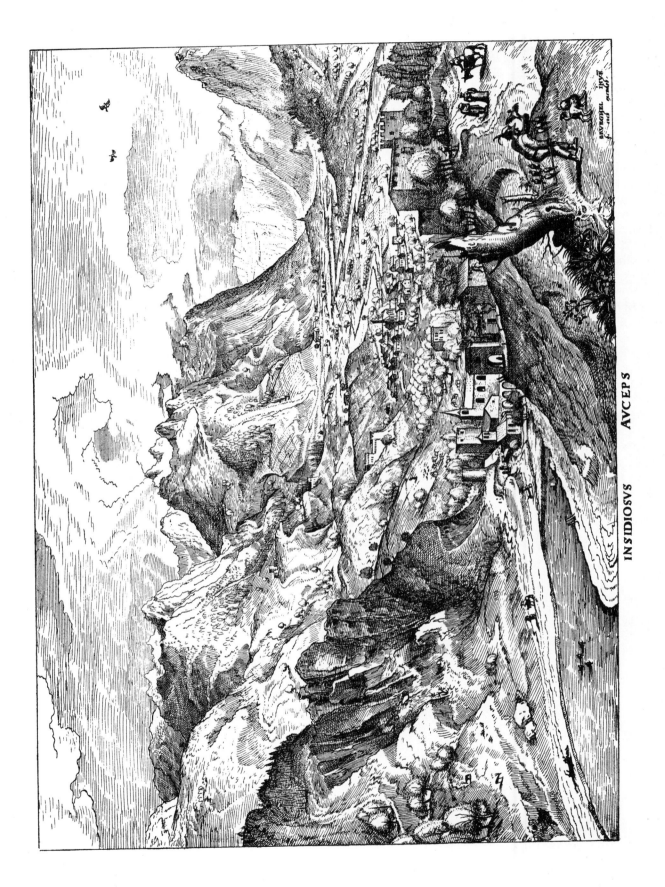

INSIDIOSVS AVCEPS

BRVEGEL INVE
ad scult

5. BELGIAN WAGON (Plaustrum Belgicum, B.11)

The "protagonist" or title giver for this print, too, appears in the immediate foreground. Here, it is the heavy covered freight wagon (Latin: *plaustrum*) common in Bruegel's country.

With its four hoops and loose cover it looks like a crude and smaller ancestor of the "covered wagon" used sometimes by the pioneers and constantly in TV westerns.

The wagoner seems to sit astride one horse while he controls the team. His position is not completely clear, and the cut-off of the bottom margin hides details of harness.

Of the four figures seen near the wagon, only one reveals even part of a face. That is the peasant plodding along the hillock at right, back of and above the wagon. His dark profile shows, insofar as it is not hidden by the hat.

The wagoner, however, turns his back toward us. So too does the figure seated by the roadside cross above the wagon. And the rustic emerging from the cottage door is, as so often in Bruegel, only a body topped by a pulled-down hat. At the far right, shaded by trees, a dumpy figure plods toward us.

Nearly a dozen sheep graze around the bare, branchless tree at the left. Beyond it, one man rows another across the river. A horse grazes on the bank beyond them, while farther up and to the right a couple walk along a path leading from village to river.

A walled and fortified town appears to occupy the middle distance at left. Beyond it, sailing vessels of various sizes move on the water or ride at anchor, unmanned.

A pair of migrating birds stretch their necks in flight. Against the horizon, right of center, like a wisp of smoke ascending from a mountain peak, rises a line of tiny dots. This appears to be a line of migrating birds coming over the horizon, following the pair just mentioned.

Also, over another peak left of center, a similar line rises in the same direction. Probably it is likewise a line of migrating birds, beloved of Bruegel.

Of the prints thus far presented in the *Large Landscapes* series, this is the most "countrified" or peasant-like.

The foliage of the trees at right is notably solid and competent.

It has been said that the plan of composition of this print is related to that of Bruegel's intriguing painting, "The Fall of Icarus," dated at about the same period, the range being 1554 to 1558, with two scholars—Grossmann and Tolnay—holding for a date as early as 1555.

Comparison of this print and that painting gives this writer no impression of marked similarity.

The "Icarus" painting, however, has one aspect worth mention here: Icarus, the title figure, appears only in the form of his flailing legs disappearing distantly into the sea. Meanwhile, elsewhere in the scene, all goes serenely and indifferently on its accustomed way. The plowman plows, the sheep graze, the shepherd gazes at the sky, his back toward Icarus' watery grave. A great sailing vessel rides at anchor, sailors at work on its rigging.

A tremendous, trance-like pageant of indifference to the disaster and disappearance of the "hero" distinguishes the "Icarus" painting. This almost cosmic irony is, of course, absent from the engraving here being considered. But it remains an important and recurring "trademark" of Bruegel.

Plate 5 is reproduced by permission of Mr. and Mrs. Jake Zeitlin, Los Angeles, California.

6. COUNTRY CONCERNS *(Rustic Efforts, Solicitudo Rustica, B.12)*

The Latin title above is spelled as it appears below this print. More properly spelled *sollicitudo*, the word stands—with one *l* or two —for concern, care, or something to which one devotes attention and effort.

In the telltale right-hand corner, again beside a near-at-hand tall tree, sits a rustic, concerned with beating his scythe blade straight on an anvil. His face is barely visible under his hat.

A little to the left stands another man, his back turned toward us. He leans on the long, straight pole of his scythe. His concern is to get a little rest. To his left and beyond, a wagoner is beating a horse with upraised whip, concerned, apparently, to get along with a heavy load. This is a two-wheeled wagon, not a four-wheeler like the *plaustrum Belgicum* in the preceding reproduction.

Another devotee of rest sits under a tree below, center; and beyond him along the river bank sit two fishermen with poles, concerned to get a meal from the water.

Along a river-bank road, beyond the fishermen, a heavily loaded two-wheel wagon is being drawn by four horses hitched in single file.

Elsewhere, horses, sheep, and cattle graze; boats move over the waters, their sails furled and unfurled; and a waterwheel turns at the mill just this side of the fishermen, near the bottom margin.

In the sky flies a single long-necked bird, followed by a more distant group of three.

The landscape is abundantly spotted with trees, rendered by the engraver with a peculiarly puff-like or explosive technique. This approximates—though naturally cannot duplicate—the technique Bruegel commonly used for distant trees in his pen and ink drawings.

The high point of view; the range of distance from near in one corner, to many miles away on the horizon; the multiplicity of landscape, activities, structures, and terrain textures—all these are characteristic of this print as of others in the *Large Landscape* series which have been reproduced on preceding pages.

The clean-cut architectural detail of the church seen just to the left of the near tree, is worth mention and attention.

So too is the reproduction of another artifact common to the country world Bruegel knew so well. If the eye follows a line through the right-hand corner of the mill, straight up about halfway to the top of the print two wheels will be seen mounted atop poles standing side by side. The pole at left leans left at top; the other leans away, toward the right. These are the wheels which served as gibbets for punishment of offenders. Punitive structures like these stand in the distance in many a Bruegel painting and print.

The apparatus of social control, or man's inhumanity to man and beast, received ample attention in these scrupulously realistic records of Bruegel's world. Yet it is as an incidental record, part of the complex interdependent whole, that all these elements appear —free from either artistic euphemism or cynicism.

Plate 6 is reproduced by permission of Mr. and Mrs. Jake Zeitlin, Los Angeles, California.

SOLICITVDO RVSTICA

7. *VILLAGE AMID WOODS (Wooded Village, Pagus Nemorosus, B.16)*

Executed about 1558. Here Bruegel has returned home. He is now not in Alpine areas nor in the desert near Antioch, Syria. He is back in his native district of Brabant.

The point of view is correspondingly flattened. We are observing from a location only a few feet higher than the lowest point visible on the print.

Here is a wooded place. Trees of many varieties surround the village so completely that, aside from the church at center, we see only bits and pieces of the other solid-looking residences.

A cluster of trees, drawn in elaborate and loving detail, stands close to the spectator at the right. Shrubs and vines cluster about the tree trunks. An ivy-like leaf can be seen. Below, a well-fed rabbit nibbles the luxuriant ground cover.

At left a Belgian covered wagon (*plaustrum Belgicum*) makes its way through an accumulation of water. The cover of the wagon has been raised, revealing a bearded man seated or lying nearly supine inside, his head toward the horses. He may be ill. Or is this simply the most comfortable way to travel in what must be a jolting vehicle?

In any case, the necessity for large wheels on the wagon is clear enough.

The driver sits astride one horse, and the wagon is escorted by a party of three—two horsemen, already in the water, and a trotting foot soldier, his spear on his shoulder, his scabbard clutched in his right hand. He still has to achieve the crossing of the giant puddle.

The wagon driver and the three escorts all have their backs toward us. Their faces, accordingly—and characteristically—show not at all. The foot soldier and the rearmost rider have, however, turned their heads toward right, as if in response to a wave of the arm from the pedestrian who walks on what might be described as "dry land." He is looking at the party which is hastening in the opposite direction.

Some distance ahead of the wagon negotiating the passage of the water, another covered wagon is leaving the scene at the far left. It has come through successfully, so far.

A stork soars to the left of the church steeple. To the left and farther away, four birds fly in a group. No mountains appear on the horizon.

True to its name, this print shows a host of trees. About forty trees appear entirely or in part, including varieties probably identifiable even today in the Brabant area.

In the opinion of Tolnay, this is one of three engravings which were added about 1558 to the original seven engravings made for this series. The other two, entitled "On the Way to Emmaus" ("Euntes in Emmaus"), and "Resting Soldiers" ("Milites Requiescentes) are identified, respectively, as B.14 and B.17. They, like the following print, are distinguished from the earlier seven, according to Tolnay, "in their lower viewpoint, in the greater weight of their forms, and in the more powerful structure of their composition."

In this print which follows, the second of these characteristics may be traced in the markedly solid tree trunks in the woody cluster at right. Its composition seems no more powerful than that of several of the first seven.

Seven plus three equals ten. . . . There were, in all, twelve of the *Large Landscape* prints, but, as previously mentioned, Tolnay classed one of the twelve "Flight into Egypt," as not from a Bruegel original; likewise he excluded from his Bruegel canon another engraving not reproduced here, known as "Rustic Peddlers," or "Nundinae Rusticorum" (B.13). Tolnay suggests the engraver-publisher Jerome Cock as the draftsman of the working drawing underlying that (B.13) engraving. Another possibility is Hans Bols, who was closely associated with Cock.

Plate 7 is reproduced by permission of Mr. and Mrs. Jake Zeitlin, Los Angeles, California.

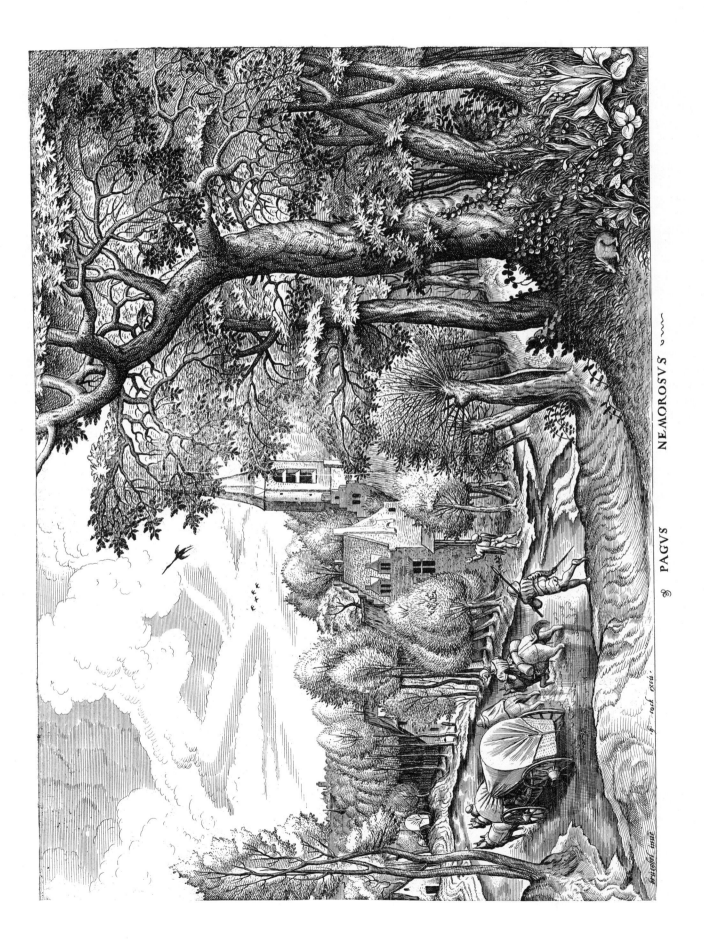

PAGVS · NEMOROSVS

8. *LARGE ALPINE LANDSCAPE* *(Grand paysage alpestre, B.18)*

This huge and teeming print, believed to have been engraved after a Bruegel drawing of about 1558–59, is not, like those previously reproduced, one of the series of twelve *Large Landscapes*. It is a separate work. It is larger, having an area nearly one-third greater than the average of the *Large Landscape* series.

Similar characteristics show up here, however. The key close-up position at right is occupied by a cloaked rider, his face away from us, gazing into the vast valley below. The slope beneath him plunges precipitously. A sixteenth-century substitute for barbed wire—thorned boughs—is used for the weatherbeaten fence dividing the slope from the sheer drop-off on our side.

Some deer are feeding at the foot of the slope. Far beyond them and somewhat to the right, cattle are grazing on meadows next to the stream in the valley floor.

One stream seems to flow from horizon center toward lower right. Another meanders to or from the lower left-hand corner. Near that corner of the picture, horsemen ride across the stream on what may be a rude bridge or embankment. Goats or small deer—difficult to distinguish because of the suggestion of long horns in the delicate engravings—are feeding here and there.

A pack train walks single file along the road cut into the steep far side of the valley, just above the center of the print. Two or three men are driving and leading at least half a dozen laden horses or mules.

The heights above this road are commanded by an imposing castle fortress.

And far up in the sky toward the right a pair of storks stretch out long necks and beaks as they fly side by side.

Another mark familiar to Bruegel lovers appears in the distance, just left of the cloaked rider at right—a gallows and a gibbet. Both lean in crazy fashion. They are tiny—but there is no mistaking them.

The mountain ascending steeply at the extreme left is jagged and abrupt like rows of giant teeth. This is a rugged, new sort of country. Weathering has not rounded and refined the jagged edges.

The power is here and the vastness, yet one cannot sense real menace or hostility in this vista. The places of men, their farms and villages, have taken hold. It is not utterly untamed, however unlike Bruegel's native Lowlands it may be.

To a rooted, untraveled Netherlands bourgeois, a steadfast citizen of Antwerp or Brussels, prints of Alpine majesty, such as this and others reproduced here, must have seemed spectacular and exciting—fine conversation pieces for Bruegel's fellow Flemings.

9. LANDSCAPE WITH RABBIT HUNTERS (The Hunt for Wild Hares, La Chasse aux lapins sauvages, B.I)

The only surviving etching by Bruegel himself, dated 1566, this appropriately concludes the reproductions of Bruegel landscape prints. It reveals more than any other his own sensitive and refined technique. Most of this was obscured by the engravers who cut all the other copperplates from his original drawings.

Note the lacy, delicate treatment of foliage, of tree bark, and of the ground on which the hunters walk at lower right. This suggests what some of the other prints might have been had Bruegel himself prepared the plates as he did this one, biting deep with acid and touching up here and there with the graver, traditional tool of the engraver. This is accordingly an etching, not an engraving.

Bruegel's superior flexibility, elegance, and eloquence show also in the texture of the walls of the stone castle on the height (at top right), and in the swirling, whirling lines with which he contoured the rocks (below the castle) and the slopes that run from middle right to lower left.

In general, the composition is dominated by a diagonal from bottom left to top right. The "far" triangle recedes smoothly across the low level plain and the calm water, to the distant horizon. A Dutch windmill breaks the horizon line near the left edge. Farther right is a substantial church tower; then another, so small it is hardly visible. In a nearer plane below the horizon, another church looms close to the left margin. Sailboats make their way down the river toward the sea.

High up in the sky looms a fat cloud, darkened on the bottom by the cross-hatching effect that Bruegel used to indicate "nearly black."

In the farmyard at lower left, fowl are feeding.

Back to the title action: Three rabbits crouch, apparently unsuspecting, on the slope, while the nearer hunter aims his crossbow at the middle rabbit. His dog, still in hiding, is rigid with anticipation. Another figure, carrying a pike, half crouches behind the tree. He appears to have a black mask half over his face, or a handkerchief pulled over his mouth and nose. He may be the game warden pursuing a poacher. Large mushrooms sprout on the ground at his feet.

A single stork heads upward like an arrow. It seems to have flown from the foot of the castle.

The structure just to the left and a little below the castle—perhaps a chapel?—shows two round windows, like eyes, looking down toward the hunt. An arch below the eyes forms an open mouth. The angle of the wall between the eyes becomes a nose. It is in effect a face—possibly unintentional, but one cannot help suspecting intention, however hidden, in view of the many building-faces that appear in the fantasy and diabolical morality subjects reproduced later on in this book.

The two strange inclinations complement each other: the master who so often found ways not to show facial features on his humans, very often managed to make grotesque faces on buildings. This may be such an instance.

Prints from this plate are especially rare and prized. At this time of writing (1962) only two are known to be in the United States; one is owned by the Museum of Fine Arts, Boston.

The World
of Stately Ships
and
the Sea

The following prints, it is clear, express pride—pride of artist and audience—in stately ships, the finest afloat in their day. The vessels here glorified were contemporary with Bruegel and with the burghers, merchants, and foreign traders who purchased such prints to hang or show proudly in their comfortable homes.

Very likely many of the print purchasers owned vessels like these—or at least held shares in them—for the Flemish had been for long the principal shipbuilders, ship owners, and ship operators of Europe. England's day of sea dominance was yet to come, for this was the sixth decade of the sixteenth century.

Prior to the time when England and Holland created regular navies the difference between cargo vessels and war vessels was mainly one of degree, not of kind. Merchantmen carried cannon as a matter of course. In Bruegel's time a man of war was basically a merchantman with added cannon, and cargo space packed by supplies and munitions. Converting a merchant vessel to naval service was a matter of relatively simple refitting.

Thus, when the English fleet assembled finally in the Channel to oppose the Armada, among its total of somewhat less than two hundred vessels, only thirty-four belonged to Queen Elizabeth, and as many more were large merchant vessels converted into men of war for the occasion.

The vessels depicted here with such power and detail by Bruegel were men of war right enough, and at the same time they were essentially twins of the merchantmen whose routes and interests they were equipped to safeguard against all comers.

Bruegel's series of ships is an art treasure not to be taken as a matter of course. We have today little or no definite knowledge of the appearance, construction, and rigging of many vessels most important in history. As Sir Thomas Browne said of the songs the Sirens sang, this is something for mere conjecture. The purported "pictures" are probably fairly close, so far as concerns dimensions and some details; but they are really reconstructions, not portraits "from life." This applies, for example, to the vessels of Columbus, notably the *Santa Maria* of which it has been frankly admitted, "There probably never was a picture . . . drawn by anyone who had actually seen her, so it's impossible to know exactly what she looked like" (Edwin Tunis, *Oars, Sails and Steam*, 1952).

And of the early seventeenth-century English merchantmen— "the kind of ship in which the first English settlers crossed the Atlantic"—the same authority says: "Actually nobody knows exactly what any one of these ships looked like . . . in their own time nobody thought to make pictures of them."

Bruegel, however, and his print publisher did think to make faithful pictures of vessels significant in their time. Thus, history and art are enriched by a noble—and trustworthy—group of marine "portraits." Bruegel's treatment shows clearly that he was here a most accurate as well as enthusiastic portraitist.

But what manner of vessels were these? By what names should we call them? Marine nomenclature is almost hopelessly mixed up, whether with regard to the basic vessel types or sails and rigging. Especially is this true of the period of this Bruegel series.

According to Van Loon (*Ships*, 1935), "When old Pieter Brueghel engraved his famous series of contemporary vessels early in the 16th century, he got rid of all difficulties by calling his subjects simply 'carracks or galleons'." Of course, Van Loon erred a little here: Bruegel did not *himself* execute these engravings, and they were drawn and engraved about half a century too late for "*early* in the 16th century." Nevertheless, the main point is well taken: to Bruegel the big beautiful vessels in these engravings were undoubtedly either carracks or galleons, for the use of these labels overlapped and duplicated. Bruegel doubtless called them *kraeck*, the Flemish version of carrack.

There is, in this writer's opinion, a slightly better justification for carrack rather than galleon as applied to the principal vessels in the following prints. It is not a matter of terminological hairsplitting, but rather of the history of the vessel form. The carrack was originally a Mediterranean style of sailing vessel, essentially a two-masted cargo craft with the distinguishing feature of a long platform over the bow. The main mast was likely to be square-rigged with a single rectangular canvas, or possibly with a smaller second "course" above. The stern mast, however, carried the triangular "lateen" type sail on a diagonal boom. This type of sail, a sort of triangular hybrid between square-rig and fore-and-aft, is familiar throughout the Mediterranean areas to this day.

As trade by sea developed in the fourteenth and fifteenth centuries, Mediterranean vessels brought spices and silks to Flemish ports, and Flemish vessels carried salt fish and wool to the South. Each borrowed from the other's shipbuilding practices. The Flemish liked the hull pattern of the southern carrack, but because of the rougher northern seas they raised much higher the platform over the bow. This grew into a lofty "forward castle." (English tongues eventually contracted this to "fo'c'sle.") At the stern, too, a "castle" was raised to dizzy heights. Hence the strange effect of Bruegel's vessels when seen from the side: they look almost like a sea-going letter "u," so lofty is the superstructure fore and aft. The cross section of the hull altered, too. Instead of resembling a semicircle, it became narrower at the top than at the waterline.

This pear-shaped effect has a picturesque name: the "tumble home." Basically, it was supposed to make the ship more difficult to board in an age when boarding was an essential to successful piracy or sea warfare. A look square astern at any of Bruegel's major vessels shows a "tumble home" so pronounced that the width of the topmost poop deck may be less than a third of the beam at the waterline.

The rigging evolved also. The two masts of the original Mediterranean carrack were increased to three in the Flemish *kraeck*.

The foremast was planted on the lofty forward castle; the mainmast was anchored amidships, at about the forward end of the stern castle structure; and the stern mast projected above this loftiest part of the ship. Sometimes there were two stern masts, each with a lateen sail.

The lofty superstructure at the stern caused tremendous wind pressure on the rear of the vessel. Something had to be done to balance it. Thus developed the strange and picturesque "square"

sail hung out in front of the bow on the bowsprit. This was sometimes so large and dipped so low toward the water that it was given drainage holes through which the water could run out more easily in a heavy sea! In the centuries after Bruegel drew, as vessels grew larger, sometimes two and even three of these fantastic bowsprit sails were used. Meanwhile, English nautical talk contracted the name till it became something like "spr'ts'l," an example of vowellessness that rivals certain words in the Czechish language.

Another small reason to class the Bruegel subjects as Flemish carracks is their lack of the pronounced projecting prow or beak below the bowsprit itself. This was a characteristic of most galleons, whether English or Spanish. Originally it may have been a ramming beak which was raised up, or possibly an extension of the carrack's bow platform which was moved down. In any case it became a large and imposing protuberance and the mark of a "ship." Today it may seem to have served no function except ornament, but it was known then as "the head," and it served the same essential human needs as today's "head," now located safely inside vessels.

Having made all this as clear as muddled maritime lore permits, the writer will now confess that because of prevalent practice and possibly also because of the prestige associated with the sound of the word he has in fact used the name galleon for the men of war drawn by Bruegel in the following individual comments on prints. As noted by Van Loon, it is a usage employed by Bruegel himself.

Galleons, of course, were not propelled by oars. A true *galley*, however, depended mainly on oars, and had a single large sail as an auxiliary. With anything but a fair following wind, the sail was usually furled, for when a galley listed to port or starboard, successful rowing was nearly impossible. A Venetian galley of the sixteenth century might have as many as sixty to seventy-five oars on a side projecting in a single row. The hull was extremely long in proportion to its width, and at the prow a long beak projected. It was used for ramming vessels in combat.

Galleys appear in these Bruegel prints also. Though by no means as long as the Venetian galleys, they are basically alike. The place of honor for passengers and guests was a covered cabin or canopy at the stern. In the hull toiled the oarsmen, laboring "like galley slaves." Captives in war often supplied the muscle power, while overseers watched to see that the stroke was maintained by all. Convict labor was used also in French galleys as late as the middle of the eighteenth century.

Columbus's *Santa Maria* already has been mentioned. In general disposition of sails and rigging it must have looked like the men of war in these Bruegel pictures, though somewhat smaller. Strictly, the *Santa Maria* should be classed as a caravel, a small version of the carrack. Though contemporary drawings are lacking, plans found in the Cadiz dockyard permitted a reconstruction of a vessel believed to be nearly a replica of the *Santa Maria*; it was built and sailed across the Atlantic in connection with the Chicago Exhibition of 1893. It carried a topsail only above the mainsail on the mainmast. The foremast had a single sail only, rather than a topsail as shown on Bruegel's vessels. There was also the square "spr'ts'l" across and below the bowsprit, and the lateen sail on the mizzen mast—or stern mast, as a landlubber might call it.

All this and the clumsy hull combined to produce in the *Santa Maria* a vessel that has been described as "both slow and a bad sea boat."

Probably the Flemish vessels drawn by Bruegel were somewhat better, but not much. In terms of their times, however, they were proud vessels, which well-to-do families might be proud to preserve in the form of prints such as those reproduced here.

Bruegel and the Sea

An entire book might be written entitled "Peter Bruegel the Elder and the Sea." Probably no artist of his present standing was so fascinated by the sea in all its variations and moods, or by the activities of men who "go down to the sea in ships."

A brief résumé of some of his other sea subjects—drawings and paintings—may provide a richer perspective for this series of ship portraits.

Bruegel's love for the sea, ships, and sailing was manifest throughout his creative life. Both in drawings and in paintings he concerned himself with water and its meanings for man. Perhaps the first major marine artist, he explored many moods and environments—the open sea; harbors, roadsteads and canals; lakes and rivers.

His earliest preserved drawing, dating from about 1550 (before his Italian journey) is "Marine Landscape with View of Antwerp in Background" (M.50), also known as "Roadstead of Antwerp" (Seilern collection, London; some scholars now consider this a late work). Stormy, surging waves fill the lower two thirds of the sheet. Whipped by a wind from the left, the waves are white-capped and deeply sculptured. Tolnay wrote of this drawing: "Never before... had the dynamism of the ocean been rendered so truly." In the middle distance, a ship sails before the wind—a three-masted vessel, built and rigged like the warships commemorated in these engravings. Half a dozen small fishing or trading boats tack in the breeze.

Similarly, the earliest preserved Bruegel painting is also a marine subject—"Landscape with Sailing Boats and a Burning Town," only recently discovered. It is believed to have been painted about 1552–53. The action is sensational—apparently the aftermath of a sea raid on a walled town, which has been left in flames. Naval galleons, rigged like the ships in these engravings, seek to make their getaway, but one is crippled and sinking. Another burns even as it sails. A third seems about to escape safely.

Previously mentioned in this book (page 31) is a memorable painting, "The Fall of Icarus" (about 1555?). It is virtually a marine landscape or seascape. Though the foreground is rural terra firma, it serves mainly to frame the expanse of water below; a stately galleon, shown in devoted detail, dominates the right side of the picture. Toward the horizon sail two other such ships, seemingly making for the harbor of a distant town.

Possibly from the same period, but probably several significant years later, is Bruegel's impressive marine panorama known variously as "View of Naples" or "Harbor of Naples" (Galleria Doria, Rome). Most scholars regard it as a relatively early work (1555–56?), but F. Winkler and F. Grossmann assign it to the more mature period (1562–63). Naples itself appears in only the most subordinate way, seen against the horizon from a height as it might be by an observer approaching in an airplane today. As in the Antwerp drawing mentioned above, two thirds of the picture is given over to a devoted presentation of the wave-patterned water of the outer harbor filled with ships of all kinds—dozens of them, including many warships, similar in shape and rigging to those shown in these engravings.

And as ships in action formed the focus of his earliest known painting, so they do in the latest known painting—"The Storm at Sea," also known as "The Seascape" or "Jonah's Ship and the Whale in a Storm" (Kunsthistorisches Museum, Vienna). Unsigned, undated, and even unfinished, this work was probably undertaken during the last years of Bruegel's life. (Scholars sometimes have attributed it to Joos de Momper, but recently Grossmann finds for Bruegel on the basis of close study of the technique.)

The action here is dynamic and urgent. A bitter North Sea storm is raging. Several small vessels sail doggedly amidst mountainous swells. Dolphins play in the surge. The vessel at center, a four-master, is pursued by a monstrous whale with gaping jaws and cavernous red mouth. In comparison with this leviathan the ship seems tiny. A cask floats in the sea between the ship and the whale. It has been tossed out by the crew. Sailors believed that if a pursuing whale paused to play with the barrel, the ship might escape unscathed.

Drawings and Engravings of The War Ships series

Bruegel's working drawings from which these engravings were made must have been completed prior to 1565. They may even have been finished relatively soon after the working drawings for the engravings of landscapes reproduced in previous pages of this book.

Bastelaer's basic catalog of Bruegel prints reproduced eleven *Ships* subjects, of which at least the first ten (Bastelaer numbers 98 through 107) were engraved by Frans Huys. Huys was a craftsman and artist who devoted himself primarily to fine engraving for reproduction. He was a brother of Pieter Huys, one of the two principal artists who, prior to Bruegel, worked in the manner of Jerome Bosch. The other was J. Mandyn.

Some uncertainty exists regarding the date of the engravings. Prints from the first state of the plate (B.98) show the date "1565" just above the bottom edge, in the trough of a wave about a third of the distance from left to right. In the second state of the plate this date was almost but not completely eradicated. Telltale fragments of the first two numerals can still be distinguished.

Scholars have not agreed with regard to the date of Frans Huys's death. One version has him still working in 1570, which would make 1565 a plausible date for the engraving itself. Another version places his death during 1562; in that case the 1565 might be a subsequent addition, possibly to mark the date of first printing and publishing from the plate.

Two additional prints not included by Bastelaer because they were not known to him are reproduced here, thanks to the kind permission of their owner, Lt. Col. William Stirling of Keir,

Scotland. The style of the engraving in both points to some engraver other than Frans Huys; however, the prints provide neither identifying name nor initials. That they are based on Bruegel originals, however, is generally accepted since they were first published as such by Campbell Dodgson in 1931.

10. MAN OF WAR WITH INSCRIPTION "DIE SCIP 1564" (Nef de bande ou de haut bord, B.98)

In this engraving a brisk wind blows whitecaps on the waves. The towers of a town appear in the distance on the horizon. Church and public buildings can be identified.

Across the course of the larger vessel sails a smaller one, possibly a fishing boat. The horizon beyond it shows another sail, leaning in the wind.

The warship carries a number of cannon, a dozen of which are visible. From the stern porthole at left no cannon projects; instead a sailor's arm is letting out a rope with bucket to bring up some sea water. The angle of its hang emphasizes the heeling over of the vessel in the wind.

In the crow's-nest high up the nearer mast, a sailor adjusts the topsail. No other mariner is visible here.

The high forecastle and still higher poop deck are characteristic. A couple of generations after Bruegel, a Briton, Sir Henry Manwayring, discussing in his *Seaman's Dictionary* the suitable proportions for masts, etc., declared that the "Flemings"—that is, the Dutch—built their masts taller than the English. Accordingly, the Dutch had to make their sails narrower. The sail width on "Die Scip" in this engraving seems to be ample for the size of the vessel.

The firm modelling of the clouds massed in the sky adds to the windswept, salt-spray feeling of the whole.

The floating object in the lower right-hand corner has not been identified.

In spite of the detailed, decorative, and even ornate treatment of the vessels in this *Ships* series, there is a freedom and sense of motion—of sailing, in short—which sets them apart from many a faithful "ship's portrait" of later date. The feeling that a print such as this one conveys seems akin to that extraordinary poem by Robert Bridges, "A Passer-By." There, too, in formal, even archaic fashion, is given a greeting to a great seafarer; in the opening:

> Whither, O splendid ship, with white sails crowding,
> Leaning across the bosom of the urgent West,
> That fearest nor sea rising nor sky clouding,
> Whither away, fair rover, and what thy quest?

And on to a conclusion which echoes the opening line:

> Nor is aught . . . more fair
> Than thou, so upright, so stately . . .
> . . . beauty enough is thine,
> As thou, aslant with trim tackle and shrouding,
> From the proud nostril curve of a prow's line
> In the offing scatterest foam, thy white sails crowding.

The mingling of the detailed and the decorative, the solid ship's substance and its dynamic motion at sea—such is the special quality and contribution of this series of engravings of stately ships. Bruegel must have known them intimately and cared for them deeply.

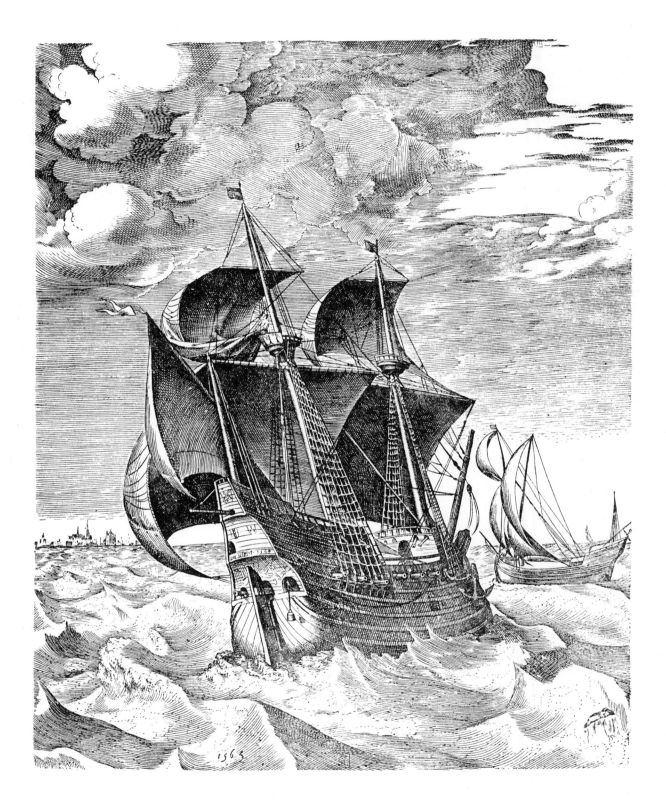

11. *MAN OF WAR SEEN HALF FROM THE LEFT* (Man of War near a Galley, Nef de bande, B.100)

Bruegel's mastery of contemporary marine "technology" and his fidelity to detail are apparent here.

This is again a ship of the galleon type. Sailors are going aloft: one on the forward slanted mast which served in lieu of bowsprit, another on the foremast, two on the mainmast toward the stern. Another sailor looks down from the crow's-nest from which project the muzzles of four guns! (Firing these in rough weather must have been difficult!)

In spite of its awkward tall "castles" fore and aft, this is a sixteenth-century floating arsenal. Four large cannon project just above the waterline on each side, two more at the rear. The next tier provides three medium-size pieces on each side and seven in the stern. In the "scooped out" section amidships stands another large cannon, wheel-mounted and probably capable of being run ashore for a siege or other excursion. The forward "castle" holds at least four smaller pieces pointing to the side, and two or more pointing backward into the "scooped out" amidships area. The total would seem to be between forty and fifty pieces of various sizes, installed all the way from a couple of feet above the water's surface to high up on the mast!

Two small features of construction may interest true sailors. The mainmast appears to be "stepped"—that is, at the level of the crow's-nest a second and smaller mast rises up from the lower one. (They probably parted company, now and then, in rough weather!) Also, the lower part of the main sail shows what appears to be a tacked-on or buttoned-on strip. This would seem to be the Flemish version of what British seamen knew as a "bonnet"—a piece added to the foot of the regular sail to obtain greater area of canvas when needed.

The galley at left is a 24- or 26-oared craft of a type very much like Greek galleys of two thousand or more years earlier. Here it seems to serve as an elegant "water taxi." In the comfortably shaded stern are seated a number of passengers, possibly important personages, who are being taken ashore after a visit to the warship. This sheer supposition may acquire greater plausibility in view of the extravagantly large ceremonial banner which flies from the mainmast of the warship. Elaborately inscribed with heraldic devices, the banner must be at least half again as long as the vessel itself. Bruegel has admirably convoluted it, to get the utmost decorative impact.

In spite of the abundance of accurate detail in rigging, ship construction, etc., the familiar "facelessness" of the humans prevails: each of the sailors we see as a compact body and a head, either turned away or so hidden by the hat that no lineaments may be surmised.

The surface of the sea is calm. Some wake follows the warship, and its blunt bow sends out a pattern of ripples, indicating a fair degree of headway with the help of the following wind.

Two states are identified in connection with the plate for this print. In the first, the name "Bruegel" and the initials "F.H." appear in a rectangular box in the lower left-hand corner; while "H. Cock ex" appears in the lower right-hand corner; and the words "Cum previlegio" appear at the extreme upper left. In the second state, trimming of strips from top and bottom have eliminated these, and the top of the mainmast now touches the upper margin of the picture.

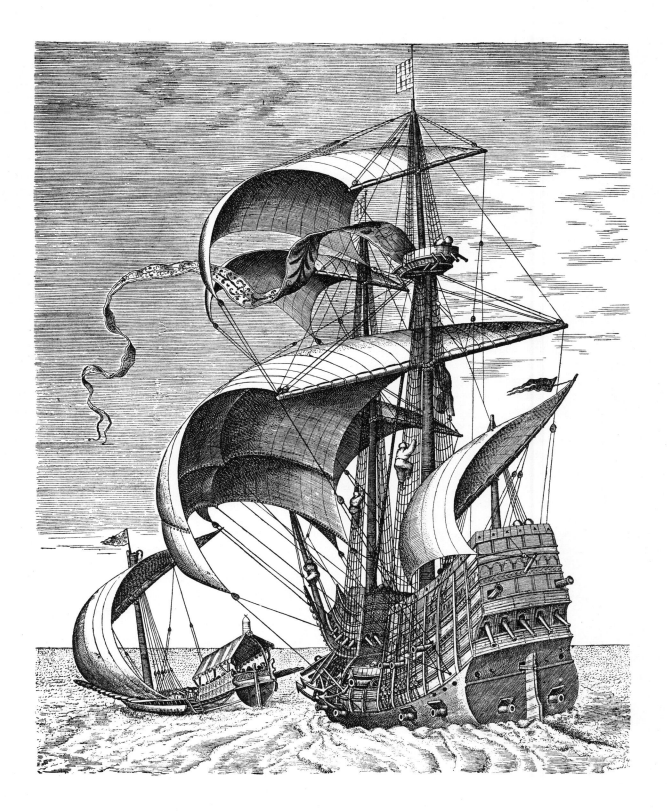

12. MAN OF WAR SAILING TO THE RIGHT; ABOVE, THE FALL OF ICARUS
(Nef de bande, armée de canons, B.101)

Here, as if Bruegel sought to inject variety and interest into his warships series, he has placed in the sky at the right a mythological subject that concerned him more than once—the fall of Icarus.

Rash Icarus, his feathers melted by flying too near the hot sun, tumbles head first to death in the sea. Meanwhile, his father Daedalus, who has flown at a more suitably "operational" level, wings on his way safely—if not quite gracefully.

Bruegel's painting, "The Fall of Icarus," has been mentioned here before. Oddly, in that painting the sun is already at the horizon, sinking, which does not fit the myth as told by Ovid in his *Metamorphoses*. However, in this engraving, solar position is satisfactory, and Icarus is still very much up in the air, whereas in the painting he has already plunged into the sea and only his legs still project to mark his point of entry.

An earlier (1553) engraving, known as "Landscape with Winding River and Fall of Icarus" (B.2), shows an Italian river landscape, probably drawn during Bruegel's Italian trip. In the sky against a background of cloud, Icarus is falling and has already dropped below Daedalus. In that engraving, as in this, individual feathers leave his melted wings and flutter earthward as he drops.

In the sky at the left of the present engraving, birds circle and swarm around rugged cliffs. A cross stands silhouetted against the sky on a summit. Barren, scraggly trees are outlined near by.

Another extraordinary "great stone face" effect can be discerned in the cliffs. Again it seems too striking to dismiss as solely accidental.

Just inside the left margin of the picture, a group of five or six trees grows on a clifftop slope. A little further to the right and above, two trees are seen growing on a light clifftop area. That light area would constitute the hair—in "page-boy" contour—for the lean, sad face which looks out toward the horizon at the right, almost toward the spot where Icarus will fall. The eyes are drooping and sunken, the nose is straight, the bearded chin merges with the rocks below. There is strong modelling of the features.

This writer does not attach much importance to these apparitions, but cannot forbear bringing them to light. Something about Bruegel's works—even the most objective representations of ships of the line, like this one—produces the conviction that no aspect is too small to mention and share with other enthusiasts. After all,

as with Shakespeare, the *facts* known about his life and mentality are sparse; whereas the creative heritage of that life and mind is abundantly rich; hence the ever-present impulse to divine the former from the latter.

At the lower right is a dolphin.

The warship central to this engraving offers some features not seen in the earlier examples. A triple division of square-rigged sails is clearly visible on both foremast and mainmast: beside the mainsail and the topsail there is place for a third—an "upper topsail" or "skysail," depending on what nomenclature one uses. This uppermost little sail is spread on the foremast but still furled on the mainmast.

The warlike nature of the vessel is emphasized by shields and sharp missiles (spears or arrows?) on lower and higher crow's-nests on both masts. Several shields are placed for protection around these nests. A "fence" of shields protects the high poop deck.

Below the bowsprit is spread the square rigged "spr'ts'l," which we all know from drawings and paintings of the vessels of Columbus and other seafarers of the fifteenth and sixteenth centuries.

At the tip of the long bowsprit rides a great globe from which flames seem to be spurting in four directions. The purpose of this interesting object is unclear. Possibly it is a lantern or perhaps simply decoration.

Two mariners can be seen. One is climbing the shrouding near the top of the foremast. The other, his sea legs wide spread, hurries along the "cutaway" section between the high stern and forecastle sections.

Far off at the right rides an oared galley with single lateen sail and a "garden house" protected area on its raised poop. It is probably a sister ship of the galley seen in the foregoing reproduction.

The first state of this plate shows relatively few sun's rays behind Icarus and Daedalus. In the second state, their part of the sky has been filled with many radiating lines, all emanating from the sun's disk; and at the bottom, below the warship, have been engraved the words "Theodorus Galle excud." They bear witness to the republication of the series by Theodore Galle, after its original publication by Jerome Cock.

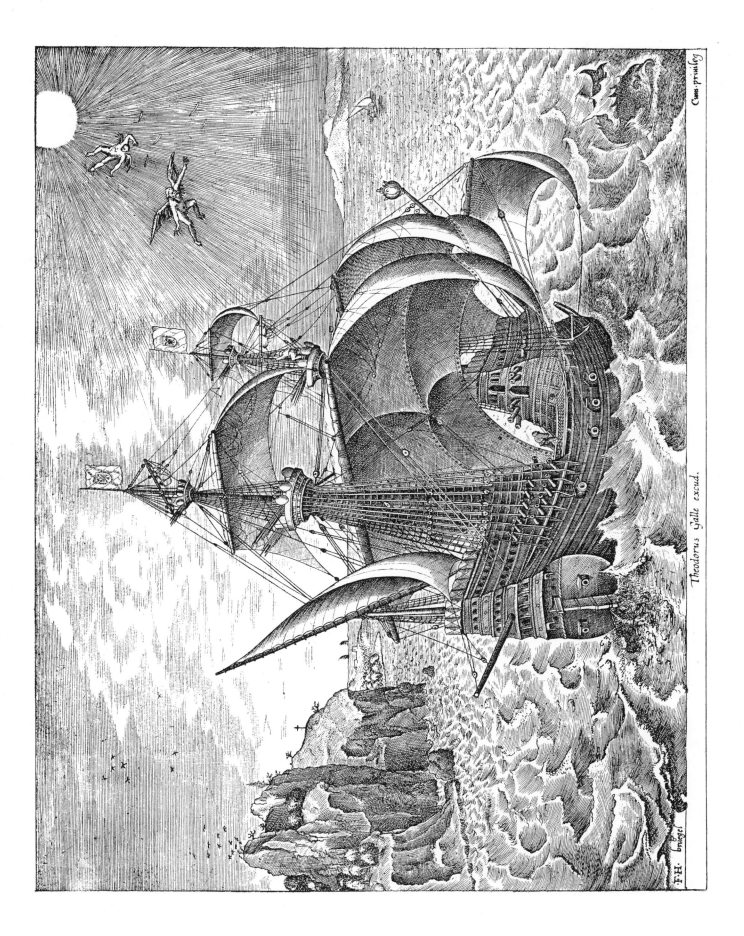

bruegel.

Theodorus Galle excud.

Cum priuileg.

13. MAN OF WAR SAILING TO THE LEFT; IN BACKGROUND A TOWN
(Nef de bande vue de profil, la proue à gauche, B.102)

The vessel moves slowly, propelled only by the mainsail on the foremast. All other sails are furled. Sailors are busy with the topsail yards on both foremast and mainmast. In all, some eight men are aloft, and more are busy forward, even in the risky position at the tip of the bowsprit.

Two "marines" stand guard on deck, holding their tall pikes. A white banner flies near the stern behind the smallest mast. A sailor is making fast, or preparing to hoist over the side, two barrels, probably containing fresh water. One gets the impression that the ship is about to leave port. A brisk wind sculptures and feathers the waves. Sea-birds fly like a ceremonial escort.

One recalls the enormous and growing seafaring activities of the Dutch in the period of Bruegel's life and the years subsequent to it. Not many years later, in 1602–03, Sir Walter Raleigh was to complain: "We send into the East Kingdoms yearly only one hundred ships, while the shipowners of the Low Countries send thither about three thousand ships." It was his estimate that the Low Countries at that time were building about one thousand ships a year and that they owned as many vessels as "eleven kingdoms of Christendom including England."

In this series of proud warships, then, Bruegel was not recording an incidental or minor interest of his fellow burghers. The growing prosperity and cosmopolitanism of his world was dependent upon the serious business of sailing, and the incidental maintenance of warships to protect that shipping and secure its profits.

This is the only recorded state of the plate associated with this engraving.

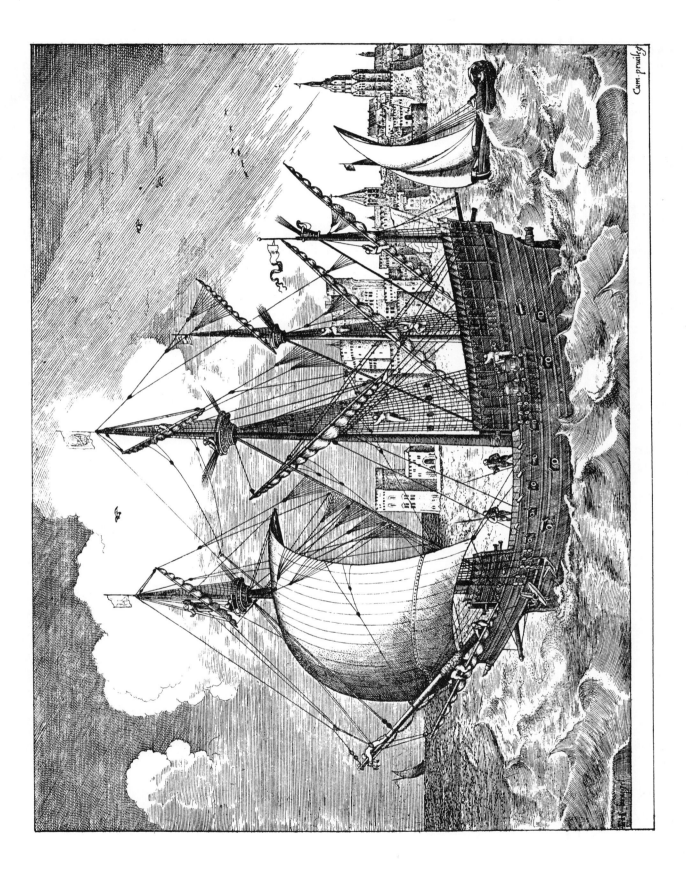

14. THREE MEN OF WAR BEFORE A WATER FORTRESS (*Trois nefs de bande, les voiles carguées, B.104*)

Here three men of war ride at anchor near one of the fortresses built in the water, with which Bruegel seems to have been familiar both in the Lowlands and from his Italian travels. (He painted one in the "View of Naples" referred to previously.)

Smoke ascending from the summit of the tower suggests the home life of its garrison or inmates.

At the right we see the prow of one of the galleons, in the center the high stern structure of another, while the vessel at the left has swung around at an angle. The varied positions demonstrate Bruegel's deliberate aim to show as much of the warships as possible. In fact, if anchored for any length of time each of the three would probably lie parallel because of the pull of tide and currents.

Four rowboats appear—one tied to the boat at the left; another containing four men who seem to be pulling up a line leading to a permanent mooring; one in the center with two men, near a small buoy floating in the water; and another, with a lone sailor, behind the rudder of the center warship. Two ducks or diving birds swim in the water a little to the right of the rowboat bearing the four men.

On the left of the fortress island stands a cross, blown into leaning position by the Lowland winds. Still further to the left looms the pointed tower of a lighthouse or town building. Two groups of sea birds fly toward the left.

In the sky a monumental mass of clouds has piled up.

Close examination of the engraver's strokes forming the masonry of the tower itself reveals a typically Bruegelian drawing effect, indicative of the scrupulous fidelity of Frans Huys, whose initials appear next to the name "Bruegel" in the small white rectangle at the lower right corner.

The crow's-nests on the masts of all three ships show armaments. Those on the center and right ships actually have small cannon protruding, while those on the masts of the ships at left and right seem to be stocked with long sharp missiles (arrows, spears, or throwing sticks).

Cannon project at four distinct levels from the stern structure of the ship at center, and from the ship at the right. In contrast, the ship anchored at the left may be a transport or supply vessel of the navy, for it shows an almost total absence of firearms. The mouth of only one fat cannon can be seen near the stern, above the tied-on rowboat.

Vessels at the left and center fly the fantastically long banners which catch the eye and fire the imagination of the observer.

For this subject, two states of the engraved plate are known. The second is distinguished mainly by the addition of the words "Theodorus Galle excud," identifying the later publisher.

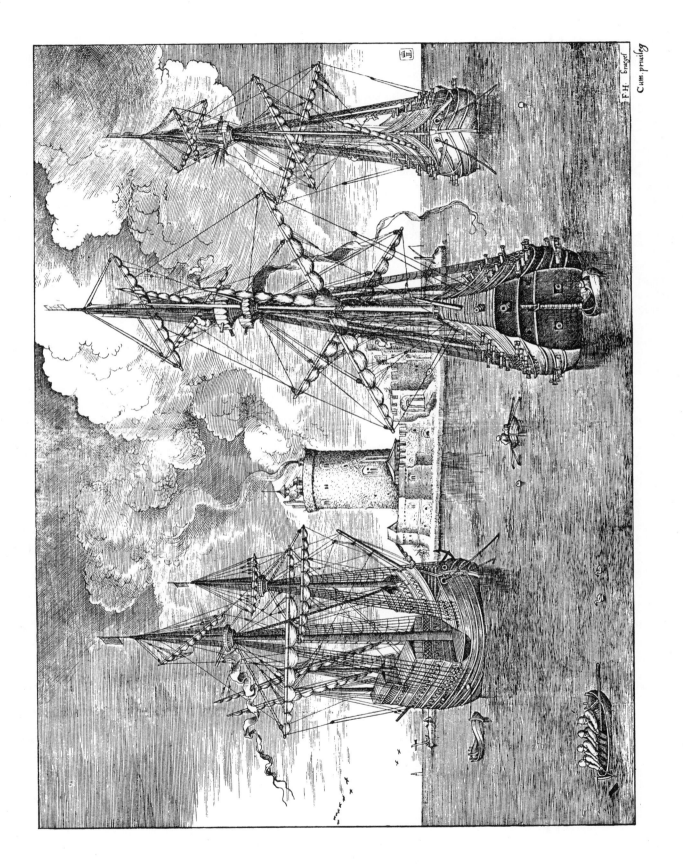

15. THREE MEN OF WAR IN A TEMPEST SAILING TO THE RIGHT, WITH ARION (Trois nefs de bande dans une tempête, B.105)

This agitated display of sea perils includes a central sea-monster at lower right, on which perches a windblown, lyre-playing naked youth. The monster may resemble a whale, but is actually intended for a dolphin. Apparently his two companions are also dolphins. Strange-looking dolphins, indeed!

They are very special dolphins—the ones who rescued the great musician Arion, and it is he who rides the middle monster while sounding the lyre.

Arion, having won a musical prize in Sicily, shipped to return to his home at the court of the music-loving king of Corinth. The seamen, however, turned pirates, and to possess themselves of his treasure announced they would toss him overboard. He asked as a last boon to be allowed to play his lyre, and the marvelous music attracted dolphins, who, after he was pitched into the sea, rescued him and bore him safe to shore.

Edmund Spenser, enamoured of all that was mellifluous and musical, wrote of Arion mounted on his dolphin as a member of the train of Neptune and Amphitrite: "Then was heard a most celestial sound," etc.

The German poet Schlegel based a poem on the tale of Arion. So did the great genius of Russian literature, Pushkin. His remarkable short lyric, in the following translation by Babette Deutsch, does not tell of a singer thrown overboard by sailors bent on murder, but rather of a sudden squall or storm from which Arion alone, thanks to the power of his song, emerged alive.

ARION

We numbered many in the ship;
Some spread the sails, some pulled, together,
The mighty oars; fair was the weather.
The rudder in his steady grip
Our helmsman silently was steering
The heavy galley through the sea,
While I, in blithe serenity,
Sang to the crew . . . when suddenly
A rough gust swooped, the waves were rearing . . .
The helmsman and the crew were lost!
No sailor by the storm was tossed

Ashore—but I who had been singing.
I chant the hymns I sang before,
And dry my garments, wetly clinging,
Upon the sunned and rocky shore.

For Bruegel, in this print, the Arion element has become—like the Fall of Icarus in an earlier print—a means of lending variety and a classical flavor to the warship series.

The three vessels in this picture plow through a stormy sea, their bluff bows laboring, their lowermost gun-ports doubtless shipping ample quantities of salt water. Aboard the vessel at right three sailors climb the foremast and two the mainmast. Perhaps they have been sent to shorten sail. In such a storm it seems unsafe to spread the topsails. They are already furled on the center ship.

Note on both vessels the beaklike prows or "heads," whose usefulness was not limited to head-on ramming in battle at sea. (They have been referred to on page 29.) The ship at the right has spread its billowing "spr'ts'l" below the bowsprit.

Each of these ships is equipped with four large anchors—two on each side.

The ships farthest left and right fly the long snaky banners from each of their principal masts.

The effect of waves with much foam and windblown spume has been attained by the relatively large use of white, unlined areas. In contrast, the sky appears all the darker and more frowning.

Bruegel's conception of the relative size of dolphins and ships is interesting. The playfulness and intelligence of dolphins is, however, somewhat suggested by the drawing of the trio—once the first shock of their size has worn off a little.

Two states of the copperplate corresponding to this print are known. The first state shows the name "H. Cock ex" in a white cloud area just below the top margin at the right. In the second state this publisher's credit has been effaced.

The translation of "Arion" by Babette Deutsch is reproduced from *A Treasury of Russian Verse,* edited by Avrahm Yarmolinsky, Macmillan, New York, 1949, by permission of the publisher.

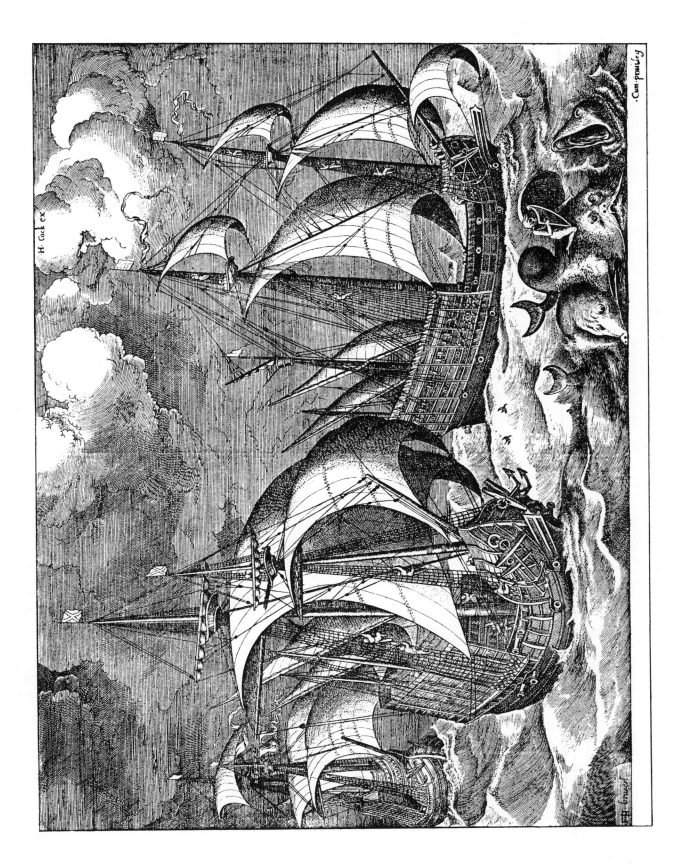

16. MAN OF WAR SEEN BETWEEN TWO GALLEYS, WITH THE FALL OF PHAETHON (Une nef de bande vue entre deux galères, B.106)

Here is the most massive introduction of mythology into the warship series. The sky is filled from side to side by the immense melodrama of Phaethon's fall. The ships themselves seem to have halted below, stopped by the celestial show. Yet in the galley at left, the helmsman at the rudder and the rowers at the oars, like the passengers under the scalloped awning, do not even look upward. In a manner characteristic of Bruegel they go soberly and seriously about the business at hand.

Atop the single mast of the galley at right a seaman waves, but his face is toward us; and nothing suggests that he seeks to call attention to the pageant of pagan legend up above.

Even the strange-faced swan swimming midway between the two galleys is oblivious to the heavenly holocaust.

The separation is quite complete between the "contemporary" representation on the water and elaborate mythological reference in the sky.

Phaethon's fall is a well-known story. He was the son of Phoebus Apollo and a nymph, Clymene. A companion scoffingly doubted his paternity, and to prove that Apollo was indeed his father, Phaethon traveled eastward to India, toward the place where the sun rose. He put the question of paternity to Apollo, who acknowledged it and promised in proof to grant anything the boy would wish. Phaethon asked to be allowed for one day to drive the chariot of the sun. Aghast, Apollo warned of the dangers, but Phaethon persisted.

Finally Apollo placed him in the golden chariot made by Vulcan, the ambrosia-fed horses were harnessed by the Hours, Dawn opened the eastern gates, the stars disappeared—and the daily journey began.

But this time it did not go as usual. Phaethon, unable to control the fiery steeds, strayed wide of the course. The earth beneath was scorched. Cities perished. Fertile regions dried to deserts, which, like that of Libya, still remain. The dwellers of Ethiopia were baked black by the heat. Father Nile fled to hide in the sandy wastes. Prostrate, Earth itself begged Jupiter to intervene. He rose up, hurled a thunderbolt at the wild driver, and Phaethon fell, his hair aflame.

Apollo resumed his accustomed round and the world was saved from fiery death—at least until the age of nuclear weapons.

Important personnel are clearly shown in the engraving: the fire-breathing horses of the sun run wild, their reins loose. Bewildered stars flash around them. The chariot itself, a four-wheeled wagon, stands empty as Phaethon falls headlong with blazing hair. The stern face of the sun—Apollo's own visage—looks in the direction of the required journey.

And at the right Jupiter on a cloud brandishes a thunderbolt which spurts flame at both ends, like a juggler's tour de force. Jupiter is seated on an eagle, one of whose wings projects below his right arm.

In the sea at the left corner are boulders, past which the galley has just been rowed. Above the boulders two more distant galleys are seen along the left side; and in the distance at the right another galleon sails toward the right, seemingly taking the wind from another direction than do the nearer vessels.

Interesting details of the rigging and construction of the lateen sails on the galleys appear in this print. The long yard from which these triangular sails are slung is seen to be made of two mast-like spars lashed together.

Only one state of the plate is recorded for this subject.

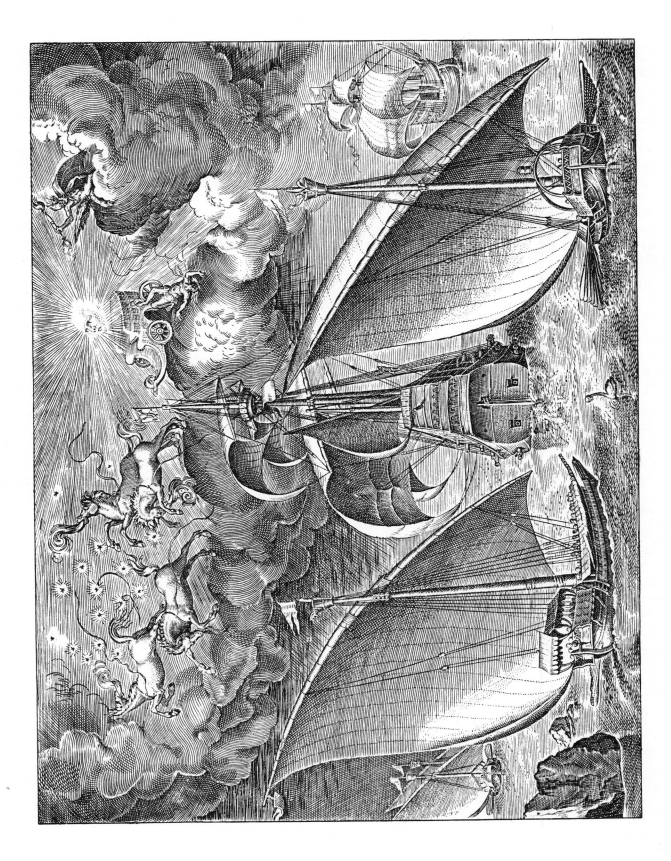

17. MAN OF WAR WITH THREE SMALL BOATS

No Bastelaer numbers exist for this print and the one following. They were not included in Bastelaer's comprehensive critical catalog of 1908, *Les Estampes de Peter Bruegel l'Ancien*, for they had not then been discovered and identified as Bruegel engravings. They were first published as such by Campbell Dodgson in 1931 in "Deux estampes d'après Pieter Bruegel l'ancien," *Mélanges Hulin de Loo*, Brussels, 1931, pages 81–82.

The remarkable completeness of the Bastelaer compilation of more than half a century ago is well exemplified here. It listed 278 different prints, each from an engraving, etching, or woodcut believed by Bastelaer to have been based on an original drawing or painting of Bruegel. Many—in fact, a majority of this number—have since been rejected as Bruegel originals by reputable scholars. But only these two new *additions* to the Bruegel print canon have been generally accepted.

These prints are owned by Lt. Col. William Stirling, of Keir, Scotland. His kind permission to reproduce them is acknowledged with thanks.

No name or initials appear on this plate—either of Bruegel or the engraver, who was almost certainly not the engraver of the preceding ship subjects. Below the lower right-hand corner of the print itself, the word "undescribed" appeared very faintly when it was shown as item No. 29 in the fine exhibition of prints and drawings of Pieter Bruegel the Elder at the Los Angeles County Museum in the spring of 1961. It was from this print that the accompanying reproduction was made. The word "undescribed" was a later addition, referring to the lack of any listing of this engraving in the Bastelaer catalog.

Noteworthy here is the unknown engraver's peculiarly rhythmical, scalloped, and "solid" rendering of the ocean waves in the foreground. The waves are "white-capped," apparently from a brisk breeze which flutters the three huge pennants flying from the masts of the small galleon, and causes the fishing boat, just to its left, to heel at a sharp angle. Yet an experienced oceanographer or wave-watcher might notice that the foam atop the waves is not very realistic: it seems to be spreading toward, rather than away from, the wind.

This writer's guess would be that the hand which completed the engraving in at least this area of the plate was not following closely an original Bruegel drawing. The master knew, better than this, the true face of the sea in all weathers.

The ship at center is anchored. So is the small fishing or trading boat farthest to the left. The galleon farthest to the right is under way, sailing before the wind.

Two rowboats move toward the left. One has just passed the bow of the central ship. Its freight is a large jar or pot. In the other rowboat, farther to the right, a seaman is vigorously rowing a stout, apparently bearded, passenger wearing a large felt hat. The impression is that of a wealthy merchant, or perhaps a ship's officer on leave.

Seven men stand on the ship itself. Four, grouped around the mast, are spear-carrying guards or "marines." A stout figure forward is looking toward the small anchored sailboat at the left, from which comes a gesture of greeting from the man seated in the stern near the rudder. On the high narrow poop deck of the central galleon stands a man, just this side of the smallest mast. He is looking out toward the right, his head seemingly raised slightly. And finally, to his right, at the extreme stern, a trumpeter blows a banner-decorated horn, facing in the direction of the departing vessel at right. Perhaps it is a farewell.

At the top margin, above the clouds in the sky, the engraver's cross-hatching produces a dark, lowering effect. Similar cross-hatching contributes to the dark and solid tones of the waved sea below. Cross-hatching also darkens the side of the ship at center. Six or seven cannon may be seen or surmised projecting from this side.

The top corners of the print are slanted, as if slightly clipped.

No prints are known which indicate any state of the plate other than that shown here.

Plate 17 is reproduced by permission of Lt. Col. William Stirling, Keir, Scotland.

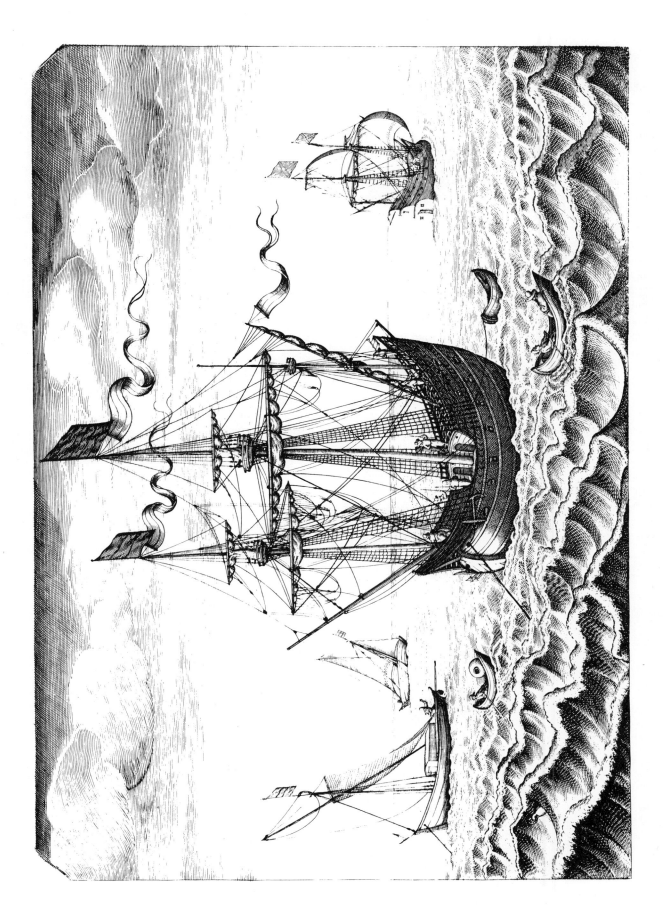

18. MAN OF WAR WITH SMALL SHIPS AT RIGHT AND LEFT

This is a companion print to the foregoing. As such it has no Bastelaer number. In the exhibition at the Los Angeles County Museum, spring, 1961, it appeared as item No. 30.

The notably "solid" and geometrical contour of the water in the foreground attracts attention here again. The engraver's cross-hatching is quite marked.

The wind comes from a direction somewhat to the right, so that the more distant galleon sails before it with all canvas spread, including the picturesque "spr'ts'l" below the bowsprit.

On the central vessel's ridiculously high, narrow poop deck a soldier or marine stands guard. He holds his spear in his raised left hand and his right arm is placed akimbo on his hip. His face, though tiny, *is* a face—to that extent, not typical Bruegel. A dense network of ropes and rigging rises to the right of this figure. Two seamen are climbing below him as if to mount to the poop deck.

The arsenal of four large anchors and the decorative "head" give this bluff bow an effect possibly more striking than that of any other ship in this series.

The lines of this ship suggest endless pitching and tossing, rolling and wallowing in the waves. It resembles rather a product of the barrelmaker's craft than a sleek ship of the line. Yet students of the working vessels of the fifteenth, sixteenth, and early seventeenth centuries will find this a faithful depiction.

The smallness of these "warships" may seem improbable. Yet history offers ample confirmation. It is recorded that the average size of more than 150 vessels in the Spanish Armada was 389 tons. About one vessel in five was below 100 tons. Queen Elizabeth's fleet, the victors, averaged about 121 tons each! The largest of Magellan's five vessels totalled only 130 tons; and even that exceeded the largest of Vasco de Gama's three when he rounded the Cape of Good Hope.

Small as it may be, the man of war at the center here is nevertheless armed. Half a dozen cannon project on the side facing us. Four of them are poked through "trapdoors" so close to the waterline that one shivers slightly at the thought of what must come aboard in a heavy sea.

Even the nearest of the fleet of more than a dozen galleys at the left is armed. It carries a larger cannon in the center, and four smaller ones above, all pointing dead ahead. The oars are all shown lifted. Possibly the wind sufficed so they were not needed for speed. Possibly, also, it was clearer and easier to draw—and engrave—them in this position.

The sun's rays shine through a rift in the dark, cross-hatched clouds at upper left. They seem to shine on the water in the middle and far distance, where it is notably lighter than toward the front.

Three long, exuberant banners form their wavy patterns in the wind as they flutter from the masts and rigging of the near warship. The more distant galleon is nobly be-bannered, too. Perhaps "pennant" is a more proper term, nautically speaking, but these are surely brave banners, every one, and they recall Edgar Allan Poe's "The Haunted Palace":

> Banners yellow, glorious, golden
> On its roof did float and flow
> (This—all this—was in the olden
> Time long ago) . . .

The only state of the plate known is the one from which this print was made.

Plate 18 is reproduced by permission of Lt. Col. William Stirling, Keir, Scotland.

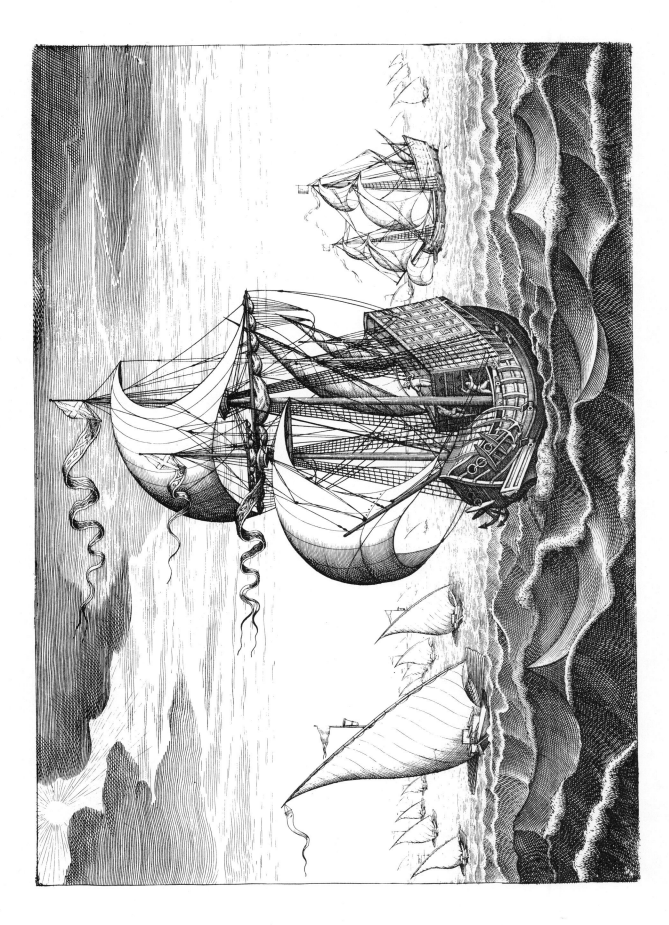

The World
of Fellow Flemings:
Aristocrats,
Burghers, Villagers,
and Peasants

Bruegel has been called the greatest sixteenth-century Flemish master in the depiction of scenes from ordinary life. The greatest "genre" artist, in short. Genre is a subject matter category. It is distinct from portrayals of nature, whether on land or on sea. It is not concerned with religious or mythological subjects, with pastoral masquerades, or with the fantasies of imagination. It is free from the allegorical, the historical-commemorative, or the ceremonial.

Genre is, as stated, simply the portrayal of scenes from ordinary life. Usually, to be precise, from the ordinary life of ordinary people. Often, but fortunately not always, this portrayal is performed in a mood which says, "My, my, aren't they quaint!" In the case of Bruegel, this mood does not prevail.

Art concerned with scenes from ordinary life need not be dull. The ordinary life scenes recorded by Bruegel are certainly not. Without melodrama, they manage somehow to convey a keen sense of reality, of sincerity, of credibility.

The present, it happens, is an era in which non-representational or abstract art has acquired unprecedented prestige. More practicing artists and more art patrons than ever before are devoted to this approach. Hence, there may be readers who wonder whether so much emphasis should be given an old-timer who, 400 years ago, was concerned with representing ordinary activities among his ordinary fellow Flemings.

The justification, if any be needed, will of course have to come from the reproductions themselves. These written comments can do no more than suggest some answers to questions likely to arise.

Bruegel's genre prints are interesting and enduring because of the extent to which he seems to have known and cared for these common folk. There is no lack of opposing interpretation. The output of Bruegel scholarship has been large during the past several decades, and it continues so. The artist Bruegel has been interpreted as a humanist neo-Platonist, a hidden heretic, a privy anti-Spanish partisan, an interpreter of the views of Erasmus, a devoted yet critical adherent of the Roman Catholic Church, etc. Some consideration is given to intellectual and ethical influences in comments later on, especially in the *Sins* and *Virtues* sections. But here the best thread to follow through the labyrinth is the simple statement of that distinguished Dutch scholar and Bruegel student, Dr. Adriaan J. Barnouw: "Brueghel's art . . . mirrors the life of the simple folk he loved with a vividness such as few other artists have achieved."

Is it needful to reiterate and justify that four-letter word: l-o-v-e? It may be, because another school of interpretation holds that Bruegel was repelled and disgusted by the world of men, to

such an extent that when he depicted people working, feasting, merrymaking, celebrating weddings, fairs, and what not, he was seeking primarily to show how sinful, corrupt, and rotten their world really was.

It is true that Bruegel in his pictures often pilloried "folly." We shall see this abundantly as he analyses common sins and vices, or probes the approved virtues of his day. But, more than that, he portrayed and preserved typical social events in the ordinary lives of ordinary people he knew—and at his best he did it without snobbery, condescension, or a holier-than-thou attitude.

This does not mean that Bruegel himself was just one of the peasants who happened to have been born a genius with the brush and the pen. He recorded peasant life superlatively, yet it was not as a peasant that he did so. As E. H. Gombrich maintains in *The Story of Art* (Phaidon, 1950), it is a mistake to think of Bruegel as one of his peasant "subjects": "If Brueghel had been a peasant himself he could not have painted them as he did. He certainly was a townsman and his attitude towards the rustic life of the village was very likely similar to that of Shakespeare. . . . It was the custom in their time to regard the country yokel as a figure of fun."

Gombrich does not believe that either Bruegel or Shakespeare "accepted this custom out of snobbery but in rustic life human nature was less disguised and covered up with a veneer of artificiality and convention than in the life of gentlefolk." The consequence: "when they wanted to show up the folly of mankind they often took low life as their model."

And Gombrich comes to a conclusion with respect to Bruegel's "peasant" paintings which may well apply also to some of the engravings which follow: "In these gay, but by no means simple, pictures, Brueghel had discovered a new kingdom for art which the generations of Netherlandish painters after him were to explore to the full."

Now we too can share in his discoveries.

19. SPRING (Le Printemps, B.200, M.151)

Engraved by Pieter van der Heyden, and published by Jerome Cock in 1570, this print is based on a 1565 drawing by Bruegel which is now in the Albertina Museum, Vienna.

The five year lapse between drawing and engraving is worthy of note.

Comparison of drawing and engraving shows, as such comparisons so often do, the extent to which Bruegel's delicacy and fluidity of treatment are diminished in the engraving.

Bruegel labeled his drawing only in Flemish: "De lenten Mert, April, Meij"—that is, "Spring: March, April, May." The Latin verse at the bottom here is consequently a publisher's contribution, with a view to impressing his public.

This is the first of two "Seasons" drawings by Bruegel. The other, "Summer," became the basis for the engraving immediately following in this book. The *Seasons* series as finally published included also engravings entitled "Autumn" and "Winter" made after Bruegel's death from original drawings by another artist, Hans Bol.

"Spring" puts us into the garden of a noble or wealthy family. It is being planted and cared for by a large number of servitors. The mistress of the garden, or lady of the estate, stands at right center. She holds a shade hat in her left hand while with her right she directs the seed-scattering of the bent worker next to her. Another female of her class stands just to the right, seemingly a younger girl, possibly a daughter of the first. Her head is tilted downward and her face covered by her hat brim. Her attention is given to a tiny lapdog who seeks to climb her long skirt, as if seeking protection from all these strange smells and activities.

Tolnay has suggested that the figure of the bearded man with the spade in front, just right of center, "seems to be inspired by the digging Noah in Michelangelo's Sistine ceiling."

This is a French or formal type of garden, not an English type. Geometrical exactness is being assured by the taut-drawn cord which passes just behind the bearded figure's spade.

All these symmetrical beds are being prepared for growth,

being sodded, raked, seeded, watered, set with plants. Potted shrubs and bushes stand just left of center.

In the upper right quadrant, sheep are sheared by two workers under the thatched eaves of the barn and by an energetic woman outside. Further right a basket of sheared wool is carried.

Immediately to the right of the shearing and behind the lady of the estate, two workers fasten vines on a bower. The supports at the entrance to the bower are a pair of armless classical statues. In the drawing, the nearer of the two appears to be a female torso, but in the engraving its sex is doubtful.

At upper center, back of the flock of sheep, stand some calves, amidst lambs nursing from grazing ewes. Still farther back, against a wall, beehives are seen. Through a gate at center rear a woman carries on her head a bag of grain. Beyond, workers are cultivating fields and pruning an orchard. Still farther back stands a church tower. At the horizon lies the sea on which tiny boats sail.

In the sky a long "v" or "u" of migrating birds provides an authentic Bruegel touch.

At left rear is the castle whose owners possess all this wealth and abundance. Around it is a moat, which does duty also as a stream for "recreational activities." It leads past a pleasure bower with two levels. Richly clad gentlemen and their female companions are feasting below, and there seems to be dancing above. Couples lie on the grass, drinking and singing. A musician plays the sixteenth-century equivalent of a cello.

In the spring a young man's fancy lightly turns to thoughts of love—or some reasonable facsimile thereof. The earnest, unremitting toil of the workers in the garden contrasts sharply with the drinking and dalliance in the pleasure bower. One of the garden workers—the woman pouring water from a pail onto a seedling bed—is obviously old. Others are middle-aged; still others, apparently young.

At the extreme right small plants are being bedded by a working woman whose hat, like an inverted bowl, covers her head completely —another characteristic Bruegelian touch.

Translation of Latin caption: *Martius, Aprilis, Maius, sunt tempora veris* = March, April, and May are the months of Spring. *Ver pueritię compar* = Spring, similar to childhood. *Vere Venus gaudet florentibus aurea sertis* = In Spring golden Venus rejoices in flowery garlands.

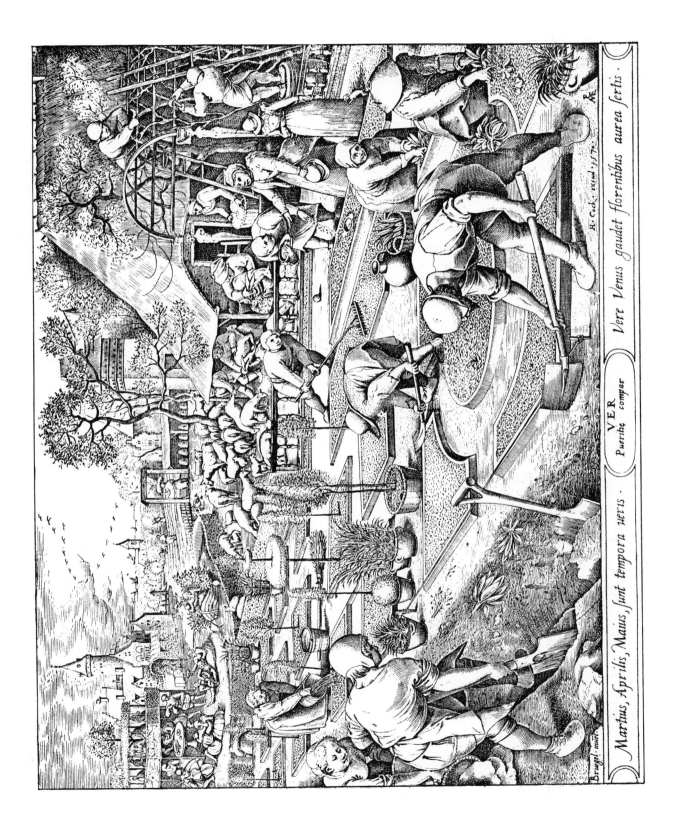

Brueg. inuent.

H. Cock. excud. 1570.

Brugi. inuit.

Martius, Aprilis, Maius, sunt tempora ueris.

Pueritiæ compar

VER

Vere Venus gaudet florentibus aurea sertis.

20. *SUMMER* (*L'Été, B.202, M.152*)

A sequel to the preceding print of "Spring." The engraver is unknown. The publisher, again, was Jerome Cock. The original drawing, dated 1568, is in the Kunsthalle, Hamburg. This engraving may have been completed in 1570, like the engraving of "Spring," or a year or two later.

This composition has occasioned considerable comment. Attention is attracted especially by the solid, substantial, and sculpturally plastic effect of the figures, especially those in front.

Comparison of engraving and original drawing reveals that the striking relief-like effects of the projections outside the picture frame (the long straight-handled scythe and the heel of the water-guzzling worker in the foreground) are by no means the engraver's afterthoughts. In the drawing, they are possibly even more striking and three-dimensional. In fact, in the drawing the lowermost border of the frame has been converted for a space into a white line of tangible breadth, against which the foot of the drinker is pressed, as if he were forcing his toes against a railing or a molding mounted on a pane of glass between himself and us, the spectators. This writer recalls nothing quite like it in any other Bruegel drawing.

The limbs of the drinker and of the reaper at the left in the engraving are seen in even more marked stereoscopy or three-dimensional relief in the drawing than in the engraving.

Depth and distance are further emphasized by the stress on lines radiating out from a vanishing point just above the center of the picture. The feeling of tangible and indubitable distance is extraordinary. There is a memorable feeling of "depth of focus"—to borrow a phrase from photography—as one follows the mounting mass of detail from nearest to farthest distance. And at that farthest distance—it seems almost needless to mention it again—lies a level sea plied by small boats.

The rays of the burning sun are less emphasized in the drawing than in the engraving.

Mass and depth, substance and sculpturesque treatment—these are the hallmarks of Bruegel's "Summer."

Tolnay has asserted significant similarity between the posture of the figure of the water drinker here, and the statue "Laocoon." He terms this likeness "a sort of ironic caricature of the art of the period, which leans to the Classic."

More recently, the Swedish art scholar Carl Gustav Stridbeck has shown likenesses between the position of the legs of the water drinker in this engraving, and another seated drinking figure in a 1545 engraving from a drawing by Nicholas Meemskerck ("Prodigal Son"). Tracing the motif still further into antiquity, Stridbeck shows the same position in the figure of a warrior in a Roman copy of the shield of the Athena Parthenos.

Much of this sort of influence-tracing seems to this writer as tortuous and tortured as the struggles of Laocoon himself. But though it easily becomes fantastically far-fetched—both in point of time elapsed, and physical similarity—yet it remains a fascinating exercise in imagination.

Beyond such skepticism, however, the efforts of Bruegel scholars in pursuit of such evidences of graphic influences and derivations do carry enough conviction and enlightenment to banish outdated assumptions such as these: (*a*) that Bruegel remained utterly immune to all Italianate and classical influences; (*b*) that Bruegel was basically just a peasant-caricaturing Netherlands peasant, playing for belly-laughs with brush and pencil; (*c*) that Bruegel was ignorant of or indifferent to the principal intellectual currents of his agitated era.

Close examination of this engraving brings to light other aspects: the stout figure at the right, seemingly a headless body supporting a tray filled with varied vegetables and fruits, calls attention to the conventionalized and often de-personalized effect of many of the master's human figures. Grossmann has used the terms "dehumanized" and "abstract" to characterize such effects.

Actually, in this picture, among more than a dozen figures near enough to matter, only the stooping gleaner just right of center has a face whose features we can distinguish. The rest are either turned away from us, or are otherwise obscured. That one face, significantly, in both drawing and engraving, is typical of many other faces that do appear in Bruegel works. Broad, round, with puffed lips; head and face together seemingly as globular as a pumpkin; the ball-like curves of the head repeated in the curve of the back—the total effect is more doll-like than human, more child-like than fully formed.

An obvious relationship exists between this engraving and the great painting of 1565, from the *Seasons* series, known variously as "August," "The Harvesters," "Wheat Harvest," or sometimes misleadingly as "The Corn Harvest." Those so fortunate as to see it in the Metropolitan Museum of Art, New York, will now be able to form their own comparisons—and contrasts. The original drawing here engraved dates from about three years later than that painting. The drawing treats with greater concentration, dignity, and heroic scope certain themes also involved in the harvest-time subject matter of the painting.

Translation of Latin caption: *Iulius, Augustus, nec non et Iunius Aestas* = July, August, and also June make Summer. *Aestas, adolescentię imago* = Summer, image of youth. *Frugiferas arvis fert Aestas torrida messeis* = Hot Summer brings fertile crops to the fields.

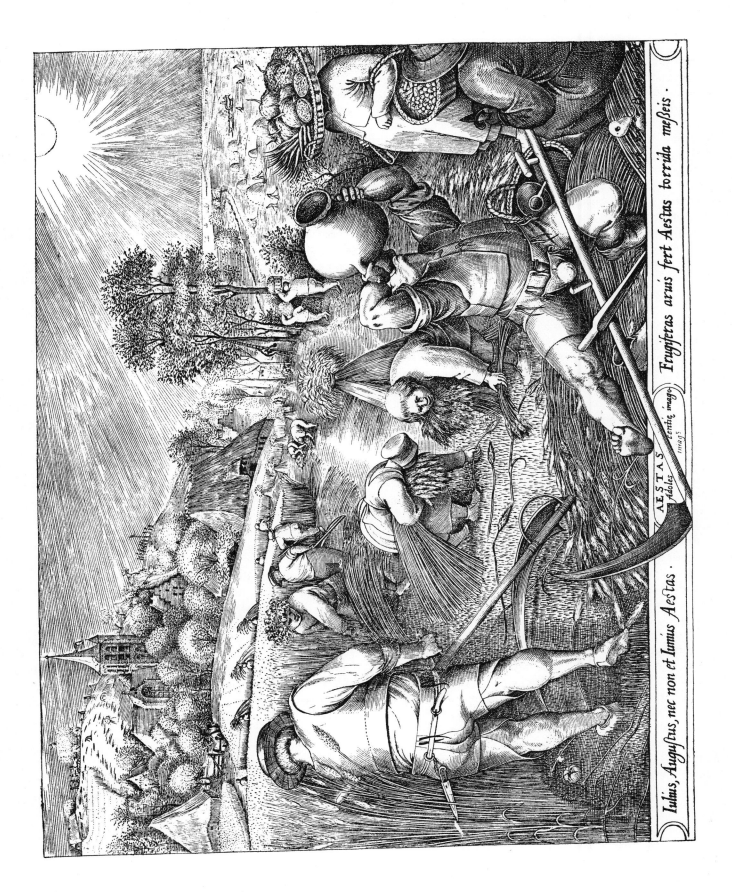

AESTAS Adolescentiæ imago. Imag 3.

Frugiferas aruis fert Aestas torrida meßeis .

Iulius, Augustus, nec non et Iunius Aestas .

A Bruegel drawing, dated 1558, was the original from which, that year or the next, this engraving was executed by Frans Huys, the same faithful craftsman who engraved the *Warship* series already presented.

The drawing itself, not listed among the more than 120 included in Tolnay's *Drawings of Pieter Brueghel the Elder*, but illustrated in Münz's 1961 complete edition of the drawings, is in a private collection in the United States.

Two states of the plate have been described by Bastelaer. The first is identified by the publisher's mark at lower left: "H. cock excudeb." and the engraver's initials at lower right: "F.H." In the second state, published by J. Galle, the credit to Cock has been replaced by a line, *P. Breugel delineavit et pinxit ad viuum 1553.* (This date obviously does not agree with that on the drawing mentioned above, suggesting possible confusion between the final figures 3 and 8.)

It seems that the master drew from life this varied and crowded composition. More than 140 men, women, and children can be distinguished from foreground to farthest distance. They sit, stand, lurch, fall, or lie prone. They skate, learn, watch, lounge, and ride (in a *plaustrum Belgicum* crossing the bridge).

A game of sixteenth-century ice hockey goes on in the distance, to the right of the leafless tree. Seen on the other side of the tree, an inverted "u" line of skaters executes some unidentified skating figure, following a flag-bearing leader.

In center foreground a beginner teeters wildly, on his way down. A little to the right, one of Bruegel's compact and ball-like children poles along safely in a sled.

Toward the left front, a well-dressed burgher, rigid with apprehension, uses the cloak of his manservant as a towline.

Farther back, to the left of the bridge which leads to the Gate, a skater has crashed through the ice and gets a helping hand from a bystander, while a group of "sidewalk superintendents" watch with interest from the bridge above.

In front of the third arch of the bridge, a gallant smiles as he holds his lady around the waist, so she shall not skate without visible means of support.

At the very base of the tree, a seated woman, basket on arm, shouts and points in excitement, probably shouting a Flemish equivalent to "See, that one's fallen!" The man looking around the tree trunk, just above her, is equally interested by the spectacle.

This varied vista offers certain ambiguous and intriguing figures. Obviously it is a cold day on the ice. Does this explain entirely the two dumpy gentlemen at left, about halfway up, who are so muffled in their cloaks and collars that only their broad noses project below their hat brims? One sports an opulent feather in his hat. The other, just a little to the right, stands as if semi-solidified. Both are quaint and comical enough, and serve to show that Bruegel did not reserve this semi-caricaturist manner for the plain peasantry.

More menacing in impression, though probably as innocent in intent, are the two cloaked characters at extreme right, on the bank by the lone tree. Muffled up to the eyes, their hats pulled low, they look as if their daggers were conveniently handy.

A trio with backs toward us just left of center foreground is worth a special look. The middleman of the three wears an oversize hat pulled down directly onto his cloak. The women on either side of him seem to be masquerading as ducks because of the long bill-like visors projecting from their cloaks at forehead level. This apparent puzzle is, however, dispelled—as so often—by discovery of a parallel in a Bruegel painting, "The Netherlandish Proverbs" (1559), sometimes called "The Blue Cloak," because in a central group a handsome woman in a red gown is hanging over the head and shoulders of an older man a large blue cloak with just such a long visor to protect the face. (The Flemish folksay or proverb thus illustrated—"hanging the blue cloak around her husband"—is equivalent to the Latin symbol of "putting horns on his head," that is, cuckolding him.) The visor obviously was a practical help in warding off winter's snow and sleet. Symbolically it also restricted the field of vision of a betrayed spouse.

Throughout this skating scene, purpose, personalities, and social "structuring" of the people are clear and consistent. This is not merely an impression of abstract skating and onlooking at the St. George Gate. It is, rather, a significant segment of the social life of real people from in and around Antwerp shortly after the middle of the sixteenth century.

Yet there is in the entire picture not one figure which seems to be the portrait of a specific person. Individual portraiture, aside from some large heads of anonymous peasants, was not Bruegel's practice. Perhaps he considered it to be outside his artistic province. In any case, it was not part of his conception of what he wanted to do, either as a draftsman preparing working drawings for reproduction by the mass medium of engraving, or as a painter applying oils to the prepared wood or canvas surfaces that would some day belong to wealthy or aristocratic patrons.

Details of architecture and construction are presented with sober fidelity throughout. The classical configuration of the stately triumphal arch or gate is clear. The heraldic motifs in relief on the façade show lions rampant supporting a doubleheaded bird (eagle?) on the shield at center. The scroll undulating behind them bears the word "PLUS" at left and what appears to be "WLTR" at right.

Between the arch and the bridge is a drawbridge arrangement over which pedestrians are passing.

Three church towers pierce the skyline. On the sea walls or canal embankments at the left and elsewhere, we can distinguish individual stones in the construction.

No engraver is named. The first state of the plate gave credit to the publisher "H. Cock excudbat" in center. The second state replaced this with the credit to the second publisher: "Au Palais à Paris Paul de la Houve excud. 1601." The panel at lower right "Bruegel Inventor" remained in both.

The original for this engraving has disappeared. Gustav Glück believes it must have been a drawing. Comparison with Bruegel's crowded painting "Combat between Carnival and Lent" (1559) may encourage the speculation that it might have been a painting, now lost.

A typical Flemish *Kermess* is in full swing here. Originally a feastday for some patron saint, the kermess became a combination carnival, festival, fair, and religious observance.

The banner of the patron, Saint George, hangs at right. He carries his bow and arrows. Over his head winds a ribbon inscribed "Laet die boeren haer kermis houven" ("Let the peasants hold their kermess"). Ebria Feinblatt writes that this is "a protest against the edict of Charles V to limit these fêtes to only one day in order to curtail the excesses of the celebration."

At the lower left corner a man shows his seated companion a game played near them with large balls, paddles, and a hoop—possibly a Netherlandish form of croquet. Just back of the game, in a shed, a girl is being swung by two people. Back of that shed, a fight with sticks seems to grow serious.

In the right foreground an open-mouthed man points to goings-on. The sword-bearing figure beside him is one of the baffling Bruegel characters with face almost utterly hidden by hat. That hat carries a small pennant with a picture of a crucifix. Just left of them four men are unhappily involved in a mingling of horseplay and fighting. To the left again, a dog pulls at a child's skirt and children tug at a man wrapped up in a basket.

Farther back, ten men do a sword-dance in formation. In the lower right-hand corner four couples dance to the music of two bagpipers, below the St. George banner. The dancers' postures remind one somewhat of the well-known Bruegel painting "The Peasant Dance" in the Kunsthistorisches Museum, Vienna (date probably about 1567). The bagpipe players, however, are rather akin to their counterparts in "The Peasant Wedding" (or "Wedding Banquet") of approximately the same date, in the same museum.

A party of eight drink, talk, and embrace at an outdoor table near the inn. Under a tree, left of center, a woman sits in the grass holding in her lap the head of a man who seems in need of such succor. On the other side of the tree, three pigs wander amidst the celebrants. Just back of the seated woman, we find a dramatization of the famous victory by St. George: a man pushes a fire-breathing dragon on wheels, while from the right rides the saint in armor, leveling the lance that will lay low the monster.

Various fair booths are strung in a row just to the right of the knight's combat scene.

Three banners are planted or borne in the churchyard behind the St. George drama. Other shows and observances have attracted crowds in the open space to the right of the church, including a stage supported on great hogshead barrels.

Against the horizon at the upper left, a group of a dozen or more bowmen and spectators are celebrating a game in honor of the bow-bearing patron saint. A target has been fixed high in the sky along the vertical blades of a windmill. Seven arrows are in the air, only one apparently with a chance of striking the target.

From a window in the roof of the church steeple a small banner has been pushed. The roofs of other houses in the town are thatched and neatly trimmed. On the roof of the inn at the right margin several pigeons pick through the thatch. Below the eaves, holes show the location of their roost. It is through one of these holes that the St. George banner has been fastened.

And in the distant sky above, five storks or other long-necked birds fly, taking to the air as usual, even on this St. George's Day.

23. THE FAIR AT HOBOKEN *(La Kermesse d'Hoboken, B.208, M.141)*

Uncertainty surrounds the graphic antecedents of this engraving. The plate is known in two states. The first, published by Bartholomew de Momper, shows the name "Bruegel" at the right, below the hand of the bow-carrier with his back toward us. The second, published by Joan Galle, places "*inven.*" after Bruegel's name. Atop the barrelhead at left is an initial design attributed to Frans Hogenberg (F.H.).

A corresponding drawing, bearing name and date "Bruegel 1559," now in Courtauld Institute Gallery, London, is regarded by Gustav Glück and Ludwig Münz as the original for this engraving; however, it was rated as a copy by Tolnay. According to C. G. Stridbeck, Hogenberg did the working drawing as well as the engraving, thus supplying a composition which, he believes, influenced Bruegel in his painting of "Combat between Carnival and Lent" (1559), referred to on page 107.

It seems most probable that a Bruegel drawing was the direct ancestor—whether once or twice removed—of this engraving. Characteristic Bruegel touches appear here and there. For example: the postures and personalities of the two bagpipe players blowing for the dancers-in-a-ring at the upper left; the couple embracing under a tree a little to the left of the inn at the right; the four storks flying to the right of the church steeple at the center; the effect of hats, heads, and shoulders of the procession moving toward the left, into the door of the church; the participation of several pigs and piglets, a trio of ducks, and some chickens among the humans at the lower left; and so forth.

Below the picture is a Flemish verse. Rendered freely into English:

The peasants delight, during such feasts,
To dance, jump, and drink themselves blind-drunk
 like beasts.
They can't let the time for such a Kermess go by
Even if, the rest of the year, they'd have to
 hunger and die.

The name Hoboken was transplanted from Holland to New Jersey, as neighbouring New Yorkers well know. The banner which flies before the inn at right declares "This is the Guild [?] of Hoboken." It contains the emblem of arrows crossed through a crown.

Archers are shooting at the lower right. Their target is at the end of the path, on the opposite side of the page. (It seems an alarming hazard to wandering animals and bystanders.)

Activities in the background include a religious procession with banners and crossbowmen marching in formation. At the head of the procession two men carry an episcopal image.

Farther back and to the right, a stage lifted on hogsheads draws a crowd, just as it did in the preceding engraving ("Fair of Saint George's Day").

In front at the left, four boys are playing a game which suggests a combination of bowling and marbles. The object, it would seem, is to knock the stone or ball from out of the center of the ring, in front of the knife.

Farther right, a man in fool's cap and bells holds by the hand and leads, or is led by, two children.

This picture lacks the surging motion and spirit of the previous "Kermess" engraving.

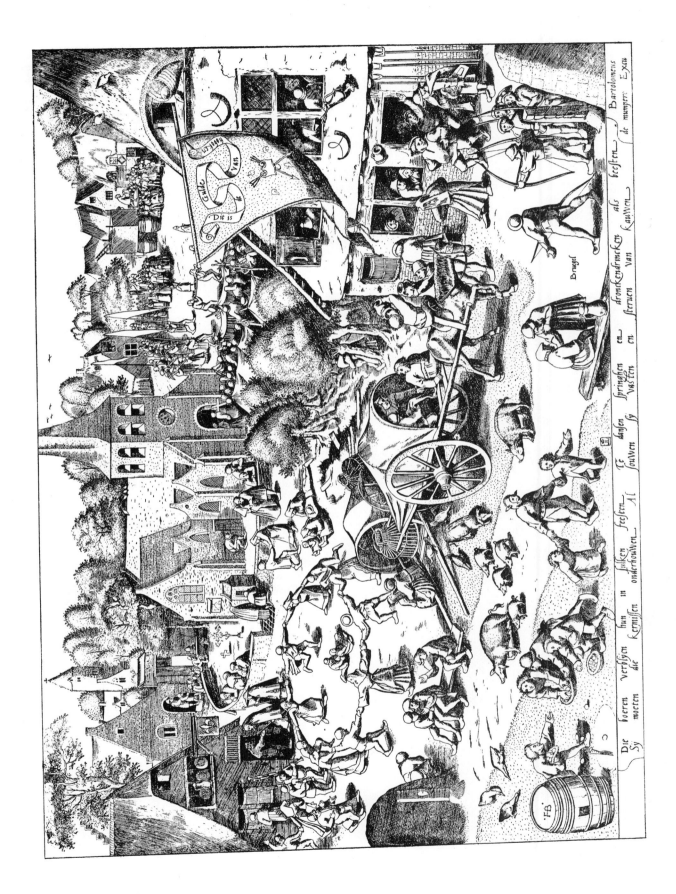

24. THE WEDDING DANCE (*Danse de noce, B.210*)

Here we are deep in the heart of the world to which belong such admired Bruegel paintings as "The Wedding Dance in the Open Air" (1566), now in the Detroit Institute of Arts , "The Peasant Dance," and "The Peasant Wedding" or "Wedding Banquet" (about 1567).

Peter van der Heyden executed the engraving, and the publisher's trade-mark Aux quatre Vents is at bottom center. Such was its plate in the first state. In the second state this was partially eradicated and changed to read "Ad. Coll. excud.," indicating Adriaen Collaert as the new publisher.

No original drawing is extant. Gustav Glück offered the opinion that the original was actually a painting, since disappeared, rather than a working drawing intended for engraving.

Some fifty or sixty people appear in this crowded print. Only four couples are actually dancing, though the impression is that of a larger group. At lower left, a stout man with hands on hips and his partner recall so strikingly a couple in a corresponding position in "The Wedding Dance in the Open Air" that a direct line of derivation must be assumed. There is essential identity in one detail after another: position of arms, legs, and body of the man; shape and draping of his sleeve; fastening of his jacket; the prominent projection of the codpiece; etc.

Behind this couple we see another pair; the woman with bent head is passing under her left arm. The same dance figure is being executed, in the same relative position, in the painting also. The couple next to the right, in about the center of the print, resembles a corresponding couple in the painting, though the latter appear younger and less coarsely caricatured than in the engraving.

Other similarities include the embracing and kissing couples at right (below the tree). Such a couple is bussing and kissing near a tree in the painting.

In the background of the print sits the bride at a table, a crown suspended over her head, and a curtain behind her and her companions. A similar group is in the far background of the painting.

There are many and important differences elsewhere, of course; but there can be no doubt of these essential identities. Chance likenesses are out of the question.

The two bagpipers playing beside the tree at the left suggest a question: Why are Bruegel's bagpipers usually so disreputable, bewildered, or stupid looking? Fritz Grossmann equates dancing and bagpipe music with sinfulness in Bruegel. To him, "The Wedding Dance in the Open Air" is a picture of lust seen in ordinary surroundings.

If that is true of the painting mentioned, then it applies equally to the print here reproduced. However, the spirit of the dance and drinking scene is perhaps best suggested by the verses engraved beneath it. Translated freely into English they run:

> Keep it up, musicians! Make it last
> As long as pipes and drum can play,
> So Liz will gaily move her ass;
> It's not her wedding *every* day.
> Queer Joes are doing fancy prancing;
> I hear the pipe, and you're missing the beat;
> But our bride has already given up dancing,
> And a good thing, too, for she's "full and sweet!"

The Flemish euphemism "full and sweet" meant pregnant.

The action in the background suggests a sort of "shower" for the bride. Furniture and household gear of all sorts are being brought from both sides. There are tubs, spoons, a brush, a pail, a pitchfork, a fire tong, and even—it seems—a cradle.

In front of the stout, smug bride is a plate containing seven coins. A woman to the right of it is adding another.

The bland and vapid appearance of the bride herself recalls unmistakably the bride in the painting "The Peasant Wedding." The same downcast eyes, the same air of mingled passivity, stupidity, and self-satisfaction.

The dancers here, as in the paintings mentioned, are indubitably dancing. The rhythms and beat of the music come alive through their postures and gestures. Bruegel may have used the bagpipe as a symbol for sinfulness, but he appreciated in the most graphic way its psychokinetic effect on his fellow Flemings of the peasantry.

Somehow, it seems difficult to see stark denunciation or disapproval in these scenes of peasant merrymaking and release.

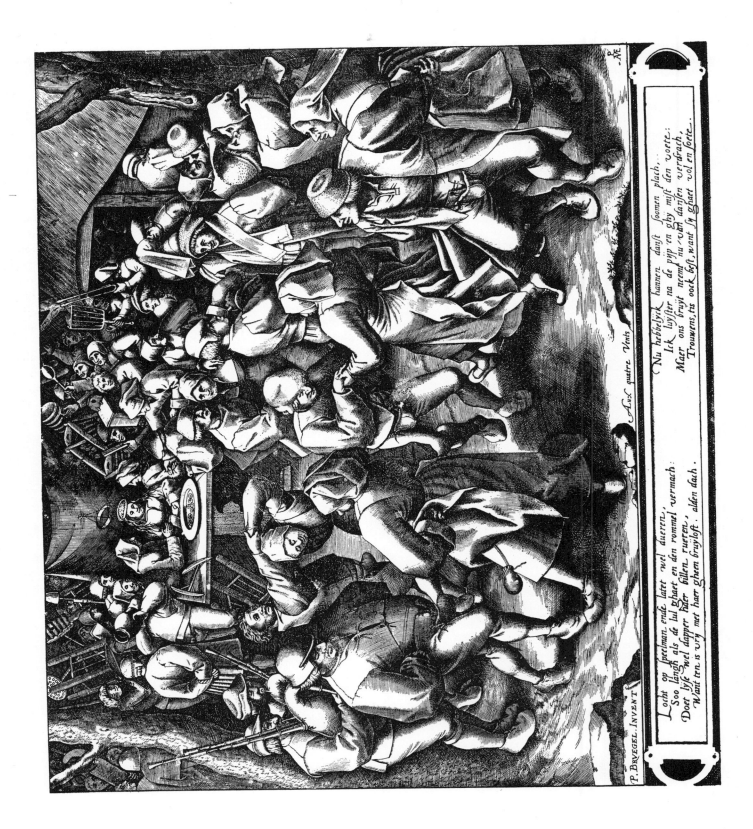

P. BRVEGEL. INVENT

Aux quatre Vents

Locht op speelman, ende latet wel dueren,
Soo langh als de lul ghaet en den rommel vermach:
Doet lijf wel dapper haer billen rueren,
Want ten is vrij met haer gheen bruyloft, alsen dach.

Nu hebbelijck hannen danst soomen plach,
Ick luyster na de pijp en ghij mist den voete:
Maer ons bruyt neemt nu oock dansen verdrach,
Trouwens, tis oock best, want sij ghaet vol en soete.

25. THE MASQUERADE OF ORSON AND VALENTINE *(Mascarade d'Ourson et de Valentin, B.215)*

This is the only known *woodcut*—not an *engraving*—after a Bruegel original. The date 1566 and the name "Bruegel" are on the lower right-hand corner of the print. The woodcutter is not known, nor does any corresponding drawing survive.

The theme is clear enough. This is a performance of a popular masque or drama, such as might have been a feature in a kermess or fair, like those previously pictured. "Orson and Valentine" was based on a French romance first printed at Lyons in 1489. It traveled widely, appearing in English, Icelandic, Italian, German, and—as here—in Dutch. It reached England in the form of Henry Watson's *Historye of the two Valyante Brethren: Valentyne and Orson* (about 1550). Percy's *Reliques* include a ballad on the same theme.

The story line will not be entirely unfamiliar. Twin infant brothers are abandoned in the woods. Fate begins playing strange tricks. One reaches the den of a friendly bear and is reared there, becoming a wild man of the woods—sort of a bearish Tarzan, in fact. That is the twin who was at first known merely as Nameless, or "the nameless one," but later was called Orson (Latin *ursus*, bear).

Meanwhile, not far off at the court of King Pippin, grows up a courtly knight, the valiant Valentine. Needless to say, he is the other twin. Inevitably, destiny reunites them, when Valentine vanquishes and "domesticates" Orson, who becomes a faithful servitor and companion. Their mother, Bellisant, has fallen into the hands of a giant. Together they rescue her.

In this woodcut we doubtless see a climactic scene of the romance. There are two conceivable identifications of the cast of characters here. The first, preferred by this writer, is, reading from left to right: Valentine, with crown, orb, and hand on sword hilt; Orson, now a sturdy crossbowman, covering the "bad guy"; the Giant, bearded and scaled, bearing his spiked club; Bellisant, about to be rescued, holding up her identifying ring by which she makes herself known to her sons. The other possibility would be King Pippin at far left; Valentine next with crossbow; Orson, still woodsy and primitive; a woman, probably their mother. The latter identifications would give us no Giant in the scene, and that would seem a shame.

The action in the background is unmistakable. Women members of the masquing troupe, their backs toward us, are soliciting "free will offerings" from spectators in the house or inn. The solicitor at the right is handed a contribution by a man in the window. The one at the left seems to hold up her slotted gourd in vain toward the female faces in the smaller window opening. From the door at far right, a couple of youngsters peer out. The lower one is seen clearly; the one above, in shadow, is almost invisible.

Note the typically woodcut technique forming the rather formalized and unconvincing texture of the ground. The effect is ambiguous, but unimportant: are the actors treading on cobblestones, as in a courtyard? Or is it simply dirt?

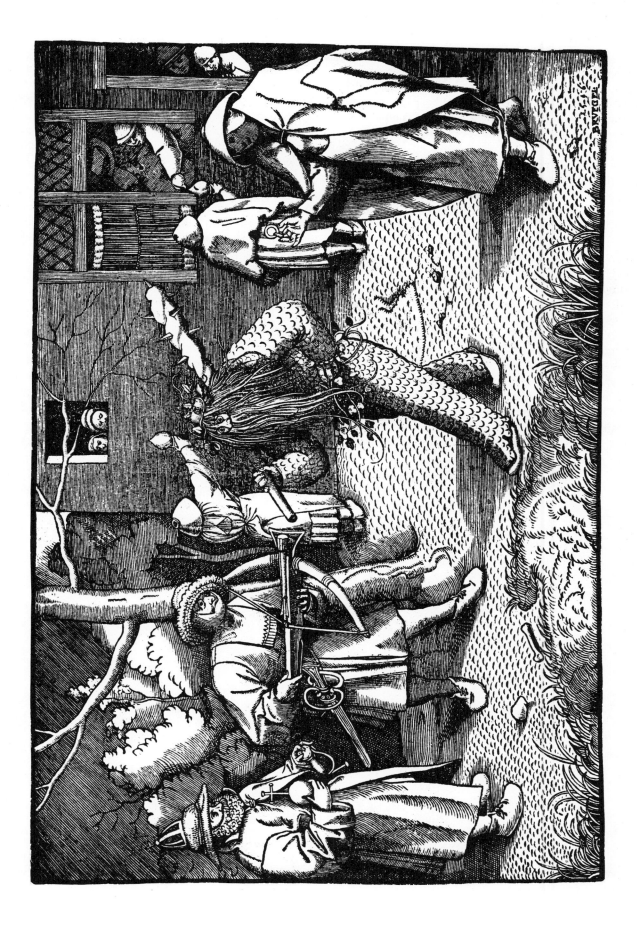

26. THE DIRTY BRIDE (The Wedding of Mopsus and Nisa, Les Noces de Mopsus et de Nisa, B.216, M.153)

This engraving bears the date "1570" following the name of its publisher "H. Cock." The engraver was van der Heyden. The original, in this case, was a woodblock which had been cut, though not completely finished, with Bruegel's own design. The block is at the Metropolitan Museum of Art, New York.

The Latin line below the picture quotes the Eighth Eclogue of Virgil: "Mopsus marries Nisa; what may not we lovers hope for!" This is, in Virgil's poem, an ironic lament spoken by a certain Damon whose beloved, Nisa, has been won and wed by Mopsus, a rival shepherd of Arcady.

As pointed out by the eminent and admirable Dutch authority, Adriaan J. Barnouw, Bruegel here by no means sought to illustrate Virgil's pastoral idyll. This is rather "a realistic scene from the life of the poor in rural Flanders."

The connection partakes of a confusion of words or a sort of pun. The word *mops* in Flemish signified a kind of small pug-nosed bulldog and, by extension, a country oaf or hayseed. Latinized, *mops* becomes *mopsus*. Hence the accidental "transition" to Arcady.

A farcical subject at Flemish fairs or carnivals was that of the filthy bride (*vuile bruid*), and the same common "low life" humor is reflected here. It is the poor peasant's equivalent of a traditional Flemish wedding "with all the trimmings." It plays in the woods outside of a moated castle. The meager nuptial feast is over; remnants of bones, shellfish, and eggs litter the site. The coarse-featured, unkempt bride, wearing a colander in lieu of crown, is taken in hand by the groom. In keeping with custom, she will be danced to the nuptial couch—that is, the uncovered earth under the rickety tent behind her.

The well-to-do flaunt banners at their weddings; these poor fly only a tiny triangular flag below the ridgepole of this honeymoon hideaway.

The place of the pipe and drum musicians is taken by a ludicrous substitute—the big-nosed man before the trees whose musical instruments are limited to a knife (probably just used for opening oysters) and a scuttle or paddle which he holds like a stringed instrument. Yet regardless of the quality of the music, this Mopsus is moved to a lively dance step, comparable to the animation of the best of the wedding dancers we have seen in other Bruegel engravings and paintings.

One wonders at the completely globular, cross-hatched faces of the two women to the right and left of the tent. Under their bowl-like hats they are more like stuffed dolls than humans.

An intriguing small detail stands out high at the right of the castle behind. The shutter of the topmost window leans crazily, off one hinge. Barnouw has suggested an answer by a rather rhetorical question: "Did Bruegel intend to suggest by the shutter off its hinges that the world which presented such stark contrasts was sadly out of joint?"

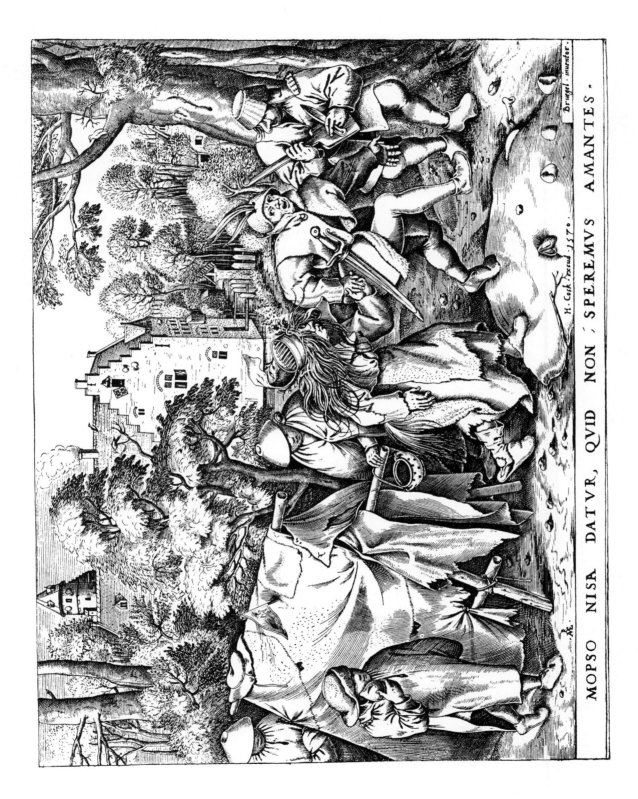

MOPSO NISA DATVR, QVID NON SPEREMVS AMANTES.

H. Cock excud. 1570.

Bruegel inventor.

27. TWO GROUPS OF EPILEPTICS GOING TO THE RIGHT *(From the series, Pilgrimage of the Epileptics to the Church at Molenbeek, Deux groupes de paysans, de la suite du Pèlerinage des Épileptiques, B.223)*

28. TWO GROUPS OF EPILEPTICS GOING TO THE LEFT *(From the same series, B.224)*

These two reproductions present prints which form the second and third of a series of three. All were engraved by Hendrick Hondius in 1642, long after Bruegel's death. The first of the three showed two peasant bagpipers playing and walking along a road, as if in advance of the groups for whom they were supplying their musical therapy.

A form of sixteenth-century dance cure is illustrated in these two prints. The treatment may seem somewhat reminiscent of the Italian tarantella, an energetic dance designed to sweat out the poison from victims of the tarantula's bite.

Pilgrims suffering from epilepsy were brought to a bridge and forced to dance to bagpipe music. This, it was supposed, would rid them of seizures during the following twelve months. The pilgrimage was associated with Saint John.

In the second engraving here (B.224), we see the small bridge itself; in the first (B.223), we are presumably looking at the road along which the sufferers are being carried or dragged toward the church.

In the Albertina Museum, Vienna, is preserved a drawing (M.A55), made a generation or more after Bruegel's death, as a copy of Bruegel's original working drawing. The latter has not survived. The Albertina drawing shows a stark detail not carried over into these engravings—namely, a bagpiper playing directly into the ear of one of the epileptic sufferers.

In the groups shown in these two engravings, all of the "epileptics" are women. This suggests that rather than epilepsy the ailment may have been a psychic disorder akin to hysteria.

Energy, intensity, and conviction are outstanding in both these engravings. They represent a deeper and more concentrated kind of realism than the engravings elsewhere in this section.

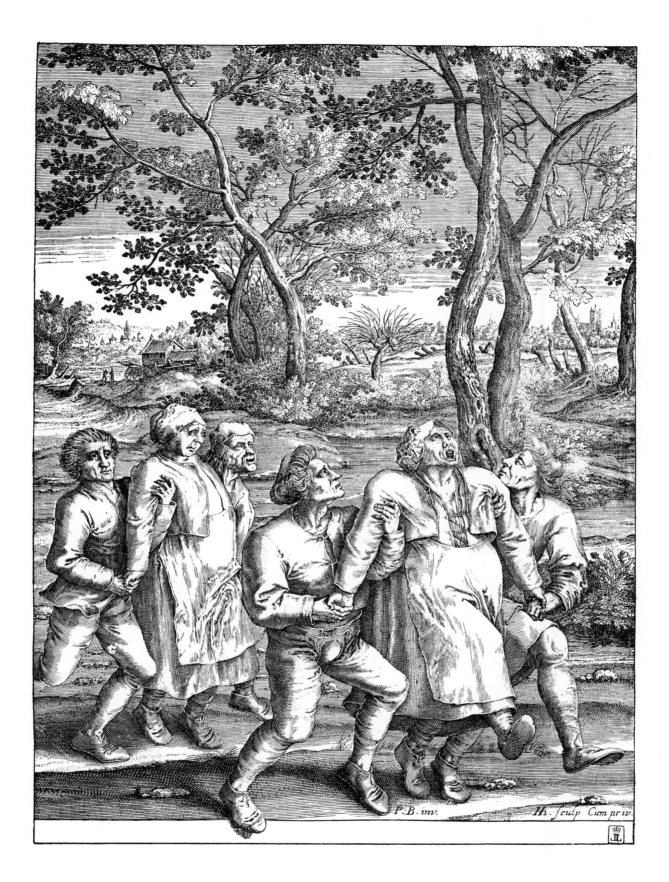

P.B. inv. Ih. sculp Cum pr iv.

28. *TWO GROUPS OF EPILEPTICS GOING TO THE LEFT* *(From the same series, B.224)*

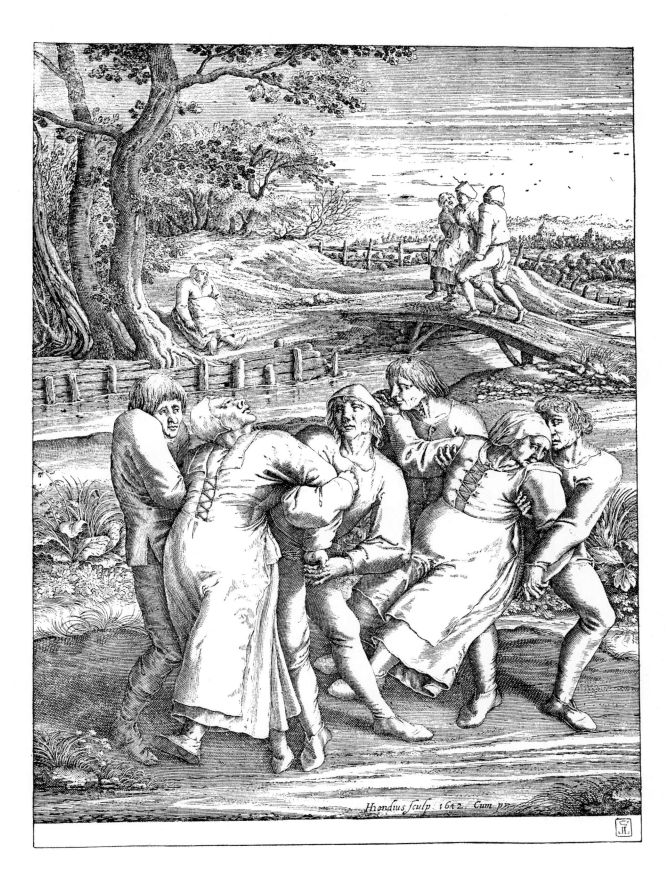

Hiondius sculp: 1642. Cum pr.

II.

Inner Worlds—

Imagination, Morality,
and Religion

The World
of Drolleries,
Didactics,
and Allegories

Part One was devoted to Bruegel's "outer" worlds—to nature (landscapes, the sea and ships) and to men and women (his countrymen and contemporaries). Now, in Part Two, we enter his "inner" worlds, the realms of imagination. The fanciful takes precedence over the actual; the fantastic submerges the realistic; the symbol transforms the report.

All formal arrangements and selections from a great artist's work are likely to be misleading—including this one. Life and art do not lend themselves neatly to arbitrary outlines. (And strictly chronological presentations are often the most misleading of all, even when definitive dates can be established throughout.) The arrangement of prints in this book, however, does permit a certain pausing from time to time to survey what we have seen and what yet awaits.

Thus we find that in the three sections immediately following, the artist is concerned with human conduct. His aim, overt or covert, is normative. His graphic comments—caustic, comical, ribald, or grave—imply the need to alter what is, and "remold it nearer to the heart's desire." The posture of the approach may be a sneer, a shrug, or a loud laugh. Sometimes a cry of despair seems to re-echo distantly.

The three-way division of the title of this section (Drolleries, Didactics, and Allegories) should not be taken too seriously. The compartmentalization cannot be watertight. This is no Teutonic super-systematization behind a façade of "scholarship." Bruegel's art is as intolerant of categorical fences as is that of Shakespeare. And the Bruegel of the following engravings, one can imagine, might have relished the parody of subdivisions like those Shakespeare put into the mouth of his pundit, Polonius: "The best actors in the world, either for tragedy, comedy, history, pastoral, pastoral-comical, historical–pastoral, tragical–historical, tragical–comical-historical–pastoral. . . ."

Among the following prints, "The Peddler Pillaged by Apes" is more or less unmitigated drollery; hence "comical." "The Triumph of Time" is almost all allegorical. The others intermingle in varying proportions all three aspects. A Polonius of art history would have to set them down therefore as "allegorical–didactical-comical."

How essential is the comical?

"Authorities" during the eighteenth and nineteenth centuries, when they devoted attention to Bruegel the Elder at all, did so usually in terms which implied that his dominant quality was a peasant-like drollery, a heavy-handed rustic comedy, coarse and racy, unfit for sensitive souls.

This distortion persisted well into the current century. Thus, one reads in Buxton and Poynton's *German, Flemish and Dutch*

Painting (London, 1905) concerning "Peasant" Bruegel: "There is a coarse humor about his pictures which, if vulgar, is better than the insipid. . . ." Etc., etc. However, according to the same source, the following generation did better, for that elegant and elaborate but rather empty technician, Jan ("Velvet") Breughel is rated as "decidedly superior to his father."

The *Encyclopaedia Britannica*, 14th edition (1929), illustrated a similar cultural lag. This is part of the short entry headed "Breughel or Brueghel": "The subjects of his pictures are chiefly humorous figures like those of D. Teniers; and if he lacks the delicate touch and silvery clearness of that master, he has abundant spirit and comic power."

This was all a long-lasting rehash of the generalization, written about a generation after Bruegel's death, by Carel van Mander: "You cannot but laugh at the droll figures that he painted." Mander, as we know now, was far from complete and not always entirely accurate in what he had to tell about Bruegel the Elder.

With regard to the "droll figures," Adriaan Barnouw writes: "I, for one, find it difficult to laugh at his drolleries . . . all the human wreckage of a time that was out of joint were rendered by him with poignant realism. The pain and the pity that stirred within him . . . found expression in the beauty of their portrayal."

"Didactic," too, deserves comment. The term is applicable here in the same sense as that in which the aim of didactic poetry is said to be "less to excite the hearer by passion or move him by pathos than to instruct his mind and improve his morals."

The "instruction" aspect is not important; Bruegel did not seek to impart information as such. He was aiming at improvement of human understanding, attitude, outlook. And these improvements are moral.

Bruegel's art held up a mirror to a topsy-turvy world. He portrayed crazy and perverse situations. See, as one instance, "The Witch of Malleghem." In the extreme view of Tolnay, Bruegel believed the world of men to be, in fact, hopeless, incapable of betterment. Things were as they had to be, because men were what they were and would always be. How, then, could he accomplish a didactic end? Where improvement is out of the question, how can there be effective moral teaching?

A more balanced and adequate interpretation of Bruegel's personal attitude is suggested in the comments which follow—especially those for the engravings in the series of *Sins* and *Virtues*. That interpretation is, it seems to this writer, closer to Barnouw than to Tolnay.

Our chronology of Bruegel's creative life, previously given in this book, shows that when the artist made his "abrupt" addition of satirical and moralistic subjects to his landscapes, he started not with the semi-theological series of *Sins* but with the folksy and proverbial drolleries of "Big Fish Eat Little Fish" and "The Ass at School." These two, as well as other engravings later in this section, are essential to the pictorial message which Bruegel penned to his audience of fellow countrymen, his contemporaries in trying times.

29. BIG FISH EAT LITTLE FISH (Les gros poissons mangent les petits, B.139, M.128)

The engraver for this striking and increasingly famous print was van der Heyden, in 1557. The original, a pen drawing in gray ink, in the Albertina Museum, Vienna, is dated 1556 and signed "brueghel."

The engraving bears, at lower left, just above the oar blade, the signature "Hieronymus Bos. inventor." This poses a problem not completely solved even now, though scholars generally agree that this is a forgery or misrepresentation, at least in the sense that the immediate model followed by the engraver was Bruegel's drawing to which the engraving conforms completely.

Jerome Cock was the publisher, as indicated by the credit at lower right "Cock excu. 1557." Opinion is divided chiefly as to whether (a) Cock put the name of Bosch on the engraving hoping thus to increase its sales—the earlier artist presumably being more sought after than the contemporary—or (b) whether Bruegel's drawing was, in fact, a recasting or "restoration" of an earlier drawing by Bosch, who was thus in a sense being given his just due. In either case, this engraving is authentically "after Bruegel."

The Latin word "Ecce," meaning "Behold!" or "See there!," seen just above the rowboat, is not part of the original drawing. The engraving is, of course, a mirror image of the drawing.

The engraving was published with the motto it illustrates printed below in both Latin and Flemish. The basic proverb is "Big fish eat small." The Flemish version is given somewhat more elaborately. In terms of a modern comic strip it would be seen as a "balloon" coming from the mouth of the older man who points at the object lesson. He says, freely rendered: "See, my son, I have known this for a very long time—that the large gobble up the small."

The spectacle on the shore illustrates abundantly this maxim of worldly wisdom. A peculiarly Bruegelian figure, all helmet and body, cuts open the belly of the beached monster. Out pours a tangled flood of fish, mussels, and eels, still whole, many themselves in the act of swallowing others. The same violent and cynical situation is repeated at the creature's mouth where a dozen or more fish can be distinguished.

Another faceless hat-man, atop a ladder, is about to plunge his trident into the monster's back.

The huge notch-bladed knife wielded by the helmeted figure has on its blade what seems to be a maker's trade-mark, but actually is the symbol for the world—the wicked, foolish, dog-eat-dog and fish-eat-fish world. The helmeted figure has been nicely termed a "storm trooper" by Adriaan Barnouw.

In the water to the right of the boat, a giant mussel gets a grip on a large fish which is swallowing a smaller. Higher and to the right, in the three-way play, fish No. 1 swallows No. 2, who is swallowing No. 3.

Above, on the bank, sits the fool of the world who dangles one fish to catch another. Beyond, in the water, a typical fishing vessel pulls its nets.

On a distant island is stranded a huge fish or whale wedged between rocks. A crowd of men approach, probably to kill, cut, and devour. Atop the towering rock rests a peculiar structure, possibly the wreck of a boat, more likely an ornament, but definitely

reminiscent of certain cryptic, elaborately "Oriental" constructions pictured in paintings by Bosch, as well as in the later *Sins* prints of Bruegel.

In the far background, at the horizon, lies one of Bruegel's typical towns with harbor. Five or six galleys (oars plus sails) are anchored there. "Normal" birds fly in the sky—two nearer, and over a dozen more distant. The dominant creature in the sky, however, is a tri-phibious monster: part fish, part snake, part bird or insect. Its mouth gapes for prey.

Another monster—suggestive of the shape of things to come in later drawings—climbs the bank at left: a fish with man's legs, its mouth gorged with a fish.

On the tree above, two fish are hung, their bellies slit open. A man climbs a ladder to hang up a third.

Many subsidiary Flemish folksays and proverbs have been traced in this print. Among them: "Little fish lure the big"; "One fish is caught by means of another"; "Fish are hooked through fish"; "They hang by their own gills" (like the fish in the tree—i.e., they are caught by their own weakness or vulnerability).

About half a century after Bruegel drew the original of this engraving, an Englishman—a playwright—wrote some pungent dialogue relevant to this picture's theme. (From *Pericles, Prince of Tyre* by William Shakespeare, Act II, Scene 1.)

> *Third Fisherman*: . . . Master, I marvel how the fishes live in the sea.
>
> *First Fisherman*: Why, as men do a-land: the great ones eat up the little ones. I can compare our rich misers to nothing so fitly as to a whale: a' plays and tumbles, driving the poor fry before him, and at last devours them all at a mouthful. Such whales I have heard on o' the land who never leave gaping till they've swallowed the whole parish, church, steeple, bells, and all.
>
> *Pericles* (aside): A pretty moral . . .
> . . . How from the finny subject of the sea
> These fishers tell the infirmities of men . . .

Adriaan Barnouw writes regarding the didactic content and connotations of this print: "Marine life is graded mass murder . . . and a counterpart of man's inhumanity to man. . . . The underfish of our day are still at the mercy of the big gluttons, but they are preyed on with a subtler . . . voracity. Big nations gobble up little ones . . . big corporations, holding companies, chains, department stores swallow up the little fellow for the general public's and the little fellows' own good."

In summary we may say that seen as a whole this engraving expresses important aspects of Bruegel the graphic artist in his "new" fantastic–didactic style. We see the exuberant abundance of action and incident, the seven-ringed circus effects, the simultaneous variations on a given theme (often cryptic, seldom dull). This Bruegel is an abundant, repetitive, and extensive artist, an analogue in line to such outpouring geniuses as Rabelais and Shakespeare in literature. Yes, and even to the Melville of *Moby Dick*, to Mark Twain, and to Thomas Wolfe (prior to editorial pruning).

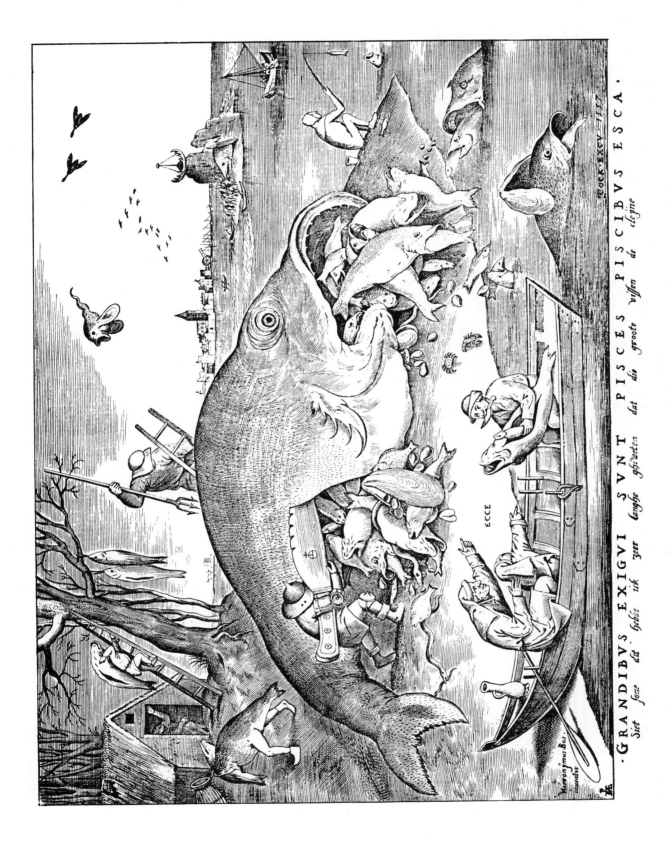

GRANDIBVS · EXIGVI · SVNT · PISCES · PISCIBVS · ESCA ·

Siet sone ich hebbe ick zeer langhe ghÿweten dat die groote vissen de clepne

30. THE ASS AT SCHOOL (The Fool at School; L'Âne a l'école, B.142, M.129)

This plate was engraved in 1557 by van der Heyden, whose monogram does not appear on the plate, and published by Cock, with credit at lower left to "Bruegel. Inventor."

The original, a pen drawing in brownish black ink in the Kupferstichkabinett, Berlin, bears date and signature, spelled "brueghel. 1556." Below the drawing, a hand not Bruegel's printed the rhymed Flemish lines which in the engraving are reproduced below the Latin lines. They may be translated freely this way:

> Though a donkey go to school in order to learn,
> He'll be donkey, not a horse, when he does return.

This practical psychology is akin to our proverbs: "You can't make a silk purse from a sow's ear!" or "Once an ass, always an ass!" Or, to coin a mixed maxim: "A fool and his folly are not soon parted!"

The donkey looking in learnedly at the left has been given "all the advantages"—eyeglasses to read with, notes to sing by, a candle to cast light on his studies. But when he essays to sing, he'll bray the same old way. . . . Hee-haw!

Through the grating at upper center, somebody is looking in at this most unprogressive educational institution.

The "children" are quite obviously grown-ups, foolish, fantastic, bewildered. The sober schoolmaster (Old Man Experience, perhaps?) is in the act of administering corporal punishment to the bared backside of a scholar. A bundle of twigs is in his hat like an ornament. He may apply them too, but probably in vain.

Dozens of the perverse and not-to-be-helped "schoolchildren" clutter up the room. They study a-b-c's, in crazy postures and combinations.

Below the window, two of them are huddled under a large hat pressed down on them by a sly fellow who peers around the corner. A peacock's feather flaunts from the hat band. This, Adriaan Barnouw points out, relates to different Flemish sayings: "Two fools under a single hood" and "Easily caught under a hat" (characteristic of a gullible fool). The peacock feather, he points out, was held among Latin scholars to symbolize cowardice because of similarity in sound between *paveo* (I am afraid) and *pavo* (peacock).

Many other proverbs and sayings, some long lost, are certainly suggested elsewhere here.

One scholar celebrates his new learning by sticking his head into a beehive (right). Two little monks seem to dispute as they pore over tomes. A woman keeps herself and books in a basket. Near "teacher" there are grimacers and weird contortionists. One balances a basket on his head. At least half a dozen figures show the Bruegel "trade-mark"—that is, no face is visible under the hat or headcovering.

The atmosphere of semi-imbecility is unmistakable.

And neither the bundle of twigs in teacher's hat, nor a spare switch in the pot at the right, is likely to alter matters much.

Translation of Latin caption: You may send a stupid ass to Paris: if he is an ass here, he won't be a horse there.

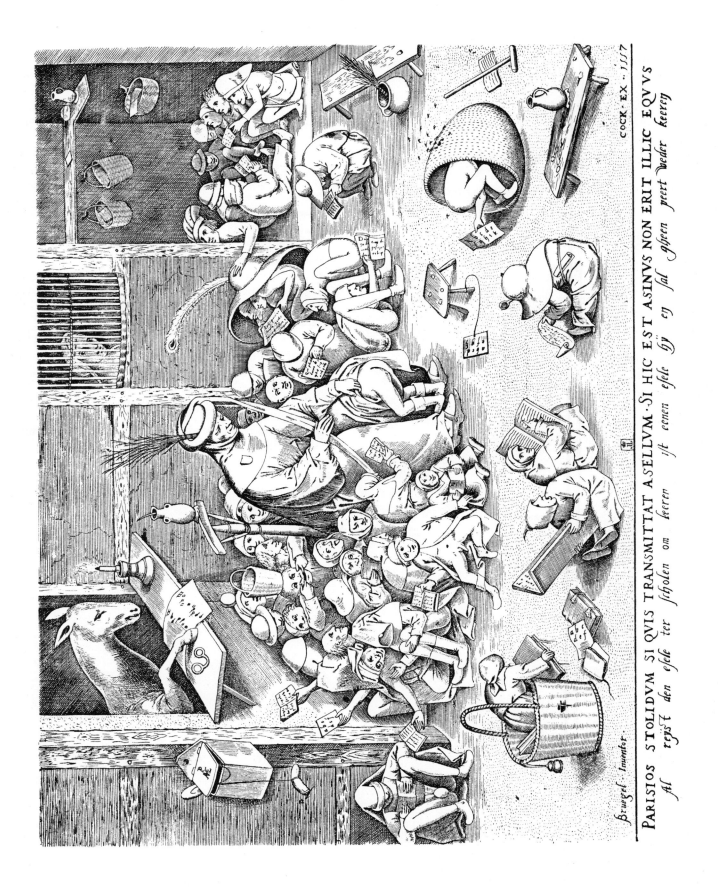

Bruegel · Inuentor

COCK · EX · 1557

PARISIOS STOLIDVM SI QVIS TRANSMITTAT ASELLVM · SI HIC EST ASINVS NON ERIT ILLIC EQVVS

Al reyst den ezele ter scholen om leeren ist eenen ezele hij en sal gheen peert weder keeren

31. THE FIGHT OF THE MONEY-BAGS AND STRONG-BOXES (Le Combat des Tire-lires et des Coffres-forts, B.146)

Another engraving by van der Heyden, assigned to 1567 by Tolnay, though more recently another scholar, F. Würtenberger, has dated it nine years earlier. As indicated by the credit "Aux quatre Vents," it was published by Cock. No original drawing survives.

Perhaps a better title might be "The Battle of the Piggy-Banks and the Treasure Chests." After all, the warriors at left are pottery, not bags.

It has been called by Ebria Feinblatt, "a satire on the forces of war and plunder . . . one of the least complicated subjects by Bruegel to read."

The basic theme is reminiscent of the title of Brailsford's book: *The War of Steel and Gold*. Here, wealth fights wealth, in a mad, dehumanized mêlée. Mammon and murder, now and forever, one and inseparable.

In the words of Dr. Barnouw: "All wars are engendered by greed. It is not the poor who make war but the rich who want to rob each other. . . . Strong boxes and barrels filled . . . with gold ducats. . . . Those are the forces that clash on each battlefield."

Below the engraving are three couplets in Latin and three in Flemish, the latter supplying a rhymed text. Freely translated, the Flemish runs:

> Have at it, you chests, pots, and fat piggy-banks!—
> All for gold and for goods you are fighting in ranks.
>
> If any say different, they are not speaking true—
> That's why we're resisting the way that we do. . . .
>
> They're seeking for ways now to drag us all under;
> But there'd be no such wars, were there nothing to plunder!

Pear-shaped pottery "banks" like these were quite common in Bruegel's time. Coins were inserted through a slot near the top, visible as a dark diagonal slash on some in this engraving. Accumulated wealth was removed by breaking the bank. Near the top, left of center, we see a flag-flying giant piggy-bank that has broken open and is giving birth to a column of smaller bank-warriors who march straight into battle.

Human heads project from some of the animated money-barrels and pots. But others, more consistently dehumanized, have only man-like arms and legs. In the foreground, right, an arm lies severed from the pierced strong-box nearby. The hand still clutches its sword. The money-containers die hard!

In that corner, a watchdog chained to a money-barrel barks frantically. Meanwhile, a foot soldier—face hidden again—extracts coins through the barrel staves. This figure reminds one of some in Diego Rivera's memorable murals of Mexican history.

The entire coin-bespattered carnage is a wild tangle of weapons, warriors, and weird violence. Weapons of various periods are represented: cannon and cannonballs; lances, spears, swords, daggers, cutlasses, maces, battle-axes, and pikes. In the lower left corner a soldier has a short kitchen-type knife embedded through his helmet and brain-pan.

No weapon is too murderous, no aggression too brutal for this "striden en twisten"—Flemish for fighting and quarreling.

Money is on the march! Make way for plunder!

Translation of Latin caption: What riches are, what is a vast heap of yellow metal, a strong-box filled with new coins, among such enticements and ranks of thieves, the fierce hook will indicate to all. Booty makes the thief, ardent zeal serves up every evil, and a pillage suitable for fierce spoils.

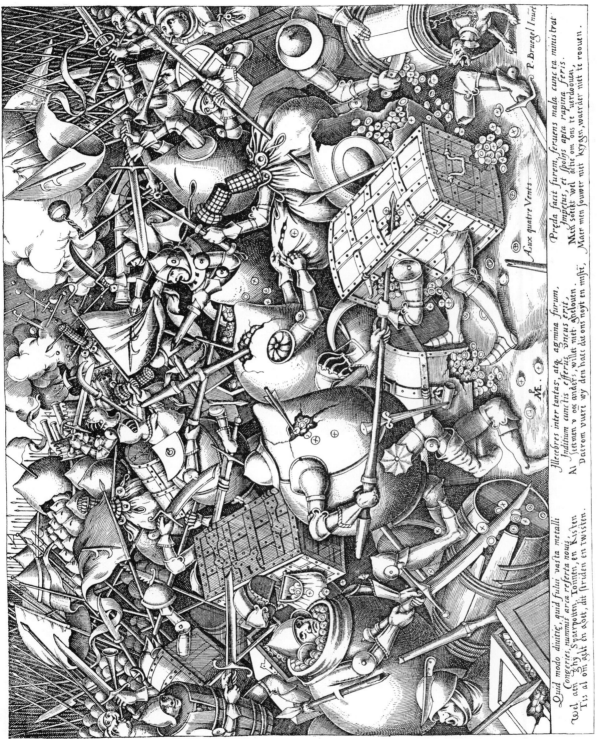

P. Bruegel Inuet.

Lux quatre Vents.

Illecebres inter tantas, atq. agmina furum.
Iudicium cunctis efferis, vncus ferit.

Preda facit furem, feruens mala cuncta minis'trat
Impetus, et fpolys apta rapina feris.

Men soeck wel allit om ons te vardooven,
Maer men souwer niet krygen, waerder niet te roouen.

Quid modo diuitiæ, quid fuluæ vasta metalli
Congeries, nummis arca referta nouis,

wel am ghy Sparpotten, Tonnen, en Kisten
Tis al om galt én gout, dit ftriden en twisten.

32. THE LAND OF COCKAIGNE *(Plenty; Luilekkerland; Pays de Cocagne, B.147)*

The names above, in English, Flemish, and French could be matched by others in other tongues. For example, the German *Schlaraffenland*, the American "Big Rock Candy Mountain," etc. Everywhere the concept is the same—the Never-Never-Land of *dolce far niente*, where roast fowl flies unaided into one's mouth; and milk and honey, or one's favorite cocktail, flow endlessly for the asking.

The original of this 1567 engraving by van der Heyden is the fine painting by Bruegel in the Pinakothek Museum, Munich. It is signed and dated "1567. Bruegel." (This same painting was mentioned in a 1621 inventory of the imperial art collection in Prague.)

In the engraving a four-line Flemish verse at the bottom issues an ironical invitation to peasant, soldier, or clerk (scholar) to "go native" in this lazy man's dream of *Luilekkerland*. Freely translated it runs like this:

> All you loafers and gluttons who love to be lying:
> Farmer, Soldier, or Clerk—you can live minus trying.
> Here the fences are sausage, the houses are cake,
> And the fowl fly 'round roasted, all ready to take!

The three "callings" mentioned in the verse are all here, lying in useless slumber under a table-tree. At the left, the scholar, mouth open not for eloquence but in snoring. Next, the peasant flat on his flail. Finally, the soldier, his lance on the grass, his gauntlet cast down, his helmet farther right. All three are literally "good for nothing."

Between the first two scampers an egg, already opened and eaten. Empty eggshells are with Bruegel, as with Bosch, symbolic of spiritual emptiness and sterility.

At left, a cactus-like plant is actually made up of cakes—and no spines! Further right, a roast pig, already partly carved, trots along, a knife handily stuck through a loop of skin.

To the right again, a roast goose lays itself down in readiness on a silver platter. A fine linen napkin or cloth is already spread below.

Above the pig, in the background, we see a man who is "making it the easy way" according to the Dutch tradition. He has just eaten his way clear through the rice pudding mountains which form the barrier to Lazy-delectable-land (*Luilekkerland*). He cushions his fall by grasping the branch of a tree which grows partly through the pudding.

The fence on the far side of the sleepers' lawn is a woven web of sausages. At the right is a house or lean-to, its roof covered with pies and cakes. Under this protection an open-mouthed figure is awaiting a roast chicken which is flying in "right on the beam." Dr. Barnouw has identified the figure as a farmer's wife; however, it seems to be rather a helmeted knight, his visor lifted, his arms propped comfortably on a brocaded pillow.

The rice pudding mountains plunge precipitously down to a sea (of beer, perhaps?) on which a rowboat and fishing boats are seen. At the horizon, just as might be expected, is a substantial city.

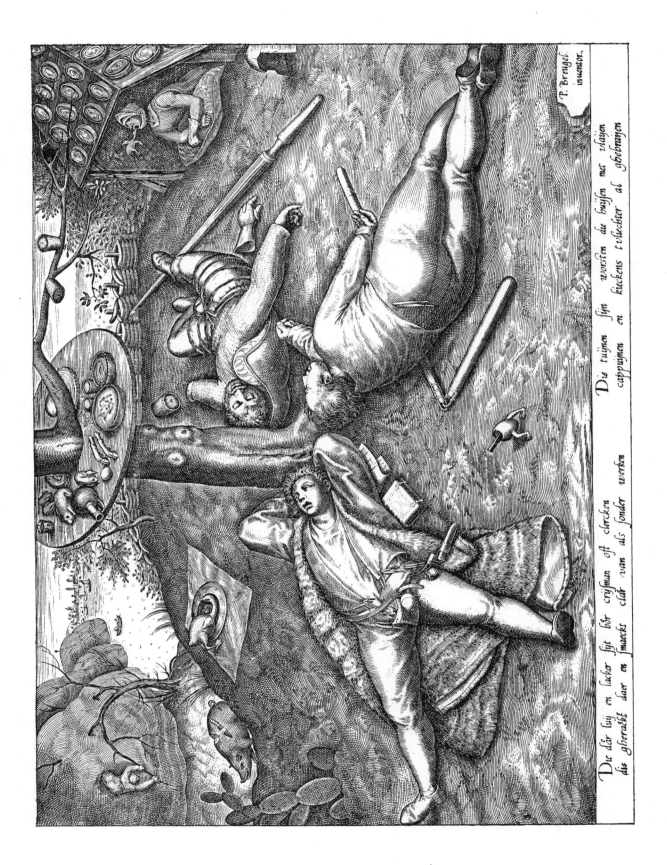

33. THE PEDDLER PILLAGED BY APES (The Merchant Robbed by Monkeys; Le Mercier pillé par les Singes, B.148)

Pieter van der Heyden engraved this bit of drollery. It is his monogram which is seen at the lower right under the small drum. The engraving was first published by Cock, 1562. Bruegel's original has dropped out of sight.

Four states of the plate are recorded, indicating the continuing popularity of the subject. The first lacks Bruegel's name at the left, but has Cock's name in the centre. The second adds in the small panel at the lower left, the words "Brueghel Invē." The third shows below those words the legend "T.G. excudit," indicating Theodore Galle as publisher; this state lacks the center credit to Cock. The fourth and final state names C. J. Visscher as publisher.

Pictures of the plight of the peddler who falls asleep and is robbed by a band of mischievous and malicious monkeys are found as early as a century or more before Bruegel. The theme was used in graphic works in Italy, Germany, and the Netherlands. It is found also, even earlier, in marginal artwork or illuminations of the late Gothic period.

More than a score of apes have descended on the itinerant haberdasher and "notions" peddler as he lies blissfully sleeping outdoors in a rural area. Some are tailed, some devoid of tails; but all are inspired imitators of humans, in a simian sort of way.

In the lower left corner, one of them lustfully regards his own image in the mirror. Above him, another is voiding in the peddler's feathered hat. Still higher, two play like children on hobbyhorses. Higher still, two roll in a stolen basket.

To the right of them, one beats a drum; another, up the tree, blows a horn; while four hold hands, dancing in a ring to the music. The trees have been hung with the poor merchant's finest merchandise. We see beads, purses, gloves, "costume jewelry," etc. Even the peddler's person is invaded. Behind him, a monkey makes a drastic and unmistakable commentary with his nose and fingers. Another, atop the peddler's head, is "grooming" his locks —looking for vermin, that is.

Below, one tries on boots; another searches through the peddler's money pouch; in his goods case a simian tries on spectacles.

And so human finery creates fun for monkeys.

Plate 33 is reproduced by permission of the Metropolitan Museum of Art, New York City (Dick Fund).

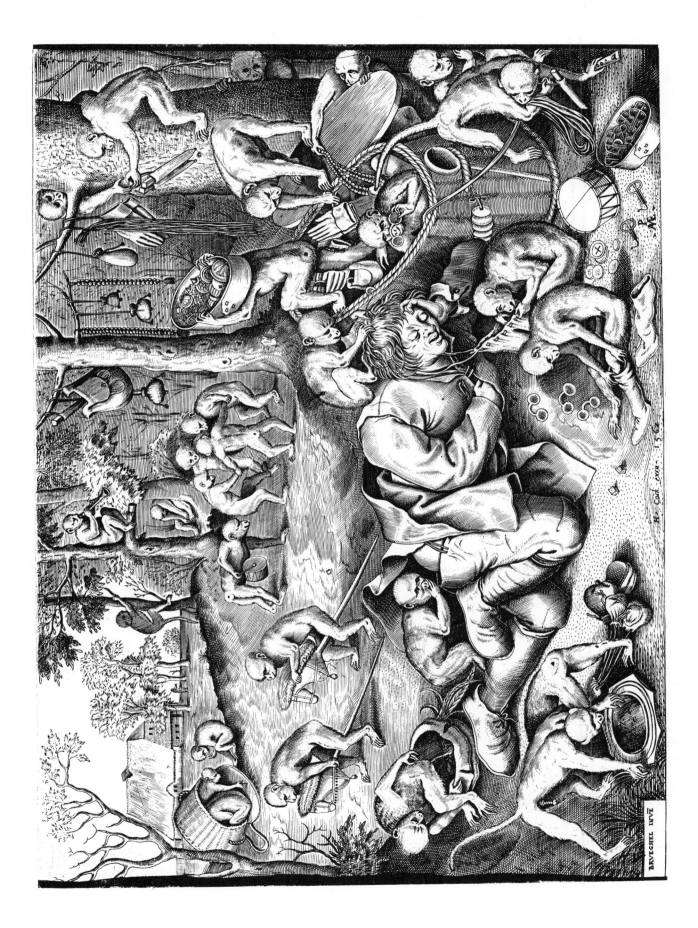

Here again van der Heyden is believed to have been the engraver.

The original drawing, in the British Museum, was executed with pen and brownish ink. It bears at lower left the signature "Brueghel 1558."

Two states of the plate are recorded: The first lacks Bruegel's name and identifies the publisher at the lower right with the words "H. Cock excud. cum Privileg." The second state replaces this with the name of Bruegel as "invent." and Joan Galle "excudit" (publisher).

A picture within a picture hangs on the wall at top, left of center. A man in medieval garb sits amid a shambles of shards looking into a mirror. The legend below expresses in Flemish this pithy and pregnant thought: "No one knows himself" (*Niemāt en kent hē selvē,* i.e., *Niemant en kent hem selven*). It is the ironic commentary—not an answer—to the age-old injunction: Know thyself!

In the scene below, five figures—each labeled "Elck" or "Everyman" on his garments—are searching, pawing, clawing, tugging through an endless pile of things . . . things . . . things. . . . The foreground resembles, as the saying goes, "a Belgian attic." A sixth and seventh, in the far distance, go seeking with lanterns.

An eighth figure is seen only in part. He holds a lantern in the hogshead at lower left. Were he to step forth, "Elck" would be on the hem of his garment too.

Unrealistic as the action may be, we somehow cannot feel that the import is utterly obscure. The general drift is indicated by the verses at the bottom in Latin, and below, at greater length, in French, at the left, and Flemish, at the right.

An English equivalent of the French and Flemish is attempted here. Too free for a "translation," it is rather a restatement of the feeling that seems to flow from the cryptic picture and the verses attached to it:

> Always, each man is seeking for himself alone—
> And everywhere . . . So how can one stay lost?
> Each man will pull and tug and grunt and groan,
> Seeking to get more for himself—get most!
>
> And no man knows himself despite such seeking;
> No light will help him in this lonely place.
> Strange! Though he looks with eyes forever open,
> He never sees at last his own true face.

The Elck seeking in the center of the picture carries a fat money-bag at his waist. Eyeglasses and a lantern do not help him to find what he seeks, though just about every kind of thing is scattered in a tangled confusion about the place. There are household goods, tools, games (dice, cards, chess, etc.). There are bales and bags and bundles. The goods and the distractions of the world are all about. Yet Everyman, in every form, is always and everywhere seeking in vain.

The Elcks here shown are aging. They are distraught, frustrated, unhappy. The abundance of things does not fulfill their need; and the lantern leaves them as much as ever in the dark.

It is a bitter business, with no final success in sight, to be looking, looking, looking only for one's self. For no man (Nemo) will find himself here, even though he may find "private gain" for himself.

Translation of Latin caption: There is no one who does not seek his own advantage everywhere, no one who does not seek himself in all that he does, no one who does not yearn everywhere for private gain—this one pulls, that one pulls—all have the same love of possessing.

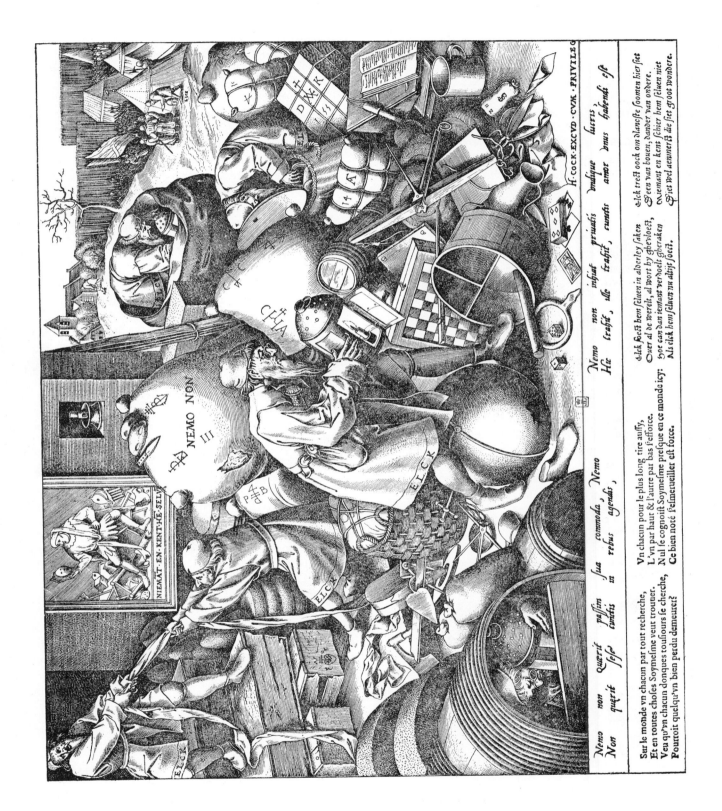

Nemo non querit passim sua commoda, Nemo
Non querit sese in rebus agendis,

Nemo non insipit priuatis lucris,
Hic trahit, ille trahit, cunctis amor unus habendi est.

H.COCK·EXCVD·CVM·PRIVILEG

Sur le monde vn chacun par tout recherche,
Et en toutes choses Soymesme veut trouuer.
Veu qu'vn chacun donques tousiours se cherche,
Pourroit quelqu'vn bien perdu demeurer?

Vn chacun pour le plus long tire aussy,
L'vn par haut & l'autre par bas s'efforce,
Nul se cognoit Soymesme presque en ce monde icy:
Ce bien noté sesmerueiller est force.

Elck soeckt hem seluen in alderley saken,
Weer al de wereld, al wort by ghesloest,
Hoe can dan iemant verdoelt gheraken
Als elck hem seluen nu ditz soeck.

Elck trekt oock om dlancste soomen hier siet
Seen van bouen, dander van ondere.
Cuemant en kent sichier hem seluen niet
Siet wel aenmerkt die siet groot wondere.

35. THE POOR KITCHEN *(The Meager Kitchen; The Hungry Kitchen; La Cuisine Maigre, B.154)*

36. THE RICH KITCHEN *(The Opulent Kitchen; The Fat Kitchen; La Cuisine Grasse, B.159)*

Both of these "polar" prints were engraved by van der Heyden and published by Cock. Both plates are dated 1563.

They are polar and complementary because exactly opposite in conception, though matching in form.

Everything, everyone is lean, scrawny, half-starved in this poor kitchen. Shortage reigns here. At the table, five men, like under-fed coyotes, reach into a bowl to clutch mussels or oysters. Under the table, a bitch with hungry pups tries to get some nourishment from the empty shells.

At center front, a mother, her thin breasts drained dry, tries to feed her nursing child from a horn.

A bearded man at left front pounds away, seeking to soften a piece of hardtack or possibly a dried herring. At the hearth some watery soup is being stirred over a scanty fire. The available "reserves" of food appear to consist of a few turnips, a carrot or two, and a half-eaten loaf of bread on the table.

On the wall at the right hangs a slack bagpipe, emblem of scarcity.

Mynheer Fatman has opened the door—possibly by mistake. A man and woman seek to induce him to come in; but he has seen enough; he is already on his way elsewhere. This is not the place for him.

The texts at the bottom of the picture in rhymed French and in Flemish state the sentiments that must fill his overworked heart and surge through his cholesterol-clogged arteries. Translated freely they might be:

> Where Thinman's cook there's meager fare and
> lots of diet trouble.
> Rich Kitchen is the place for me; I'm going
> there, on the double!

Thinman is the Flemish "magherman," the scarecrow at the hearth.

Rich Kitchen is where we next see Fatman, or his counterparts.

Flaccid bagpipe on shoulder, Thinman or one of his scrawny clan has just opened the door of Rich Kitchen, but is getting a cold —but fat—shoulder from the overstuffed inmates. They don't want the likes of him anywhere in sight. The fat fellow nearest the door pushes him out and gives him a kick for extra emphasis. A fat dog nips at his ragged shanks.

The corpulent clan reject this reminder of hunger. Theirs is the same deep-down sincerity to be found in the anecdote of the beggar who penetrates to the presence of a rich man to ask help; the rich man pulls the bell-cord and orders his butler: "Throw this fellow out! He's breaking my heart."

The verses inscribed below in French and Flemish tell what these fat men are saying or thinking. Freely done into English they run:

> Beat it, Thinman! Though you are hungry, you
> are wrong.
> This is Fat Kitchen here, and here *you* don't
> belong!

In fact, several of the overstuffed pieces of human furniture in the scene are not even aware of the episode at the door; they are too busy gorging.

One fat fellow with a tall hat, pensively biting off a cheese or huge roll, wears a chain of sausages round his neck, like a gour-mandizer's garland.

The opulence and overabundance are fairly sickening. Hams, sausages, pigs' feet, pigs' heads, cheeses, baked goods, and so forth, hang from the ceiling and sprawl over the table.

Three pots simmer over a roaring fire. A suckling pig is basted at a grill before it, while a huge overfed cat laps the drippings as they fall.

At the near end of the table, a mother, almost as wide as high, feeds her fat baby at one breast; the other is in readiness to carry on the infant's meal. Meanwhile, Mamma holds a tumbler, no doubt filled with something nourishing—perhaps a heavy Malz beer . . . a sturdy stout . . . or maybe straight cream liberally laced with sugar and cinnamon. After all, a nursing mother must keep up her strength!

In spite of the broad farce which such commentary may suggest, this pair of pictures in fact have in them something horrible. The scarcity in one is too savage and oppressive; the excess in the other too compulsive and distorted. They are more than a little mon-strous, especially when regarded together. And this impression is probably not peculiar to modern eyes and minds.

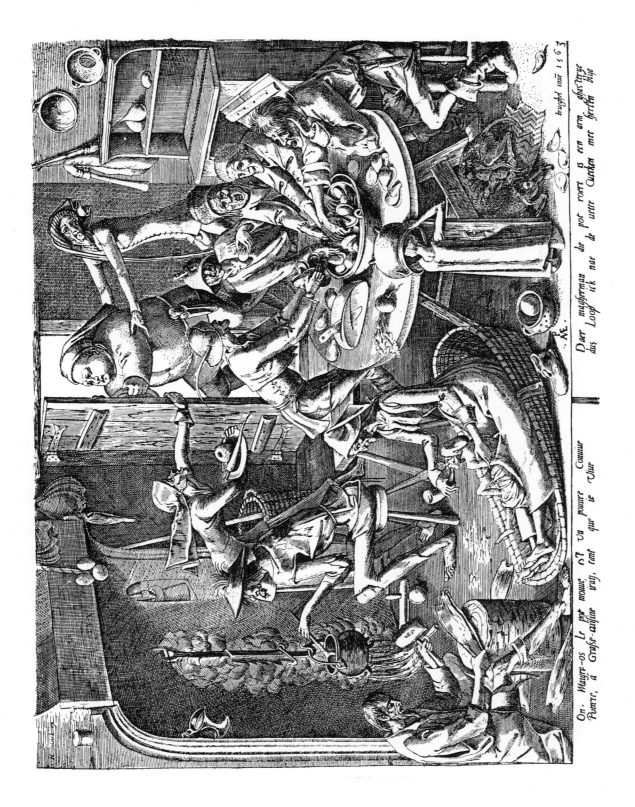

bruegel inū 1563

Dar maggerman die pot roert ïs een arm ghusterye
dus Loop ick nae de uette Cuecken mer sterten hie

.Æ.

On. Maygr-os Le pot mauue, cī Vn pauure Conuiue
Pautre, à Graſse-cuiſine vraij, tant que ie Viue

36. THE RICH KITCHEN *(The Opulent Kitchen; The Fat Kitchen; La Cuisine Grasse, B.159)*

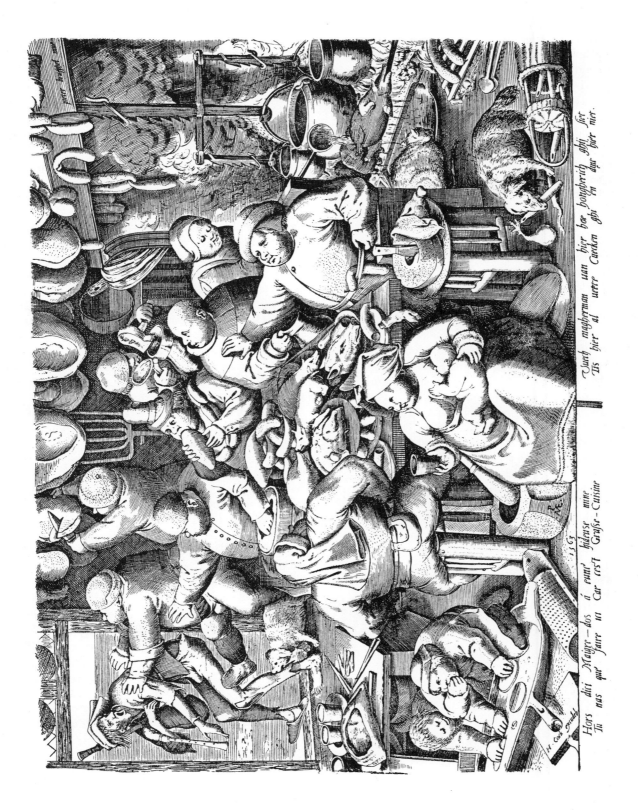

Hors diei Maigre—dos à eunt' bidrusr nunc Sunch magherman van hier bae borgbrich ghij hier
Tu nas qur' faire in Cur est Grasse—Cuisine Tis hier al uetre Cuecken ghi in duur hier niet.

In Cock anaby 1563

37. THE WITCH OF MALLEGHEM (*La Sorcière de Malleghem, B.193*)

In the second state of this plate, reproduced here, Pieter van der Heyden, the engraver, is identified by a monogram which appears on a leg of the table, lower center. Below it, the publisher, Cock, has placed his name and authorization and the date of publication, 1559. "P. Brueghel" is named as "inventor" on a card suspended from the cracked monster-egg at the lower right. Flemish verses appear in three couplets below the picture.

Such is the second state of the plate. In a rare first state neither Heyden nor Bruegel was identified. In a third state, the credit to Cock was obliterated, and in the margin below the picture, the initials of the new publisher, T. Galle, were inserted. In a fourth state, French verses were added. And in a fifth state the name of the publisher was changed to Joan Galle.

No original drawing of this subject survives today.

This is a witches' brew of quackery, gullibility, and superstition.

Malleghem was a proverbial village, a sort of "Suckerville" or "Jerkburg" of the Flemings. *Mal* in Flemish means crazy or foolish. A Flemish district, in what is now Belgium but was then part of the undivided Netherlands, bore the name Malleghem. By analogy of sound this was related to Fools' Home (*Mal-heim*).

In particular, the Malleghemians were supposed to swallow any fake nostrums and cure-alls; they were natural prey for quacks. Madness, it was widely believed in Bruegel's time, arose from alien growths in the brain or head, such as bumps and tumors on the forehead. It is this that the "witch" has come to Malleghem to cure. She is at work over the far end of the bench. In her left hand she holds up triumphantly the "stone" that she had just cut from the head of the patient whose chin she still grasps with her right.

Others among the crowd awaiting her attentions look on in stupid anticipation or shout their excitement. On the wall, upper center, appears a placard advertising the witch's wondrous healing arts. It pictures a huge knife and from the banner hang many stones that she has, ostensibly, removed from other patients.

A free approximation of the Flemish verses under the print will help to illuminate the spectacle. It is herself speaking:

> Folk of Foolsville, be of good cheer;
> I, Lady Witch, wish to be well-loved here
> As I am elsewhere. . . .
> I have come here to cure you
> With my proud aide; I assure you
> We're at your service: draw near.
> So let them come on, come one and come all,
> The large and the small. . . .
> Hurry on, every one,
> If you've a wasp in your dome
> Or are plagued by a stone.

The "aide" is the fool-hatted man with a lantern casting light on the witch's work. He carries a pouch for her surgical tools.

Another patient has been tied to a chair, to the left of the bench. His head is being doused, perhaps in preparation for the knife. In the right corner, an enormous empty eggshell, symbol of futility and barren folly, serves as surgery. Dozens of stones are sliced away from the patient there; they shower over the floor.

The motive of the round stone recurs elsewhere in this close-packed composition. Also the motive of the bird. One sits on the back of the chair mentioned above. A stupefied or alarmed owl perches at the extreme left, turned as if unable to bear watching the mass madness.

Higher, somewhat left of center, a demon-bird perches on a huge jug. A horn or musician's pipe is thrust through his nostrils. A bass viol is carried on one shoulder by a vendor of nostrums or salves. He has filled his bottles from one of the siphon tubes at the two jugs which stand on a stage or platform supported on hogsheads, such as actors used in festival plays of that period.

Against that platform leans an enormous tool, surmounted by a crescent blade. It is a giant "stone remover." Something of this size is needed to remove a stone as large as that growing on the shouting sufferer at the lower left. In his frenzy he clutches the purse of the man who is helping to support him. Gold coins spill on the floor and roll, as the extracted stones are doing elsewhere. Some kind of commentary is indicated by the two hooded figures at the lower left. Are they deploring all this stupidity and deception? Or—since one holds a stone and has two stones in front of him—are they impressed by the essential helpfulness of it all?

Above them, to the left of the platform, five figures wearing visored capes look on also. One has arrived on a horse. In front of him (and just above the man with the super-stone) a helmeted man walks on crutches, and with the help of a wooden leg. He seems to have arrived also to consult the busy witch.

Peering out from under the bench below the witch is a winking man with padlocked mouth. A fool's head up his sleeve gives him away. He, too, holds a stone taken from a basket full of them.

Some elements of sanity—or nonparticipation in the madness—are glimpsed (as so often with Bruegel) in the far background. Grain is being carried across a plank bridge to a mill powered by a waterwheel. At top center a fisherman goes about his useful business in his boat.

But then again, between mill and fisherman stands a strange, leaning hill, like an upside down carrot or turnip. Its tip projects through a bowl-like rim. And from that strange bowl there pours down on an agitated man below—a shower of *stones!*

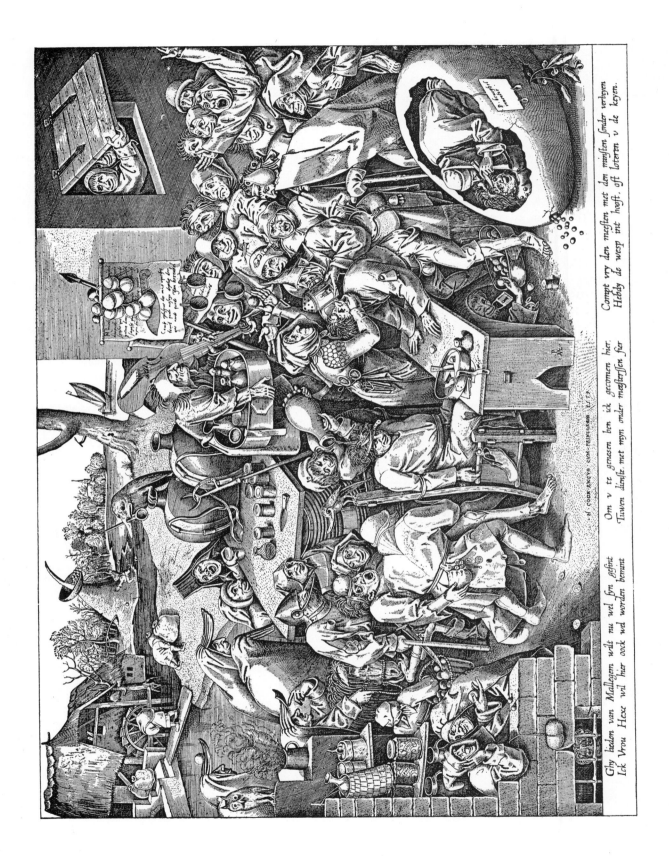

H / COCK-ZNCVS COM-PRIVILEGIO. 1559.

Ghy lieden van Mallegem wilt nu wel fyn ghsint. Om v te genesen ben ick gecomen hier. Compt vry den meesten met den minsten sonder verbeyen
Ick Vrou Hexe wil hier oock wel worden bemint Tuwen dienste, met myn onder meesterssen fier Hebdy de wesp int hooft, oft loteren v de keyen.

38. THE ALCHEMIST (L'Alchimiste, B.197, M.139)

The words "Brueghel Invē" appear in the extreme upper left corner; the name of the publisher, Cock, along the lower left margin. No date appears and no engraver's symbol. The date is probably 1558 or 59; and the engraver, Philippe Galle.

The working drawing, pen with brownish ink, is in the Kupferstichkabinett, Berlin. It is signed and dated "Brueghel 1558" in a hand not Bruegel's own, but Tolnay believes the information conveyed is correct.

The alchemist here is the shaggy and desperate man heating the crucible over the blow-flame at the left. His wife behind him woefully seeks to get a coin from an empty purse, but nothing comes. Above her, their three children scramble, and search in the empty larder.

A figure wearing a fool's cap shouts or sings as he fans the flame in a brazier with a bellows. Folly drives on the insane, insatiable quest to win gold from dross.

At extreme left a ladle, held by an "off-scene" hand, pours more fuel on the fire.

At a desk or lectern at the right sits the spokesman for experience or sanity—a scholar who points to books before him for a punning commentary on the alchemist's efforts. The headings of the pages to which he points are "Alghe" and "Mist," reminiscent of the modern German *alles Mist*. Even in Bruegel's Flemish they stood for something much like "All rubbish."

Such is the present state of this follower of the delusions of alchemy. But his future and final fate is shown beyond the window, in an ingenious example of graphic "time travel." There the same five members of the family—alchemist, wife, and children—now completely penniless, are being received at the poorhouse, or "hospital." One of the children in this future scene still wears the same pot on his head as in the main picture. The alchemist still wears one slipper, and one shoe of a sort. A bleak prospect, and inevitable.

The wealth of detail and variety in Bruegel's original drawing has been preserved admirably. Ebria Feinblatt calls the composition "one of the most beautifully drawn of Bruegel's satirical subjects, with the properties of the various materials finely rendered by the engraver."

Even the labeling of some of the hapless alchemist's supplies is preserved legibly in the engraving. Thus a bag leaning limply against the stone in lower left is labeled "Drogery" (drugs). And near the lower right corner, the table, made of a dismounted door lying on a tub, bears two labeled cans, one of which can be read as "sulfer."

The writ or document nailed to the face of the hearth above the alchemist's head also contains legible words, one of which seems to be "misero."

The situation depicted here is not entirely fanciful or far-fetched. See the tale that Chaucer has put into the mouth of the Canon's Yeoman in his *Canterbury Tales*.

Deceptions and disappointments inherent in alchemy were exposed by various moralistic and iconoclastic writers of Bruegel's time and shortly before. Tolnay has quoted, for example, lines from Agrippa von Nettesheim in his *Vanity and Uncertainty of the Sciences (Die Eitelkeit und Unsicherheit der Wissenschaften)*: "The making of gold . . . is surely a right lovely discovery, and a nice unpunishable swindle, whose vanity and futility easily reveal themselves, insofar as that is promised which Nature can in no way tolerate or attain; for every other art and science imitates Nature but never surpasses Nature, since the power of Nature is far stronger than the power of art."

Agrippa von Nettesheim, to be sure, could not know that within four centuries the art or science of nuclear physics would transmute elements, turn matter into energy, and threaten the very survival of mankind on earth.

39. THE TRIUMPH OF TIME (Le Triomphe du Temps, B.204)

The identity of the engraver is unknown. In the first state of the engraving the small plaque at the lower right contained the name of the first publisher, Philippe Galle, and the date 1574 (five years after Bruegel's death). In the second state, here reproduced, this was replaced by only the credit to the second publisher, "Jo. Galle excudebat." Farther left, the original artist is named in Latinized form: "Petrus Bruegel inven."

At lower center, worked directly into the design, is the Latin motto, meaning: "Time devouring all and each."

Doubt has been voiced as to whether this engraving was in fact based on a Bruegel original. The consensus of scholars seems to support Gustav Glück's contention that it was. Earlier in this book we have seen Bruegel's use of pagan mythology in a subsidiary way in landscapes and marine (ship) subjects. In recent years, *The Calumny of Apelles*, a Bruegel drawing from 1565, has come to light. Like this work, it is concerned completely with a classical theme.

The stamp of Bruegel is clear in many details of treatment here.

The essential meaning is obvious: Time destroys all that it has brought into being. Nothing survives permanently, neither man nor his monuments.

Like Saturn in classical mythology, Time devours his own offspring. The identification of Time and Saturn grows out of the persistent and understandable confusion of two names: *Kronos* (the Greek name for the figure who corresponds to the Latin's Saturn), and *Chronos* (Time).

Adriaan Barnouw has written that the infant that Father Time here carries on his right shoulder "betokens the principle of constant renewal." This would imply that the babe is along, so to speak, "just for the ride." However, examination of the print shows beyond doubt that Time is engaged in a grisly act of cannibalistic infanticide. Everything is a child of Time, comes into being within Time, and is eventually swallowed up mercilessly by Time. The face of Time here, though grim, is not savage; he eats his child without frenzy, rage, or lust; it is simply the way things are. And in his left hand Time raises high the snake with tail in mouth, a widespread symbol of renewal, continuity, and the endless cycle of life.

These major allegorical acts take place amidst a plethora of allegorical objects and symbols. Time rides his car, drawn slowly by the light horse of day (sun ornament) and the darker horse of night (moon ornament).

The great globe of the earth itself is carried on the car, belted around by the signs of the zodiac, together with their conventional symbols. Three of the signs are a little outside the circle: the scorpion is halfway up the trunk of the tree (Tree of Life?); Libra, the scales, hang higher from a branch; and the crab (lobster?) seems to be slipping off the wagon between the wheels.

In the crotch of the tree stands a clock, its hammer striking the unceasing hours.

Time himself sits on a great hourglass. One foot is shod, the other bare—a symbol which this writer is at a loss to interpret.

The earth rests on a bed of bare boughs in the cart. The body of the wagon is built like a galley, with hook-beaked prow. Its wheels contrast: the hind wheel's tire is woven of vines; the front wheel flaunts an ornately patterned tire. This writer's guess—nothing more—is that there is some reference here to the seasons—perhaps autumn and spring. Or possibly it should suggest that Time sometimes travels along smoothly, sometimes roughly.

Time is followed by mounted Death, bearing a long scythe. As always, mortality is on the march. The Grim Reaper mows down all life when its Time has come. Behind death follows an angelic herald, trumpeting atop an elephant of truly Bruegelian proportions. The Latin caption identifies this herald as Fame. And Fame all too often follows only after Death.

Adriaan Barnouw concludes: "All that remains of man's deeds is a breath of wind."

Time and his entourage ride roughshod over a road strewn with the emblems and objects of human life. Here, in profusion, drawn with precise detail, are scattered men's tools and trophies. Like blinded Samson, they lie "at random, carelessly diffus'd."

From left to right we can identify: the painter's palette and brush; the musician's instruments and compositions; the artisan's tools; the warrior's weapons; the crown of the king, the helmet of the knight, the hats of the cleric and the burgher; then sword, scepter, and pruning shears; the broken column of a church or temple; a treasure chest, a money-bag.

All that men slave, sweat, kill, conspire, cheat, or bribe to acquire, lies here like rubble in the road. To on-marching, devouring Time these "treasures" mean—nothing.

Bruegelisms permeate the background. At left two men in a fishing boat sail in the direction of a town that burns on the horizon, filling the sky with flames and smoke. To the left of the town is a squat water fort.

On the other side, just above the horse's hips, a rural couple walk side by side. Thomas Hardy's verse comes to mind:

> Yonder a maid and her wight
> Come whispering by.
> War's annals will fade into night
> Ere their story die.

Far back at the right are the buildings of a town. On the green near the church, dancers have formed a ring around a tall maypole. They are not aware of the Triumph of Time, or if they are, they are not depressed by it.

A windmill and a castle are farther back, up the hills.

This, too, shall pass; Time will take care of that. But meanwhile it gives the background an illusion of safety and durability of a solid Dutch sort.

Translation of Latin caption: The horses of the sun and moon rush Time forward; who, borne by the four Seasons through the twelve signs of the rotating extensive year, bears off all things with him as he goes on his swift chariot—leaving what he has not seized to his companion Death. Behind them follows Fame, sole survivor of all things, borne on an elephant, filling the world with her trumpet blasts.

Plate 39 is reproduced by permission of Mr. and Mrs. Jake Zeitlin, Los Angeles, California.

TEMPVS OMNIA ET SINGVLA CONSVMENS.

Solis equus, Lunæque, unuctium quattuor Horis, Prorumpunt Tempus: curru quod præpete fecum Pone fubit, cunctis rebus Fama una fupers fes,
Signa per extenti duodena volubilis Anni, (uncta rapit: comiti Morti non rapta relinquens. Gæstulo boue vecta, implens clangoribus orbem

Petrus Bruegel inuen

The

World of the

Seven Deadly Sins

or Vices

Pieter van der Heyden engraved all seven *Sins*. They were published by Jerome Cock in 1558. Fortunately, all of Bruegel's original drawings have survived. Their present locations are mentioned following the corresponding commentaries.

One of the seven drawings, "Avarice," is dated 1556; the rest, 1557. Bruegel must have completed the originals for all of his most famous single series within two years. They were conceived and executed with engraving in mind. The consistency of style and composition leaves no doubt as to that.

Some deviations between details of the original drawings and the corresponding engravings indicate that Bruegel as designer had less than complete control over the engraver. Van der Heyden, or possibly Cock as publisher, exercised censorship in certain small details, notably in the engraving of "Lechery," as pointed out in the accompanying comment.

This series is sometimes called the *Sins*, sometimes the *Vices*. The difference in terminology is not important, but does afford an insight into the subject. Theological tradition and consideration of rhetorical effect give *sin* a slight edge. After all, "The Seven Deadly Sins" has the sort of sulfurous aroma which proves alluring on theater marquees and book covers. On the other hand, "Vices versus Virtues" affords "alliteration's artful aid." And, psychologically speaking, Bruegel is, in fact, concerned with depicting

vices (continuing evil habits or practices) rather than single sins (conceived as isolated, individual acts transgressing moral laws).

For the sake of simplicity, we refer here to the series as *Sins* and note that they do denote vices—for the habitual and inveterate aspect of the sinful conduct is what makes it vicious in the eyes of the artist, and of the school of thought which he expresses.

At first glance these prints are likely to give a modern viewer the feeling that this is all most assuredly "out of this world"—and that there is much more implicit than can be understood in a single seeing. Here monsters and monstrous actions are multiplied in unrealistic or surrealistic landscapes. Here are pungent symbols, some reminiscent of the "iconography" of Bruegel's great predecessor, Bosch—others seemingly peculiar to Bruegel—yet all highly charged and emotionally loaded.

One wonders, sometimes: is the more appropriate reaction a loud guffaw, or a whimper of despair? All this is demon-infested, yet with a difference; it is like an Elizabethan melodrama, mingling physical violence, moral horror, and grotesque slapstick.

Compare one of the *Sins* with one of the *Virtues* which follow (excepting only "Fortitude"). The difference is immediately apparent. The *Virtues* are impossible juxtapositions, but of completely possible and usual people. The diabolical element is absent. They are didactic, but sans devils.

Clearly the *Sins* have urgent messages to impart. But what are they? What was Bruegel, landscapist turned moral teacher, trying to tell his fellow Flemings?

Scholarship permits surmises to be made more confidently today than half a century ago (when Bastelaer's almost definitive catalog of the engravings was fresh from the press in Brussels)—or even than a dozen years ago. In the following comments some highlights will be offered. They are intended to contribute to the satisfaction and the depth of meaning that the engravings will give.

Do not look on the seven *Sins* as pictures of future hells that await sinners after death. True, devilish things are happening. Monsters are making "life" miserable for tormented men and women. One might doubt whether theirs can be called a "life," even with benefit of quotation marks. Nevertheless, though the *Sins* certainly take us out of this world, they are not attempting a Dante-like tour of the realms of eternal punishment.

The scene of these *Sins* is, rather, within the souls of men. Of men, mind you, not of just one man. None of these *Sin* drawings was intended as a single solitary sinner's foreboding of his future. These are social situations, with social outcomes and implications, even with regard to a vice seemingly so non-social or anti-social as "Sloth."

Tolnay, a Bruegel critic deserving of mention again, interprets this series as evidence that Bruegel believed all men to be sinful beyond all help or change—so basically sinful that even if one sinful passion is cast out, another rushes in to fill the gap. Thus Tolnay writes: "Bruegel deprives the hereditary sins of their supernatural and destinal qualities." In other words, he does not picture sin as an infernal importation or injection into the lives of men who would, if left to themselves, remain free from it. If sin is, on the other hand, something that men originate within themselves, then there is no point in blaming an Evil One, a seducing Satan.

Bruegel—again according to Tolnay—understands the sins "as natural instincts" and "seeks the mainsprings of the forever ineradicable vileness of the real world"—a vileness which is, in fact, a result of human "devotion to the acting out of impulses."

Here is a good place to introduce another interpretation which seems better able to unfold the richness and validity of Bruegel's *Sin* subjects. This interpretation is identified with two of the foremost contemporary Bruegel scholars: Fritz Grossmann in England, and Carl Gustav Stridbeck in Sweden. (References to works of theirs have been given earlier.) They find graphically displayed in the *Sins* the viewpoint of a religious-ethical movement variously known as "Libertinism" or "Spiritualism" which was influential during Bruegel's lifetime and within his intellectual circles. The leading spokesman of the viewpoint in the Netherlands was D. V. Coornhert, himself both an artist and a sort of lay-preacher.

This view represented a departure from orthodox Catholicism, though during Bruegel's lifetime it seems to have escaped direct persecution. Coornhert's religious conception, as summarized by Grossmann, "centered on a personal relationship with God that dispensed with the outward ceremonies of the churches (Catholic, Lutheran, or Calvinist), [and] a moral philosophy concerned with man's duty to overcome sin, to which he is driven by foolishness."

This view differs drastically from the Lutheran or Calvinist conceptions of sin as inborn. It is not the view of approved Catholic theology, either. Yet it is the view basically illustrated by the *Sin* engravings, and underscored by the subjoined mottoes or morals in Flemish and Latin. Those statements again and again paraphrased or closely paralleled passages in Coornhert's writings. Whether they were selected by Bruegel himself or by his publisher Cock, or even—which hardly seems likely—by the engraver van der Heyden, does not matter greatly. There is no ground to suppose that they were added in opposition to the wishes of Bruegel; and the finished prints purchased at Aux Quatres Vents combined their pictorial and verbal commentary in an integrated whole. These inscriptions are so close to Coornhert passages that Grossmann, in fact, is inclined to attribute their wording to Coornhert himself.

The Coornhert view of sin can be summarized more fully as follows:

Sin, though prevalent, is neither foreordained nor inescapable. It is a course of conduct contrary to nature—"a battle against nature, a delusion of the spirit."

Punishment for sin was not deferred to a hell in an afterlife, Coornhert held, for "sin is the occasion of the ruination of men already in this life; it leads to misfortune and degradation, to spiritual and bodily decay." Sin, in short, "spoils men" in the here and now. The lives of sinning men become, in effect, a hell on earth, since "sin exercises a dictatorship over miserable men as over slaves, for sin incessantly torments . . . with pains, with discontents, and with cares."

The bondage of sin is underscored: The sinner is "a slave of sin, whose chain is the bad habit." The addict of vice is thus its victim.

We seem in this exposition to be entering a realm of psychological understanding rather than of theological dogma. Flashes of similar insight may be found elsewhere during this era, and in following periods. It is perhaps strange to encounter a similar touch in that great and paradoxical mingler of the medieval and modern—the poet John Milton. A memorable line in his *Paradise Lost* speaks of "jealousy . . . the injured lover's hell" (Book V, 449). Milton would hardly have placed jealousy among the sins, mortal or venial; but he does here establish the equivalence between the impulse, or emotion, and its punishment.

Then, Robert Burns, in his "Epistle to a Young Friend":

> I waive the quantum of the sin,
> The hazard of concealing:
> But, och! it hardens a' within,
> And petrifies the feeling!

Bruegel's *Sins* picture the compulsive vices, or follies, of men in a similar sense; they serve as their own punishments. They harden and they petrify the spirit of the sinner.

Thus the sinners who are hunted and harried, naked, through these engravings are bedevilled—but not by demons at whom one could, like Luther, hurl an inkpot. The monsters about them are the symbols of the heart-hardening and internal petrifaction engendered by the practice of sin in daily life. This is not a Hell with a geography and a location, like that of Dante or even that of Milton, but a hellish state of mind—a devil of a fix.

The vicious life is in itself hellish. The battle is joined, not so much for, as *in*, the souls of men themselves.

To convey this in pen and ink, Bruegel used means which were new with him, though the elements came from earlier artists. There is first the central allegorical figure, always a woman, representing the personification of the Sin. (Each of the *Virtues*, too, has a female figure as its personification; so no misogyny need be suspected.)

Around and behind this central personification, in a broad landscape, are ringed individuals and groups who illustrate what the vice does to those addicted to it. Monsters and bestial symbols guard and goad the human sinners. These demons are sometimes almost normal animals; but most are horrendous composites, anatomical impossibilities combining human, animal, fish, bird, and reptile elements in permutations of endless ingenuity.

Such use of the central allegorical figure corresponds to some extent to a primitive and persistent human tendency to personify when thinking about dangerous natural forces or compulsive patterns of conduct: "Alcohol has her in its grip!"; "I didn't mean to, but Something simply *made* me."; "Envy is making his life miserable."; "Reason flies out the door when Anger enters . . ."; etc.

Bruegel's treatment is related also to the traditional presentation of a deity and attendant devotees, such as Bacchus and his train of revelers, Satan and his company in a witches' Sabbath or Walpurgisnacht, etc. The central figure embodies the influence; the devotees or addicts act out the consequences. The central One is a static symbol; the others the active embodiments. So it is with these *Sin* engravings.

Coornhert and the ideas he voiced were influenced by the humanistic revival. This is apparent in their sin concept which paralleled the ethical teachings of leading "pagan" philosophers. Ignorance is the essential root of wrongdoing. An enlightened man can break free of folly, which is in effect another name for sin itself.

Since sinful actions—or foolish conduct—bring their own punishment, a man who through enlightenment overcomes his folly will also avoid the suffering consequent upon it. To this extent, a virtuous life is its own reward. Virtue as its own reward is a pagan rather than a Christian concept.

Yet the pagan philosophers, in keeping with the social structure of their society, hardly conceived of such virtue and happiness for all men. The great mass had neither the capacity, the leisure, nor the inclination for the necessary enlightenment.

The early theologians of Christianity based their creed on a code of conduct divinely revealed to mortal beings—men—who had both freedom of choice and unconditional responsibility for the consequences of such choice. This was essentially a legal system: laws laid down for men (all men) to follow; judicial verdicts as to the observance or violation of those laws; punishments for violations, and rewards for observance. It was a complete system of enforcement through sanctions, and the penalties became effective in afterlife, when the soul had shuffled off the mortal body. Hence, they were eternal.

Coornhert, on the contrary, taught an ethic in which hope for human betterment was rooted in human reason and enlightenment. It was a break with the hierarchical, authoritarian, and legalistic concepts prevalent in medieval theology, and several steps closer

to the attitude congenial to the majority of the educated in our own time.

There is a backward-looking aspect to Bruegel's *Sins* also. In their diabolism, their choice of symbols, and their crowded compositions they derive from traditions going back to Bosch and far beyond. However, this was no complete going back. It was a use of old and even archaic elements to convey ideas which were, for their time, advanced, if not radical to the point of sheer heresy.

It is tempting to speculate to what extent Bruegel deliberately chose old bottles into which to pour the heady, effervescent new wine of these ideas of individual worth, freedom, and opportunity.

Why *seven* Sins? This number, by Bruegel's time, was accepted and traditional. Mystical numerology had played a part here. It had worked during long centuries of brooding on sin, punishment, and the eternal afterlife.

The first influential listing of sins is found in the writings of the Church Father, Jerome—the same Jerome we have seen studying in the desert in Bruegel's landscape at the start of this book. Jerome's list differed from that which follows, both as to sins included and those excluded. For Jerome, and indeed during the Middle Ages, the Deadly Sins were usually conceived of as the antitheses of the Cardinal Virtues. Seven Sins: Seven Virtues—a tidy symmetry.

Eight sins were commonly identified at first, but numerology reduced the number to the mystically efficacious seven. Five specific sins appeared on most lists—Pride, Avarice, Anger, Gluttony, Unchastity (Lechery). The remainder of each list was made up of two among: Vainglory, Envy, Gloominess (*Tristitia*), and Sloth (*Acedia*). *Tristitia* was a sinful excess of depression; and *Acedia* was excessive languid indifference.

Historians of ethics have pointed out in such sins the effect of the monastic life, so highly esteemed during the Middle Ages. Traits as negative and damping in their results as *acedia* or *tristitia* were likely to be frowned on, especially in the close, restricted, and interdependent life of a monastic community.

Chaucer himself supplied an exhaustive and informative treatise on one selection of Seven Deadly Sins, complete with discussion of their intricate ramifications, inter-relationships, and remedies. This treatise is known as "The Parson's Tale" in *The Canterbury Tales*, that unfinished symphony of social types and favorite fictions in an awakening England.

The "Tale" is, in fact, no tale at all, but a parody of typical sermonizing by such a moralizing preacher. The Parson, though riding toward a late fourteenth-century Canterbury, was mentally still journeying in the Middle Ages. He was an anachronism, even in his own era.

Accordingly, Chaucer made the Parson's preachment windy and wordy: a thousand or more lines of particularly prosaic prose. Its tone is earnest, assertive, trite, dull, hair-splitting, saturated by second-hand scholasticism, and by ponderous distinctions void of true differences.

More than half the Parson's wordage winds its way slowly through the Seven Sins. Pride was placed first in position and importance. Then, in order, came Envy, Wrath, Acedia (here undue despair rather than crude laziness), Avarice, and those unheavenly twins: Gluttony and Lechery.

Nowhere has the central position of the Seven Sins in conventional ecclesiastical thought of bygone centuries been more amply elaborated than in this, one of Chaucer's most consummate "spoofs."

He wrote more than a century and a half before Bruegel created this series of *Sins*. Obviously, then, the subject was not new. We may see in the following pages whether Bruegel succeeded in placing it in new light. . . .

The order of Bruegel's *Sins* here is that which it seems the artist himself might well have preferred. It differs from the order of the same subjects in the Bastelaer catalog. We place first "Avarice," which dates from 1556, the very year in which Bruegel began his design of satirical and moralizing subjects. Next comes "Pride," followed by "Envy," "Anger," "Gluttony," "Lechery," and "Sloth"; these last six are all dated 1557. Alternative titles of the *Sins* are given in English, when it seems helpful; also corresponding titles are included in Latin, French, and German, in that order.

40. AVARICE *(Greed, Covetousness, Avaritia, L'Avarice, Geiz, B.128, M.130)*

The original drawing, in the British Museum, bears the date 1556. Fritz Grossmann, in evaluating the *Sins* series, sees Avarice as the moral source of all other sins. Stridbeck, too, stresses the central position of avarice—greed for gold and gain—in the constellation of sins: "Avarice like Pride has a key position. . . . Avarice is the spur that drives men to evil deeds and is the direct occasion of a whole series of other sins and vices, such as betrayal, falsehood, discord, strife, animosity, aggressiveness, bellicosity, war, etc. . . . Avarice is an unquenchable desire which can never be satisfied . . . the avaricious person shuns no means and respects no restraints."

An English proverb, deriving from the New Testament, says: "Money is the root of all evil." The Latin motto below this print asks: "Does the greedy miser ever possess fear or shame?" The question is, quite obviously, rhetorical.

The Flemish motto, freely translated, asserts:

> Grasping Avarice does not understand
> Honor, decency, shame, or divine command.

The personification of Avarice is a seated lady guarding a lapful of money, while she reaches into a handy treasure chest which a lizard or crocodile demon fills from a huge broken jug. The eyes of Avarice seem to look down at her hoard of gold; but close study of the original drawing shows that it is possible, as Tolnay believes, that Bruegel meant to depict her as blind. In any case her attention is fixed on gold; she sees nothing of what goes on around her. She wears a crescent-shaped head covering, a shape symbolic of the profession of procuress, for Avarice violates honor and decency for the sake of money.

Near her feet crouches the toad, her animal counterpart. He was believed to betoken avarice because, according to Cesare Ripa's *Iconologia*, a toad is able to devour dirt and sand, so abundantly available, yet withholds eating for fear that he should not, after all, have enough.

A dozen different groups and actions compete for attention around the fantastic landscape. Behind Avarice is the hut of the moneylender. He takes in pawn the clothing and utensils of the poor. They are left naked, like the man clad only in visored cloak, handing over his plate. To the right of the hut sits a pair naked except for the crude "shorts" which some evil-minded censor scratched onto the reproduction! Before them is a large tally-sheet. It shows accumulated debts. A winged monster points to the reckoning. These men, in the words of the proverb, have "sold their souls to the devil," and all for gold. In the original drawing, their faces express sharp despair and horror. In the engraving, van der Heyden—here, as so often—blunted Bruegel's sharp point; their expressions are ambiguous.

Nearby, a naked miser loses coins as a grinning reptile monster

rolls him in a barrel, spiked inside. Money spills from the barrel itself.

Victims of the moneylender are caught in the shears, like the one hanging beside his door. The shears symbolize cheating and fraud. Yet even the moneylender is a victim; he is being robbed, more openly. A thief has climbed the roof and reaches in to steal. The avaricious cannot retain what they have snatched in their greed.

The Orientally ornamented onion-like savings bank or pot on the roof holds a fish, very likely a shark, symbol of rapacious, insatiable greed. From the cone on top projects a stick, dangling a huge purse or money-pouch. Crossbowmen to the right use it as a target. Their arrows are tipped not with points but with money. The pouch has been pierced and the money falls out. As they shoot their money-arrows in an effort to get more, two smaller figures farther right are cutting away a purse. Greed preys on greed. Tolnay has traced several Flemish proverbs in the multiple symbolisms of this group.

In the farther background, same side, a man rides backward on an ox followed by a figure burdened under sheets or clothing.

Still further, a monstrous bellows fans a fire which sends smoke through a hat pierced by a saw-like sword. Tolnay finds this a symbol of fanning the passions into flame, and the men beating hammers alongside, he calls coiners of money.

In the right foreground, a bird-tailed beggar holds out his bowl toward a gruesome monster composed solely of a great face with legs. At the beggar's rear a demon bird pecks, probably a reference to the common identification of insatiable greed and constipation.

At lower left a winged demon claws gold from a great bag, near a dead hollow tree—symbol of sterility and vanity—in which a pot of gold has been hidden. A cross projects from the dead wood, like an afterthought.

Above, several demons conduct a pair of naked and terrified sinners while one gesticulates toward the shears as if to point out what awaits. In a bramble thicket behind them, a victim is buried almost to his neck.

Behind this group an armed assault attacks another Flemish savings pot (piggy-bank equivalent). With a long pole an attacker is poking a coin out of the slot near the top. Another has climbed a ladder and is about to smash the pot. Below, some attackers already scramble to grab coins on the ground.

Nearby (to their right), an ornate castle with Oriental design elements is ablaze. Smoke pours from the domes which resemble great beehives. In the sky a fish-bird monster is plunging like a dive bomber. This is a first cousin of the monster flying in the print of "Big Fish Eat Little Fish," reproduced as Plate 29.

In the farthest background great blazes destroy a city and forts. There is no safeguarding the wealth to get which the avaricious sacrifice honor, decency, sense of shame, and divine commands.

AVARITIA

P. Brueghel. Inuentor Cock. Excud. cum priuileg. 1558

QVIS METVS, AVT PVDOR EST VNQVAM PROPERANTIS AVARI?
Eua belustheyt scaemte noch gelsrick Vermaen En siet die sregende ghierichheyt niet aen

41. PRIDE *(Arrogance, Vainglory, Vanity, Superbia, L'Orgueil, Hochmut, B.127, M.132)*

The original drawing, dated 1557, is in Paris, collection of Frits Lugt.

Pride personified is a haughty royal lady, in rich court dress, "looking down her nose" at the world, while she admires her image in the mirror. Tolnay points out that Pride's garments were high fashion for Bruegel's period, whereas the other allegorical figures in the *Sins* series were clad in styles identified with the early fifteenth century.

Fashion may play a further role here, for according to Barnouw the roofs of the fantastic buildings are "ludicrous contraptions apparently suggested by contemporary fashions in headgear" and "the surrounding architecture . . . is a nightmarish satire on the conspicuous waste indulged in by the proud upon this earth." (All that is missing apparently are a few luxury American motor cars with fancy tail-fins and an abundance of chrome trim.)

The animal counterpart at the side of Pride is, of course, the peacock flaunting ornate tail feathers.

The mirror worship of Pride is echoed and mocked in the foreground by the knightly monstrosity, all head, forelegs, and peacock-feathered fish-tail, who admires himself in a mirror held by a nun-mermaid. The padlock through his lips indicates enforced silence, and the nun's gesture points to the big-mouthed braggart monsters at left. Their idiotic boasts deafen the human wearing a dunce-like cap. Barnouw suggests that the nun may be predicting that a similar padlock-punishment is in store for them, too. Tolnay calls the mirrored monster a "fool of fashion."

Just back of him, a bird-monster contorts so as the better to admire its anus in a mirror. An arrow is deep in its back. Perhaps this implies that vanity dies hard.

Above is a gruesome group. Monsters in the garb of shepherd, nun, etc., escort a naked, terror-stricken girl. A winged demon bears a shield inscribed with the symbol of a pair of shears. Tolnay reads this as evidence that the girl has "fallen into the clutches of the bawds." Barnouw suggests the group illustrates a proverb; "'Where pride and luxury lead the way, shame and poverty bring up the rear.'"

In any case, human nakedness in these Sin fantasies of Bruegel is in itself an indication of sin. A naked figure may be read, per se, as a human being suffering the consequences of his particular vice.

Farthest right at this level, is the sin's inevitable "house" or shop. Here is a busy "beautician's" establishment of the 1550's; a barbershop with trimmings. Outside, a woman gets a shampoo, administered by a wolfish demon who balances a pitcher on his head. (Acrobatics and contortions so often are interwoven with the idea of horrible punishment in these pictures!) Out of the window, a barber pours slops onto the head of the helpless customer. And up above the doorway, a naked sinner squats and voids into a pan, and so on down to a piece of music lying on the roof. (Barnouw calls this an enactment of the contemptuous expression "I shit on that," indicating popular contempt for the vanities here catered to.) Nearby hangs a lute. Instrument and music were not alien to the barbershops of that age; they served to amuse customers waiting their turns. The roof, too, displays the barber's license to cut hair

and practice surgery, plus a mortar and pestle showing that he also dispenses drugs.

Strange structures, many with humanoid faces, are spread across the background. At top center is a strange ship-like structure which Tolnay calls a stove-pot. It is packed with nude victims, guarded by a demon whose spiked helmet completely covers his head. A tree grows through this cryptic ark. On its top we see again the recurrent symbol of the broken hollow egg in which humans huddle. This always indicates some sort of rottenness and degeneration. Below the tree is the monster-mouth to this baffling structure. It is formed of wing-like segments, and naked humans crouch to enter. It is a kind of Hell-mouth—perhaps the entrance to the ultimate, sinister sideshow in this Vanity Fair.

Just to the left, a tree grows through another ornate structure, decorated by mirrors. Smoke ascends from holes in the roof. Below is a rivulet on the banks of which sinners sit. One falls in backwards. Immersion in water in these *Sin* studies signifies involvement in some sort of vice or shame. A bear-like monster on a horse, his naked companion mounted behind, fords this stream of pride. Tolnay sees this as a reference to a proverb which declared: "Two proud people cannot stay long on the back of the same ass."

In the far background of the stream, a sort of portcullis is being raised in the gate of the hat-topped castle. A crowd of naked sinners there are wading or being overwhelmed by the waters.

The hat on top is torn. Birds peer out through the opening. On top, a broken eggshell seethes and steams. There are suggestions of a church about this dungeon or fortress. Also suggestive of the church is the tiara-like hat of the owl-monster just below the "prow" of the ship-like "stove-pot" previously pointed out. The monster is devouring a naked victim. Its quadruple hat is as though made of stacked beehives. A mast projects, which is braced by ropes to the ground. Interpretation fails at this point, but one cannot doubt Bruegel knew well what he sought to symbolize here.

A saying warns that "Pride goes before a fall." And so, in the background, two figures fall headlong into the lake to the right. They resemble frogs or tadpoles. One drops from the height of the cliffs beyond the lake. This is the Icarus motif again. On the shores, figures are gathered dimly, waiting to be rowed across, or perhaps to plunge in.

As published, this print had both Latin and Flemish inscriptions below the picture. The Latin means: Those who are proud do not love the gods, nor do the gods love those who are proud.

The Flemish, freely translated:

> Almighty God detests the vice of Pride,
> And God himself in Heaven by Pride is defied.

Clearly Bruegel symbolized here Pride in many forms, not merely the narrow sense of craving for personal admiration and prestige. There are plays here on the pride of excessive display, the pride of malicious gossip, the pride of overweening ambition, and many other aspects of the Sin.

Plate 41 is reproduced by permission of Mr. and Mrs. Jake Zeitlin, Los Angeles, California.

NEMO SVPERBVS AMAT SVPEROS. NEC AMATVR AB ILLIS.

42. ENVY (Invidia, L'Envie, Neid, B.130, M.135)

The original drawing, in the private collection of Baron R. von Hirsch, Basel, is dated 1557.

Envy, according to Coornhert's constellation of sins, "is the eldest daughter of Pride." Indeed, the insatiable self-love and desire for aggrandizement of Pride, as conceived by Bruegel, could not tolerate the success or honor or fame of another. Envy, the inevitable result, poisoned the mind of the proud self-seeker. The envious one "eats his heart out" with resentment.

That is literally what Dame Envy does here. One recalls, with a difference, the stark poem of Stephen Crane, "The Heart":

> In the desert
> I saw a creature, naked bestial,
> Who, squatting upon the ground,
> Held his heart in his hands,
> And ate of it.
> I said, "Is it good, friend?"
> "It is bitter—bitter," he answered;
> "But I like it
> "Because it is bitter
> "And because it is my heart."

The Flemish verse below the picture, freely rendered, declares:

> Envy, endless death and sickness cruel, unpent
> Is a self-devouring beast and merciless torment.

The Latin means: "Envy is a horrid monster, a most ferocious plague."

Envy herself wears a headcovering of a style already outdated in Bruegel's time. Beside her is her appropriate animal symbol— the turkey, emblematic of envy.

At her feet, two curs battle over a bone. Behind her a demon extends over her head a crown in a travesty of honor. To the right is another hollow tree, in whose unclean interior lurks a monster bearing a distaff. Peacock feathers are the tree's only growth. To the left, a breasted monster with stag's horns and wings lures a naked human woman with an apple, a symbol of discord and downfall since before the Christian era. The horns are the usual symbol of cuckoldry.

As Barnouw points out, "The most striking feature of this print is the display of footwear." He quotes Dutch folk-sayings in which shoes serve as an index to social standing, similar to our "He lives on a luxurious footing." There is the class distinction, too, between the man in boots and the man in mere shoes.

Hence the shop, to the right, is a shoeshop. The merchant, his face hidden, forces a shoe on a customer, held by a monster. Other victims wait, seeking to get on the best possible footing.

From the top of a broken money-pot, above, the legs of a giant flail the air. One leg, pierced by an arrow, wears a great boot with spurs; the other has only hose. The latter has been lassoed by an armed force below, and is being pulled down. (Possibly a play on envious conflict between social classes?)

A crossbowman aims his weapon through the hole in the pot.

At front, left, a sad old woman lives, not in a shoe, but in a basket while she seeks to sell shoes. A shoe sits on her head. No customers appear.

Still farther left, a monster with dragon head, wings, and forelegs is about to devour a shoe. An arrow is shot or thrust through its nostrils. Farther back, a contorting demon examines its anus.

A boat floats on the stream or moat beyond. It carries a cargo of strange monstrosities. A winged monkey perching on the gunwale evacuates into the stream. An original "hollow man" is in the prow, his agonized face framed in a boat on which rest a tray, napkin, and apple. From his empty torso project dry twigs, always in Bruegel the emblem of futility and folly. Birds perch on a bare branch and on a dismembered knee. Perhaps this man has eaten himself up with envy. A spooky demon raises a hand in greeting. Envy has done its dirty work.

Another boat, beyond, capsizes, dumping its sinful passengers into the waters of degradation.

Across a bridge over the stream marches a funeral procession of hooded monks. They head for the chapel whose bell tolls. At the near end of the bridge is another of Bruegel's many house-faces. It has a sort of Hell-mouth through which multitudes can be seen guarded by a bird-beaked or crocodile-snouted demon. A tailed demon carries a nude human up the ladder toward this entrance. Smoke pours out, past the "upper lip," toward the "eyes." This is a strange sort of Hell with a built-in chapel.

The opposite end of the bridge runs into a watchtower or water fort. In the far distance, a tower appears to be in construction. Is this a structure rising because of envy or rivalry? In the farthest distance, a church burns; and again at the far right a tower is ablaze.

At the upper left, a figure like a scarecrow stands on a pole. A funnel is inverted over its head. Its snout is a bottle or flask from which projects a perch for a pair of birds. Its body resembles a beehive.

Many *what*'s and *why*'s must remain unanswered. Even the most ingenious interpretations leave much unexplained in this phantasmagoria. But clear enough is the indication of dissatisfaction with one's social standing, of the desire to get into the shoes of men more favored, and of the self-consuming nature of the sin of Envy.

Plate 42 is reproduced by permission of Mr. and Mrs. Jake Zeitlin, Los Angeles, California.

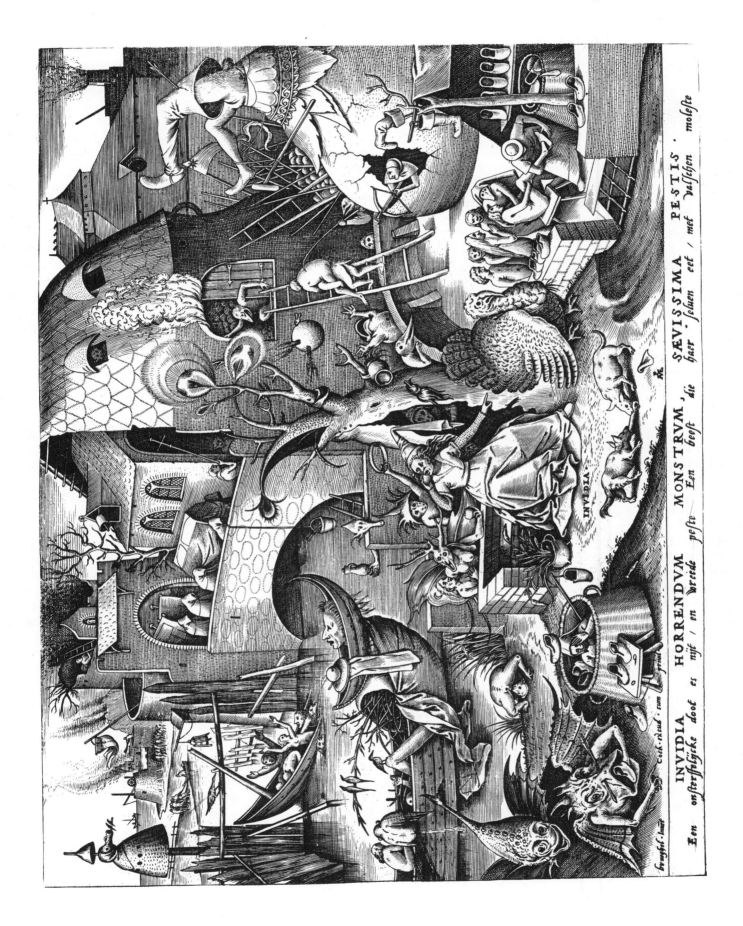

INVIDIA HORRENDVM MONSTRVM, SÆVISSIMA PESTIS.

Een onsterffelijcke doot es nijt / en wreede peste Een heeft die haer seluen eet / met valschen moleste

43. ANGER (Rage, Wrath, Ire, Ira, La Colère, Wut, B.125, M.134)

The original drawing, in the Uffizi Gallery, Florence, is dated 1557.

Central to this print is war, the ultimate form of anger. War was familiar to a Fleming like Bruegel. Like other observant Netherlanders, he must have known at close hand the realities of occupation, invasion, and resistance. For his land was ruled by a regime imposed from Spain, and disaffection was growing toward rebellion.

"Dame Anger," the allegorical figure here, takes an unusually active part in the proceedings.

In full armor, a sword in one hand, a torch in the other, and an arrow embedded in her brain, she rushes out of her war tent followed by a shock troop of monsters.

Her attendant animal, the angry bear, attacks the leg of a fallen and bruised human victim.

Twin warriors, faceless again, wield a giant knife of the style that was cutting the great fish in "Big Fish Eat Little Fish." The knife cuts into several terrorized naked victims at once. Their nakedness shows them to be sinners, the prey and playthings of Anger, the merciless tyrant.

Another, at the left, cowers in desperation awaiting the blow of the spiked club wielded by the armored monster with enormous mouth. (See the reference to congested or swollen mouth in the Flemish verse under the print, translated below.)

The "shed" here is a horrible barbecue. A human victim, spitted and bound, is being roasted over a fire of "anger" raging in a hollow tree. The snout-nosed chef bastes him as he turns on the spit.

Heat treatment is also administered to a couple stewing in the pot atop Anger's war tent. And in the background at the left, a towered town blazes. Fire and fury are partners here.

The middle distance is dominated by a gigantic ugly female, knife in teeth, right arm in sling, left holding a flask (poison!). Her hat bears a thorn branch as ornament. She crouches over a barrel that contains a bar-room brawl. The daggers are out in a battle to the death. A herald blows a long trumpet of alarm.

The hollow tree behind the giantess contains a nest of dry twigs bearing an egg. In a sort of tree house farther left, a man tolls the tocsin, and a fish is hung by its own gills, as seen earlier in the "Big Fish Eat Little Fish" print.

Two waterfowl fight in the sky. Toward the top right, another winged fish-monster flies. Below, in a strange dry-land war, an attacking party tilts at a landlocked boat propped up on huge hogsheads. The boat bears the by now familiar symbol of the hollow and broken egg, or ball, with human figures inside.

Warfare rages also at the lower right. Demons seek to advance behind a wheeled shield from which projects a saw-toothed sword, a symbol several times seen in Bruegel prints. A monster who bites an arrow in his beak reaches around seeking to bring down with his pike another armored monster, with one clawed foot and one stump, who unsheathes his sword. The spiked tail trails forward between his legs.

The original drawing shows expressions on the faces of these two which this writer believes indicate that Bruegel meant to show they were playing at, or parodying, human war. Both are smiling slightly. This is a bit of byplay between demon and demon, rather than a demonic punishment of human sinners. A reptilian demon pokes his head out from under the war shield, and yelps, as if in encouragement. Perhaps he is involved like the wife in Mark Twain's anecdote, who shouted, "Go it, husband! Go it, bear!"

Another deviation deserves mention. A white banner flies above the war shield. In the print it bears no emblem. Yet in the original drawing it clearly carries the emblem of the world and worldly power: the orb surmounted by cross.

Possibly this detail was deleted for fear of the authorities—that is to say, the Spanish rulers of the Netherlands. The drawing was made in 1557, some two years after the rule of the Netherlands had been transferred by Charles V of Spain to his son Philip II, who spent in the Netherlands the first four years of his reign. The historian, E. M. Hulme, summarizes the situation as follows: "Philip, unlike his father, was unmistakably a foreigner in this northern state. To the several causes of revolt . . . at work before his accession to the throne, there was added another and more fundamental one—a deepening antipathy to the Spanish rule." (*Renaissance and Reformation*, New York, 1921.)

In such a period of increasing tension and crack-down on expression, it is plausible to suppose that a canny publisher like Cock would prefer to omit an emblem which might seem to identify a devil with the secular authority, that is, the regime headed by Philip. Moreover, the stump-legged demon outside the shield, on the flag flying from his helmet, displays the key of St. Peter. This is clearly the symbol of Papal authority. Philip sought to maintain that authority and to stamp out opposition as "heresy." The drawing, thus, implied a strange struggle between the secular and the Church authorities, both represented by demon warriors. This implication is absent from the print.

The Flemish verse supplied as a moral to the picture indicates that men in the grip of anger are unable to talk right, feel right, think right, or function right; for it says, in free translation:

> Anger congests the mouth, poisons the mood,
> Disrupts the spirit, blackens the blood.

Anger's dominion over the angry is dreadful and ruthless. Instead of dynamic, self-assertive masters of the circumstances leading to their anger, they become impotent, beaten victims of a merciless master.

Translation of Latin caption: Anger swells the mouth and blackens the veins with blood.

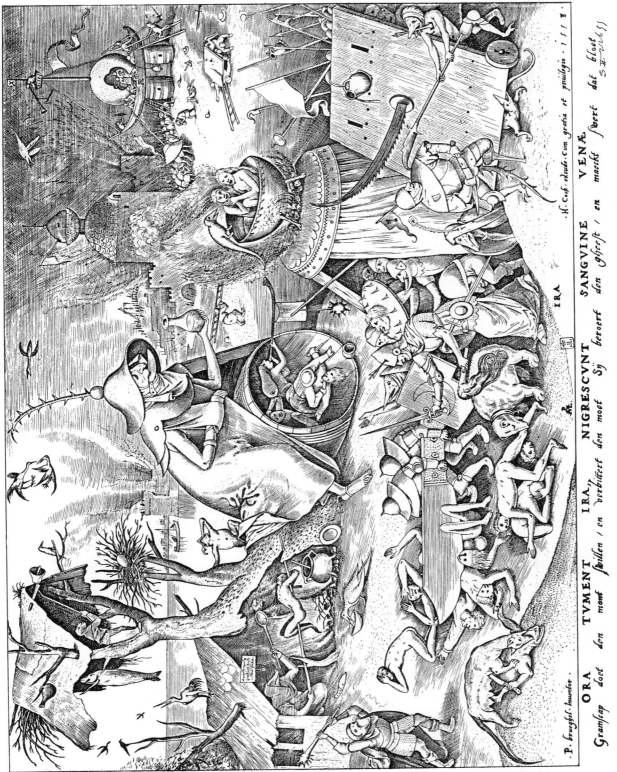

P. bruegel. inuentor.

ORA TVMENT IRA,, NIGRESCVNT SANGVINE VENÆ.

IRA.

·H·Cock·excude·Cum gratia et priuilegio·1558·

Gramscap doet den mont swillen / en verbittert den moet Sij beroert den gheest / en maeckt swert dat bloet
5·X·22·655

44. GLUTTONY *(Overindulgence, Voracity, Gula, La Gourmandise, Unmässigkeit, B.129, M.131)*

The original drawing, dated 1557, is in Paris, collection of Frits Lugt.

Evils arising from excessive eating and drinking crowd this composition. The print itself and its Flemish rhymed "moral" make clear that *Gluttony* includes drunkenness as well as overeating, and that both lead to human degradation. Very freely rendered, the verse warns:

> Shun drunkenness and gluttony
> when you drink and when you feed;
> For in excess a man forgets himself
> and forgets his God, indeed.

The allegorical emblem of overindulgence is a fat woman, dressed like a Flemish burgher's wife (not a "monk," as Adriaan Barnouw stated). She gulps wine from a pitcher. A drinking cup, like that held by an attendant fat monster in cloak, would not allow her to guzzle fast enough. So the monster must impatiently wait for a "refill."

Dame Gluttony squats on her symbolical beast—a sinister hog with ears and hind legs like a donkey. He too has gorged—on turnips and carrots. And on the overturned feeding tub next to him, the engraver has inscribed the credit to "brueghel" as designer.

Other guests cram their guts at the table with Dame Gluttony. Two naked fat humans swill wine, encouraged by monstrous drinking companions. The naked female's belly is so big that she appears pregnant.

After-effects of such indulgence are expiated by another human; he vomits abundantly over the bridge (left) while a beaked demon holds his forehead. The vomit pours down, to the horror of another immersed in the stream below. For an old soak, this is a torment saturated with poetic justice.

In a dark corner under the bridge the upper part of a face projects above the polluted stream. An egg is balanced on the head. The egg appears again and again, either entire or empty and broken, always to symbolize sinful situations.

Another balancing feat is performed by the monster crawling and eating on the bank, just to the right: an enormous head, supported only by arms, a bowl and spoon balanced atop its hat.

At the extreme lower right corner lies the monstrous fish-eater, his stretched belly split and laced together. In Bruegel's world, overeating often took the form of too much fish.

Near the fish-monster's tail, a devil-dog jumps up to snatch food and drink from a tray on the back of a fat demon, dressed like a butcher.

Back of Dame Gluttony's table is the inevitable ruinous shed or tent. It partly shelters a huge wine barrel. A fat man-monster uses pitcher and drinking cup to guzzle from its head-hole as fast as he can. His garments have monastic suggestions.

Above the tent rises the familiar dead sin-tree. A bagpipe is draped in its crotch. This too betokens gluttony, for its bag is a fat belly. A basket-cage hangs from a branch. Creatures, seemingly birds, are pent inside. Plucked chickens hang from the ridgepole.

A giant in human form is imprisoned on the left in a building from which his head emerges. His head is pierced by a shaft carrying spiked wheels. He is thus forced to look at the guzzling and feasting he now cannot share. Horror and desperation are on his face, especially in the original drawing.

At the upper right, a human head forms a monstrous windmill. One eye is a mullioned window with broken panes. This symbol, suggestive of some twentieth-century surrealism, appears elsewhere in Bruegel's prints, notably in the "Temptation of St. Anthony."

Bags of grain—or possibly sacked humans—are carried up a ladder to be ground in this man-mill. It never ceases its mechanical mastication. Atop the head perches a motionless owl, watching all.

On the banks of the stream of iniquity below appears one of the most horrible examples of compulsive eating: the man too fat to walk unaided; he must trundle his monstrous abdomen in a wheelbarrow. Other groups of men and monsters illustrate the theme alongside and in the stream.

At the right, and nearer, the legs of a man thresh vainly out of a wine barrel. He has been caught, seemingly for all time, in the symbol of his vice. Another sinner on his knees is supplicating to be spared such punishment. Comparison of these two naked figures in the print and in the original drawing shows that the engraver eliminated genital details from the original design.

Conflagrations, so common in the backgrounds of the *Sins*, rage here also. On the left side of the bank a fire heats a great stewpan into which men reach from a boat. Behind them and to the left of the man-mill, sinners are driven by demons into a sort of tower-oven to be cooked or smoked.

Translation of Latin caption: Drunkenness and overeating are to be shunned.

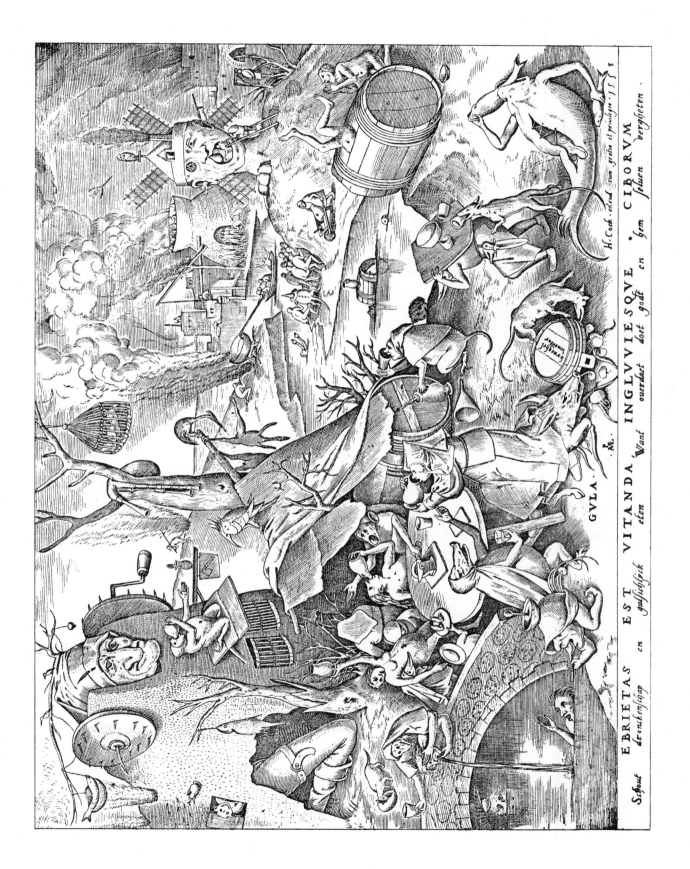

GVLA . .Ht.

EBRIETAS EST VITANDA INGLVVIESQVE CIBORVM

Schout dronkenschap en gulsicheyck etem Want ouerdaet doet god en hem seluen vergheten .

H. Cock excud cum gratia et priuilegie 1558

45. LECHERY (Unchastity, Lust, Luxuria, La Luxure, Unkeuschheit, B.131, M.133)

The original drawing, in the Royal Library, Brussels, is dated 1557.

"Sexual Excess" might be a more precise title than any of those in the four languages above. This sin, to Bruegel, like Gluttony, is an enslavement through overindulgence. The sin lies essentially in the physical excess. This is not, in other words, a pictorial polemic for celibacy or absolute chastity, any more than "Gluttony" was a preachment against ever eating or drinking.

The Flemish verse below the engraving, freely translated, declares:

> Unchastity stinks; it is drenched with dirt;
> It weakens men's bodies and does them hurt.

More literally, it weakens a man's fibres, and undermines his powers. It unmans a man.

This is symbolized with shocking sharpness by the face-muffled figure near lower right. He is caught in the act of self-castration. His right hand holds an amputated phallus; his left, a long knife, about to cut again. On one of his feet perches a demon bird. A garter or sling dangles from the ankle.

Lady Lechery herself is a naked woman being debauched by a throned monster. He tongues her open mouth and fondles her breast. One of her hands is around his shoulder, the other at her genitals. Demon beasts surround them in their dead hollow-tree "love nest." One of the fiends waits to serve them from a flask—a love-philtre or aphrodisiac.

Behind the throne, a composite animal-human lies on its back, a huge tail projecting phallus-like between its legs. Atop the throne sits the cock, symbol of insatiable lechery.

Directly below we see one of Bruegel's most indelible nightmare conceptions: an open-mouthed head with upraised arms. It is at the same time, and unmistakably, buttocks, vaginal opening, and legs. This animated obscenity spills over its hair the contents of a great egg through which a knife is thrust. (The egg then, like the oyster today, was regarded as an aphrodisiac or provender for potency.)

Just above, a pair of winged monsters copulate like cats. At the far right, two dogs couple, while a monster raises a club, about to strike them down in the very act.

The hollow tree itself takes the form of an antlered stag. (Possibly a play on the concept of cuckoldry?) In the stag's mouth is an apple; other apples are on branches. (The apple of original sin, perhaps?) At the treetop is a strange love-bower. Its counterpart will be found in paintings by Bosch. A partly opened monster mussel or oyster grasps a bubble or glass sphere; inside, a naked human couple embrace. Barnouw suggests that this means the delights of love "are as futile and transitory as the colors of a soap bubble."

A monkey—another beast associated with unending lechery—lowers a lamp or container from near the hinge of the giant bivalve.

To the left of the tree marches a horrible procession, headed by a monk playing the bagpipe (here, as so often, the symbol of sinful indulgence). A naked human is being ridden on a horselike monster. He is an adulterer, as revealed by the writing fastened to his hat. He is being publicly punished, as adulterers sometimes were in Flemish villages. In the procession behind him march a naked man and woman, probably also guilty of illicit intercourse.

Near the lower left corner, an animal demon points out the spectacle to a human sinner seated beside him.

Examination of the original drawing shows a significant change or censorship in the engraving. The adulterer in the drawing wears what is unmistakably a bishop's mitre. In the engraving this has become a noncommittal and nonecclesiastical hat. Probably even in 1557, before the full fury of the Inquisition struck the Netherlands, it was unsafe thus to link the hierarchy with adultery and public punishment.

A meandering stream flows through the middle ground from the left background. It is a stream of sin, flowing past the fountain of lechery and pleasure bowers where clandestine couples meet and indulge their lusts. A naked woman wades in the stream, immersed in water above her genitals.

The stream has come from a mill. In the water near its turning wheel a couple stand with upraised arms. The mill itself in the engraving shows another alteration from the original drawing, in which the mill roof was made to form a face along the right edge where a trapdoor seems to be opened. This anthropomorphic detail was missed by accident or omitted on purpose.

A snake-tailed bird-monster hovers in the sky. On the skyline we see the expected fishing boat and the traces of a fire far down the horizon.

To the right of the hollow tree stand a castle and some humanoid structures. In one, a ravenous shark or pike (of lust?) has leaped up from the moat and crushes one of a number of horror-stricken sinners.

Near the lower left corner, scatology and lechery combine: a human squats to void his bowels, aided by the beak of a demon-bird. Above them a monkey-monster rolls on its back, lewdly flaunting anus and genitals.

A grinning monster at the lower right wears the characteristic crescent-shaped headdress regarded in Bruegel's day as the sign of the procuress or female pander. A similar headgear is visible on a figure seated near the fountain of lechery.

Beasts scattered throughout this lecher-land—peacocks, swans, sheep, dogs, monkeys, etc.—are all associated in Flemish folklore with lechery. The symbolic "language of beasts"—as developed in its day as the "language of flowers"—assigned, for example, to the swan the idea of Vanity. This vice was linked closely with lewdness and whoredom. And so on.

Stridbeck points out that this "Lechery" engraving contains, relatively, fewer hellish or infernal elements than others in the *Sins* series. In fact, some of the infernal "props" have been replaced by the pleasure dome, the garden of fleshy delights, the meadows of fornication and the fountain of lechery, etc.

But even here—near the upper right corner—sinners are stewing on the hot seat. As they are devoured in life by the fires of their uncontrolled lusts, so here in the symbolic world of their moral degradation they seethe and suffer in an unquenchable blaze.

Translation of Latin caption: Lust enervates the strength and weakens the limbs.

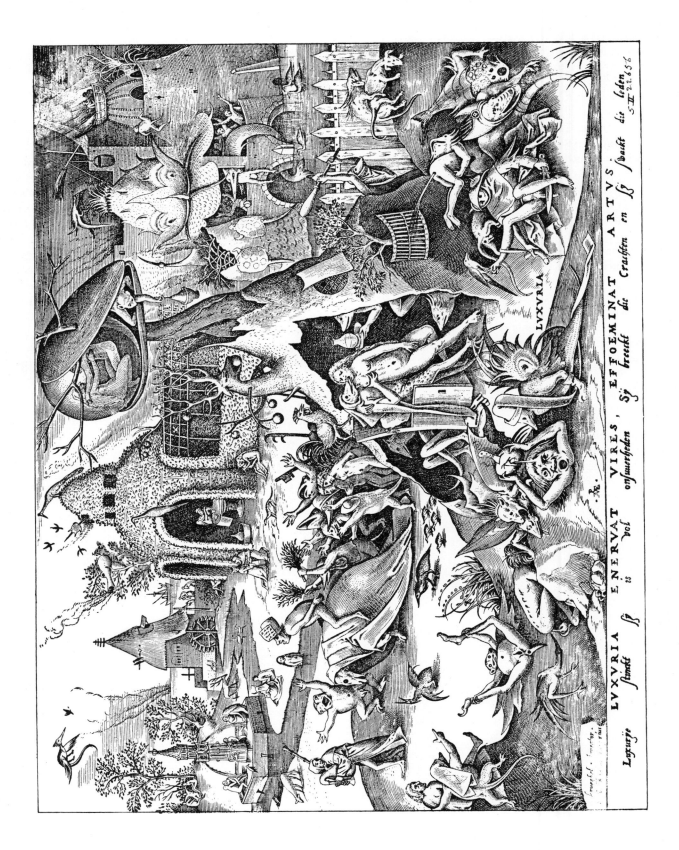

46. SLOTH (Laziness, Indolence, Desidia, Accidia, Pigritia, La Paresse, Trägheit, B.126, M.136)

The original drawing, in the Albertina, Vienna, is dated 1557.

Many a modern must find this not only the most passive and negative but in many ways the most haunting and shattering of Bruegel's seven *Sins*.

It symbolizes the evils of the vice which was treated with more irony and folksy fantasy in "The Land of Cockaigne," reproduced as Plate 32. In that print, Plenty has destroyed ambition, energy, activity. Here, Sloth herself, older and uglier than the other allegories, sleeps open-mouthed in a landscape of delay, decay, and ultimate impotence.

She reposes on her beastly counterpart, a sleeping ass. A monster behind her adjusts her pillow. Around her crawl huge snails. Even the hill of Sloth is soft as shown by a winged demon sawing into it at left. One art historian sees the saw as a suggestion of Dame Sloth's snoring as she sleeps. Another regards the sawman as a symbol for malicious gossip, his mouth ever open as he cuts away the ground from under others.

From the right, a stork-beaked monster in monk's garb drags a sinner too indolent to leave his bed; he eats as he lies. The counterpart of this monk, Tolnay finds in Bosch's "Temptation of St. Anthony" painting (Lisbon). At the lower left, on a nearer hillock, crawls an all-head-and-feet monster, dragging a tail half fish, half branch. A hollow tree, farther left, contains a great pig's head and provides a perch for a demon bird.

The hollow-tree symbol is extended enormously to the right of Dame Sloth. In this shell-like structure mingling building and tree, naked sinners and monsters sleep around a table. A couple lie together in bed behind a curtain. The demon leers around it as he seeks to draw the sleeping girl inside. Sloth or excess leisure encourages lechery. An owl, again, looks down cryptically.

Dice on the table to the left of the owl refer perhaps to gambling by lazy time-wasters. A man, caught in a great clockwork above, strikes a bell with a hammer. Tolnay reads this as a kind of pun,

for in the Flemish *lui* signified both the verb "to ring" (as a bell), and the adjective "lazy."

The idea of clock and time a-wasting appears again at the upper left. Like some effect in a Jean Cocteau motion picture, a human arm points to 11 o'clock. The lazy leave things till the eleventh hour.

And catastrophe lies behind—a blaze is burning up the broken structure, filled with dead branches.

A little to the right, just below the top margin, a mountain top with human face spouts smoke. A little farther to the right an enormous slug raises its feelers into the sky as it crawls through a stone arch. On its neck rides an almost unreadable strange distortion: a monster with a shaft (candle?) instead of a head.

Below, just above center, a squatting giant, built into a mill, enacts a proverb common to many a culture: "He's too lazy to shit." The faceless midgets in the boat behind him are inducing a bowel movement with poles and pressure. Another owl looks through a small square window in the roof above this operation.

On the bank, somewhat to the left, two demons drag into the water of sin a woman almost hidden inside a seething hollow egg, which looks also like a beet or turnip.

References to many other Flemish proverbs have been shown or suspected.

Basic to the complicated spectacle as a whole is the thought in the Flemish rhyme below the print. It is roughly rendered in English thus:

> Sloth weakens men, until at length,
> Their fibres dried, they lack all strength.

In short, sloth, far from resting, recuperating and rejuvenating, wastes a man away, renders him impotent and good for nothing. He becomes like a slug, a slave of the stupefied tyrant, Dame Desidia.

Translation of Latin caption: Sloth breaks strength, long idleness ruins the sinews.

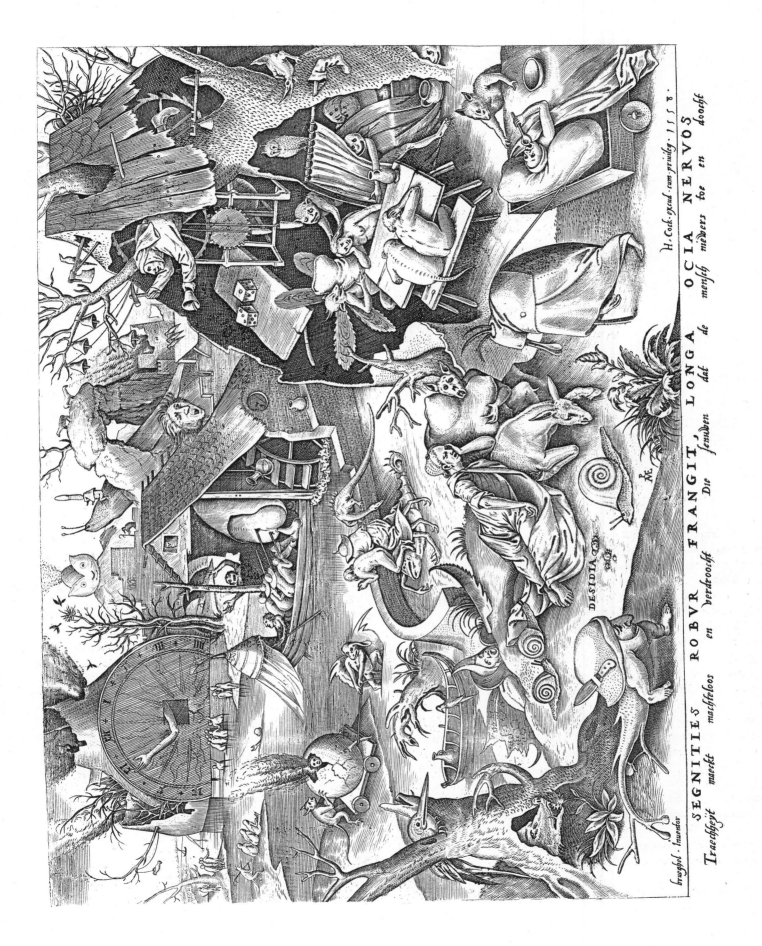

brueghel . Inuentor SEGNITIES ROBVR FRANGIT, LONGA OCIA NERVOS H . Cock . excud . cum priuileg . 1558 .

Traecheyt maeckt machteloos en verdrooft Die sennden dat de mensch midders toe en doorsf

The
World of the
Seven Virtues,
Plus One

"Patience" is the "plus one" referred to above. It is placed first in the following section, for though it is quite clearly a "virtuous" subject, it is nevertheless not part of the subsequent series of *Seven Virtues*. In terms of its devil-drenched treatment, its date (1557), and its engraver (van der Heyden), it conforms to the pattern set by the earlier *Sins*, already presented.

"Patience," we may assume, was a sort of transition between the seven *Sins* and the seven *Virtues*. One may speculate in this way: after the *Sins* were successfully completed, Publisher Cock suggested that Bruegel design something similar, representing, perhaps, the "other side" of the ethical struggle; hence "Patience," which was given to the same engraver to put on a copperplate. However—and here we continue to conjecture—the patrons of Aux Quatre Vents wanted still more. What more natural then than to launch the full series of seven *Virtues*?

Whatever the story lost in unrecorded history, Bruegel in 1559 and 1560 made the seven *Virtue* drawings. These originals, it is good to record, are all preserved in our own day in the collections or museums indicated in the following comments. The engraver was not van der Heyden but, in all probability, Philippe Galle, most subtle and resourceful of the engravers who worked from Bruegel originals during the master's lifetime.

These seven subjects are sometimes called *The Seven Cardinal Virtues* as counterparts or opposite numbers to *The Seven Deadly Sins*. Quite strictly speaking, this is not correct. Actually, the *Virtues* fall into two groups: the three "theological" virtues and the four "cardinal" virtues. Faith, Hope, and Charity are the "theologicals," so called because they were set forth in the New Testament, and so can be considered to have come direct from God through his spokesman. The medieval fixation on numerology and symmetry, however, demanded there be seven virtues as well as seven sins. So the "cardinals" were added. They differ somewhat depending on what list is consulted. However, as drawn by Bruegel they comprise Justice, Prudence, Fortitude, and Temperance.

How does Bruegel approach the *Virtues*, graphically?

Formally, his original drawings are here similar to those for the *Sins*. The allegorical female is prominently situated at front center; she is surrounded sides and back by groups and individuals illustrating in action the named quality or virtue. A motto engraved below sets forth the "official position" of the engraving— or its publisher—with respect to the moral sentiment to be absorbed by the viewer.

Yet there is a fundamental difference here, as previously hinted. Excepting only the special case of "Fortitude," none of the seven *Virtues* includes devils in its cast of characters. The macabre is missing. No nightmare monsters, no delirium tremens com-

posites, no animated impossibilities counter to anatomy, morphology, and observation.

Instead, the six *Virtues* soberly and painstakingly picture situations which may—to modern eyes—seem drastic or deplorable; yet the actors are all "normal" men, women, and children; and their actions, though unnaturally juxtaposed, are not "out of this world."

How did Bruegel conceive these *Virtues*, psychologically?

The answer cannot be quite as simple as one might wish. Bruegel lived in a period far from simple or placid; and he was obviously not one of its simpler spirits. Hence, in his *Virtues*, as in so many other engravings, ambiguity of meaning may walk hand in hand with mastery of means.

See especially such subjects as "Faith" and "Justice." "Faith" shows slavish, superficial church ceremonials, heavy and uninspired rituals, a creed seemingly imposed from outside. Participants appear to lack sense of communion and uplift. "Justice" is replete with legalistic tortures and punishments. They deserve to be described as both cruel and unusual from a present-day viewpoint (if one can conveniently overlook what was done by the Germans during the days of Nazi rule, and forget Hiroshima and Nagasaki, also). Sadism seems to run rampant, systematized and administered by an elaborate state establishment.

Are these pictures then intended as travesties? Did Bruegel seek to satirize the emptiness of Faith within the Church, the mercilessness and savagery of Justice within the State? Tolnay thought so. His reading, especially of the two subjects just cited, seemed for some time quite convincing to the present writer. Consequently, there seemed little merit in the views of Adriaan Barnouw, who sees the *Virtues* as illustrations of their titles—composites of human actions or attitudes which were both necessary and commendable.

Restudy of the engravings and their critics, in the preparation of this book, led to a view somewhat midway between Tolnay's and Barnouw's. Again Grossmann and Stridbeck's writing contributed to a sort of synthesis. It seems now that the *Virtues* must be conceived neither as harsh satires, nor as representations in which all that occurs is divinely and utterly right.

For example, with "Faith":

In the same composition we see around the allegorical figure the mementoes and symbols of the Passion of Jesus. These, undoubtedly, represented to Bruegel a true and valid Faith. It would be difficult to assume as much for the figures of the priests as he has drawn them, performing the marriage and preaching to the congregation, etc. Yet it is not needful to assume that this engraving was essentially an open or disguised attack on the Church of that time. Coornhert—already referred to—and other "Spiritualists" and "Libertines" of that era—took a rather dim view of the Church and of all forms of creedal organization. Though he did not break openly with the Church, he was "tolerant" or indifferent toward it. Sacraments of the Church, he held, were all right for those who wanted them, but certainly not essential. In practice, he recognized solely the authority of the Gospels, whose climax is the Passion story represented in the center of the engraving. What really mattered was the inner relationship between a man and God, between a man and God's message incorporated in the Gospels—and this relationship could not be mediated or assured by any "third party," not even by the priesthood and hierarchy of the Church. Coornhert was called "a Catholic but no Papist."

Bruegel cannot be conceived of as flouting or mocking Faith itself, even when he graphically portrays what must be considered a "dim view" of the formal observances of the Church. And similarly, he does not sneer at the ideal of Justice, even when depicting its utmost rigors.

In the discussions which follow of the individual *Virtues*, the viewpoint may not be completely consistent throughout. The engravings themselves, rather than any suggested commentary, must in any case take precedence.

47. PATIENCE (Patientia, La Patience, Geduld, B.124)

No original drawing survives.

The engraving, dated 1557, is by van der Heyden, published by Cock.

This print stands alone, yet is related both to the *Sins* which precede it in this book, and to the *Virtues* which follow. Like the seven *Sins*, it makes use of diabolical, monstrous, and fantastic creatures; yet the subject, Patience, manifestly is not a vice, but a virtue—even if not one of the seven cardinal virtues.

Patience is seated, in the customary place in the center foreground. She is drawn somewhat smaller in proportion to the entire composition than the allegorical figures in the *Sins* series. She has no symbolic animal near her.

Seated upon a block of stone to which she is shackled, Patience clasps her hands in prayer, holding a cross. She raises her eyes to the sky as if to say: "Heaven, give me patience to endure all this."

And indeed she has much to be patient about. The scene is alive with trials and menaces. It is crowded with symbols and charades indicating the evils that beset the patient person. In a sense, Patience is assailed by trials deriving from most if not all of the seven *Sins*. In this respect, and in the general organization of the composition, this print may be compared with the "Temptation of St. Anthony," reproduced as Plate 59.

Enormous, at upper left, looms the fantastic egg-man, a multiple monster. Various symbolisms combine here. The rider wears the garb and hat of a cardinal. A dead tree grows out of his back. His legs project through the empty eggshell which signifies folly, or its equivalent, sinfulness. The egg itself has a head, which is on fire. As this steed crawls on all fours, its posterior has been broken open. A crowd of men, with ladder and huge knife, are crawling inside.

Both are hollow—that is to say, rotten, empty, void, sinful— the egg-man who serves as horse, and the tree-man who acts as his rider.

The keys of Saint Peter, symbol of Papal authority, decorate the cardinal's hat. Into his belt is stuffed a Papal document— probably an indulgence. It is difficult for this writer to read this dominant double monster as anything but a drastic attack upon the state of the Church of Rome. Or perhaps it would be more accurate to name it as the Church of the hated Spanish rulers of the Netherlands.

The cardinal-monster gazes out, away from the burning church at the left. Fish-monsters fly and plunge in the sky above. Below, a loathsome toad tries to crawl up the side of the egg-horse.

Near the right rear foot of that creature, a demon beast has downed and is devouring a soldier, whose crossbow lies on the ground. Another crossbow lies useless on the bank at the left.

The water is crowded with diabolical craft and conflict. A strange fish-boat has hoofs or swimmerets instead of oars like a galley. Nearer, a marine jousting contest on a duck and fish results in the fighter at the left poking his lance into the posterior of the one at the right. Farther left, a man with abdomen bloated to balloon-like shape floats near the bank, a bird perched on his belly-button, and a monk holding above him a switch of dry twigs. Still farther left, on a horse, an idiot town crier or scholar reads from a document in his hand. His horn hangs about his neck.

Obviously souls in need of succor are not getting it.

Also in the water, a man drowns. Not far from him, on a raft, floats a monkey-monster who balances a lute with its feet, while exposing its anus and genitals. It is a first cousin to the exhibitionist monkey seen in the "Lust" print.

On the bank nearer to Patience herself are figures which may well refer to symbols already seen in the "Anger" print. A fat monster (Gluttony?) feeds a bird perched on the bent back of a one-legged knight, whose spiked shield is assailed by a sword-bearing monster with a long beak. They may well refer to Anger or strife of some sort.

Looking past other enormities, we find at the lower right a great fish, cut open. A demon peers out of the dark belly. On top, a dog steals wine from a table which bears a knife. (Reference to Gluttony?)

The inevitable hollow, dead tree is crowded with symbols of sin from rotten roots to twisted tip. A dance of men and demons goes on below, the fiddler projecting at the left side of the tree.

Jugs are mounted a little higher (perhaps Gluttony again). And on a round platform near the top occurs some lofty Lechery, as the lutanist entertains a lovely court lady at the left, and a drinker taps a barrel at the right.

The owl higher up looks mysterious and a little silly, also as usual.

Near the foot of the tree, at the right, a bird is roasted on a smoking spit, while a winged demon reaches round the screen. This diabolical reaching around or reaching out from a concealment occurs more than once in Bruegel's infernal fantasies. It bears comparison with his penchant for completely or partially concealing facial features or the entire heads of human characters. After all, nothing is quite so sinister as the obscure; nothing so hauntingly horrible as the hidden; nothing so suggestive as the incomplete.

Farther back on the bank, a bird-monk walks carrying a harp, and just over the hill a demon tolls a bell.

On the water at the right another nightmare galley is rowed by out-growing swimmerets. The vessel has a domelike canopy or deckhouse, and seems to tow a rowboat containing a horse.

Still farther back, the sun sets on this entire riot of sin and folly. But the allegorical lady still sits on, like Patience on a monument, looking upward for strength, if not succor.

Translation of Latin caption: Patience is the tranquil endurance of evils that assail you through malice or through accident (from Book 5 of the *Institutiones Divinae* of Lactantius).

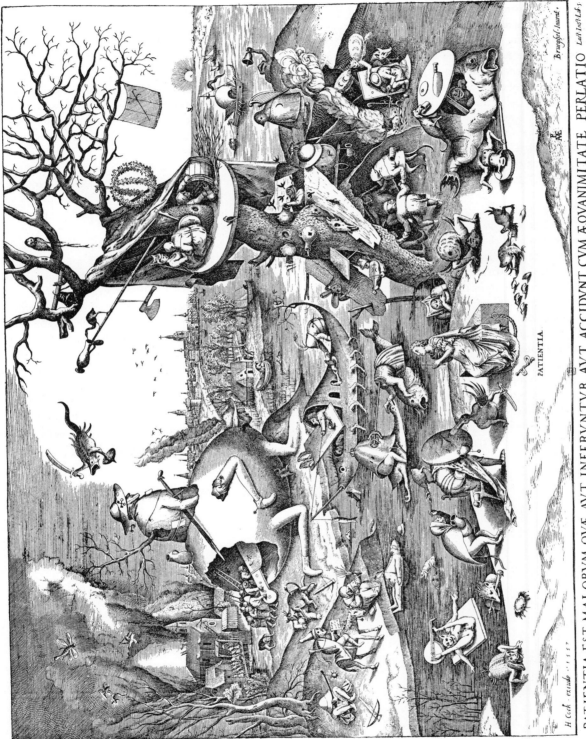

PATIENTIA.

Brueghel . Inuent .

Lau Ins Fl . f 5

PATIENTIA EST MALORVM QVÆ AVT INFERVNTVR AVT ACCIDVNT, CVM ÆQVANIMITATE PERLATIO

48. FAITH (Fides, La Foi, Glaube, B.132, M.142)

The original drawing in the Rijksmuseum, Amsterdam, is signed "BRUEGEL" and dated 1559 by a hand not Bruegel's.

The Latin motto at the bottom affirms: "Faith above all is to be preserved, particularly with respect to religion, for God comes before, and is more mighty than, man."

Faith, garbed like a nun, stands on the lid of the open tomb which contained the body of Jesus. All around her are the objects named in the Gospel story of the crucifixion of Jesus. On her head are the tablets of the Law of Moses, indicative of the Old Testament. In her hands she holds, and points to a passage in, a volume of the New. Faith personified thus symbolizes the Gospel message, which Coornhert and the "Spiritualists" held to be all-important, as against the essential unimportance of the forms and ceremonies of a creed.

"The rest of the scene," Ebria Feinblatt notes, "is held to be rather a satire on churchly cult, or outward ceremony, as Bruegel, in keeping with the Libertinism, or Spiritualism, of his time, stressed the need for personal and direct communion between man and God, without intervention of the church."

Back of Faith the sacraments or outward ceremonies are shown, in the interior of a great church that stretches far behind.

At the upper left a child is baptized. Closer, still at the left, communion takes place at the altar. The priest extends a wafer to an open-mouthed communicant. Nearer still, a wedding is performed. In the background just left of center, a confession takes place, At the right, in the church nave, a congregation sits listening to a sermon.

Images abound in this church. Tolnay points out that "on every pillar there is, if possible, a religious statue or devotional picture, and at the altar . . . the donor and his wife have also had themselves immortalized by small statues."

The seeming apathy of the congregation is emphasized by the same critic: they are "heavily bundled up, each one withdrawn into his own snail-shell." Individuals are observed—"One man yawns, another has fallen asleep, one woman grins: the Word passes by."

Turning to the original drawing for the scene of the sacrament of marriage—in face and figure the priest appears gross and coarse. Some of the wedding party look stupid and vulgar. The engraver has made them appear slimmer, more dignified. In the original drawing there is far more of caricature in the faces of the women listening to the sermon, than in the engraving as shown by the print. The engraving, whether purposely or otherwise, has watered down the element of discrepancy between the purposes and the realities of the church observances.

Faith herself bears on her shoulder a haloed phoenix, symbol of resurrection from death.

With utmost devotion to detail and complete knowledge of the Gospel story, Bruegel has placed around Faith every relevant object identified with the crucifixion. The cross itself stands behind her; against it lean the ladder and the spears of the Roman soldiers. The thorn crown and the veil with the imprint of Jesus' face are there also.

In the foreground from left to right are the whipping post and lashes, the rooster who crowed for the disciple Peter, the basin in which Pilate washed his hands, the seamless cloak and the dice with which the soldiers cast for it. On the tomb are the ointment flasks of the Marys, the hammer used in the crucifixion, and even (alongside) Judas Iscariot's thirty pieces of silver, scattered upon the floor.

The immediacy of the dramatic story symbolized here suggests a different and more basic kind of Faith than the formal observances in the church environment elsewhere in the print.

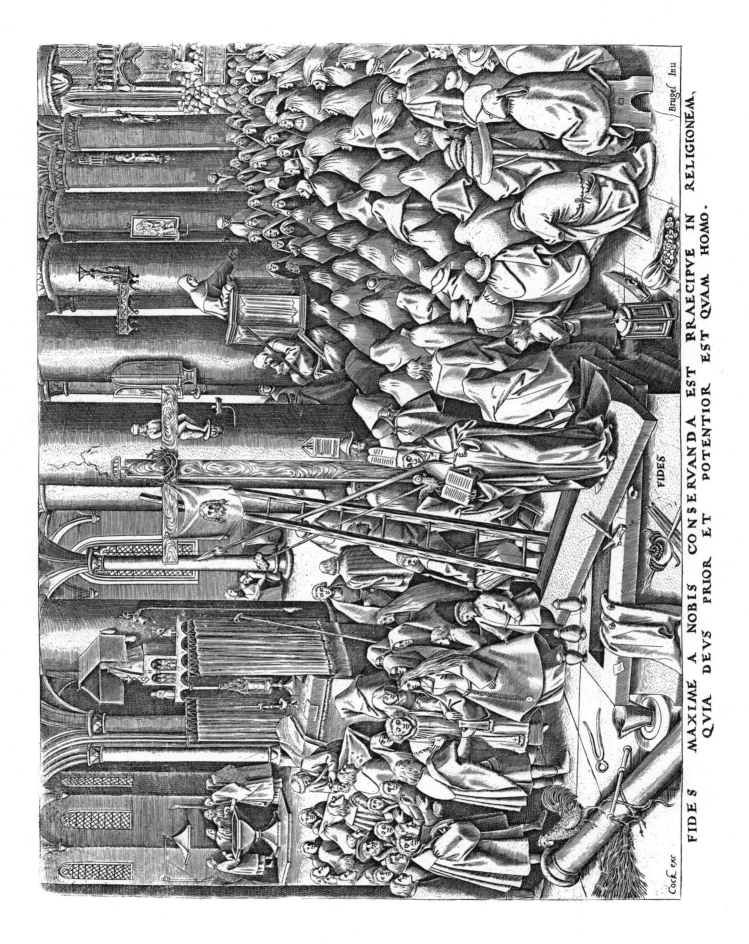

Cock exc

Brugel Inu

FIDES

FIDES MAXIMÆ A NOBIS CONSERVANDA EST RRAECIPVE IN RELIGIONEM,
QVIA DEVS PRIOR ET POTENTIOR EST QVAM HOMO.

49. HOPE *(Spes, L'Espérance, Hoffnung, B.133, M.145)*

The original drawing, in the Kupferstichkabinett, Berlin, is signed "Bruegel" and dated 1559.

The allegorical figure, Hope, stands on a large anchor on a raging "sea of troubles." She holds in one hand a spade, in the other a scythe; a tall beehive serves as her headgear. These are tools used by men whose work is especially subject to risk, and whose hearts are hence filled with hope for a favourable outcome— the peasant (farmer) and the sailor or fisherman.

These tools were the special symbols of Hope as depicted in medieval allegories, Stridbeck points out. Hence Bruegel reached back to symbols traditional long before his time.

The Latin motto below the picture sets the tone for the whole: "The assurance that hope gives us is most pleasant and most essential to an existence amid so many nearly insupportable woes."

The face of Hope in the original drawing wears a smile that fits well the thought of a "most sweet message." The engraving, however, gives her an expression far less comforting and less "involved" with the fate of the poor human hopers.

On sea and land a multitude of "almost insupportable woes" are taking place. The storm-lashed sea wrecks a ship at the right. One sailor, already overboard and riding a plank, stares into the open jaws of the fish who swims up to swallow him. Another castaway, on a segment of broken mast, floats to the left of Hope. He hopes to survive somehow. Still another struggles unaided, somewhat to the right of the beehive hat. He stretches his arm toward the seawall, which he hopes to reach alive.

The foundering boat at the lower right has three despairing sailors still aboard, and another who clings exhausted to the gunwale near the prow. Fear makes the hair stand out on the heads of the sailors in the prow and of one who clutches the stump of the shattered mast. A man between them raises his hands toward heaven in hope of miraculous aid.

In another wrecked boat farther back, a sole survivor shinnies up the breaking mast, while a great whale or pike leaps out of the water to get him.

Beyond that, the storm wrecks a far larger vessel—a carrack or galleon like those we have seen in the series of stately ship prints reproduced in previous pages. The mainmast has broken and a couple of sailors have taken to a rowboat. They hope to make their getaway alive.

A prison tower or donjon keep stands at left. Inside, below, prisoners sit shackled and locked in stocks. They hope and pray for release. In the window above faces of two prisoners are seen. (The original drawing shows four faces there). A bottle or pitcher hangs by a cord from this window.

A hooded falcon is perched on a prison window below. Barnouw writes that he "stands hopefully waiting for the lifting of his hood."

To the right, a pregnant woman stands praying on the seawall, probably for the safety of her husband and the welfare of her child to come. Next to her is that most hopeful of mortals, a fisherman. He supports his hopes by using three rods and lines at a time.

A house is ablaze at the upper left. The local bucket and ladder brigade seek to douse it with whatever water they can bring up. They hope to put out the fire before all is lost.

In the background, right of center, labor men whose futures depend almost wholly on realization of their hopes—tillers of the soil. And in the sky at the right the crescent moon shines. A dozen sailing vessels of various sizes ply the sea at the horizon. Each carries its cargo of men's hopes.

At first sight this print may seem an instance of bitter irony: Hope stands blandly, calmly, holding her symbols, while behind her men suffer all manner of catastrophe, loss, and misery. Yet it is clear that to Bruegel and the ethical point of view he represented graphically, Hope was what gave men strength to hang on somehow "amid so many nearly insupportable woes." One hopes that *despite* the disaster one will come through somehow.

Without the woe—imminent or eventuated—what would be the meaning of hope? There has to be something one hopes to overcome or survive or get away from.

The allegory here does not identify Hope with selfish ambitions or unsanctified aims of men. This is not the hope of a man who wants most awfully to succeed in snatching another's purse, seducing his neighbor's wife, or quickly acquiring a royal title. It is the Hope that somehow supports existence amid seemingly insupportable woes, and the more terrible the trials, the greater the hope needed to survive them.

At wit's end perhaps all will be lost "save hope."

The *hope* of this print seems a sort of opposite or antidote to *despair*, the sometimes tempting surrender to hopelessness. Despair and hope are confronted in the opening lines of Gerard Manley Hopkin's great poem, "Carrion Comfort":

> Not, I'll not, carrion comfort, Despair, not
> feast on thee;
> Not untwist—slack they may be—these last
> strands of man
> In me or, most weary, cry *I can no more.* I can;
> Can something, hope, wish day come, not choose
> not to be.

So even in the ultimate extremities, the men in this picture "can something, hope."

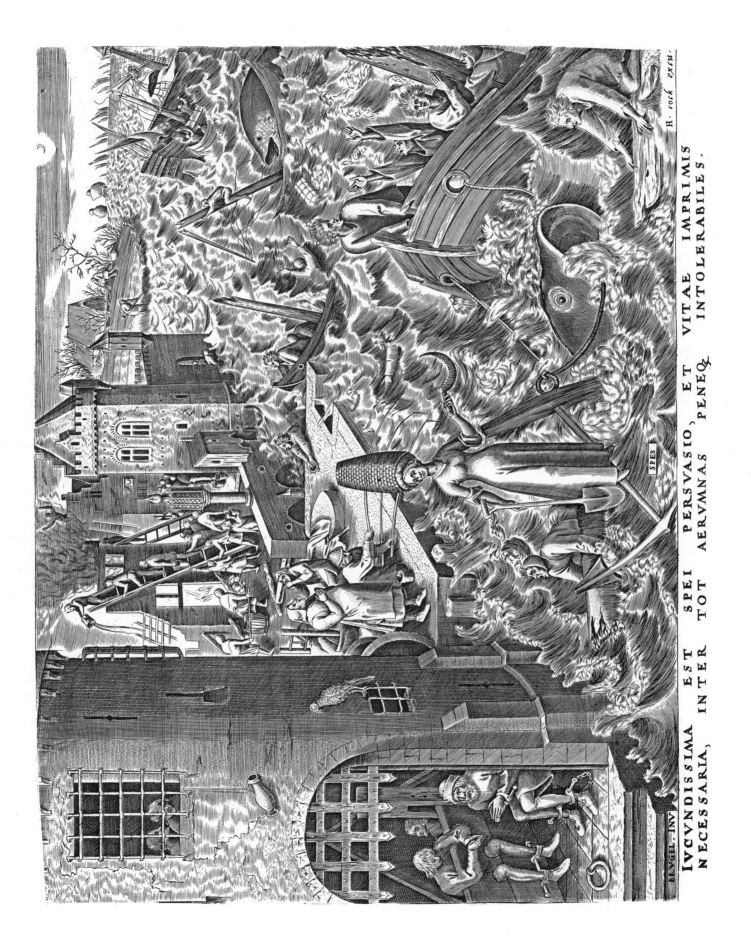

BRVGEL. INV

SPES

H. cock excu.

IVCVNDISSIMA EST SPEI PERSVASIO, ET VITAE IMPRIMIS
NECESSARIA, INTER TOT AERVMNAS PENEQ INTOLERABILES.

50. CHARITY (Love for One's Fellow Men, Charitas, La Charité, Nächstenliebe, B.134, M.143)

The original drawing, in the Boymans Museum, Rotterdam, is signed "Bruegel" and dated 1559.

The charity with which this print is concerned has the original, basic meaning of active benevolence: love of one's fellow men as manifested in practical acts, or good works. The years have overlaid very different connotations on our word charity. To many it means now merely a matter of "picking up the tab" for a handout to somebody who is said to need it. Even that composite word philanthropy, which meant the love of men or mankind, has become for most indistinguishable from alms-giving; and the adjectives charitable and philanthropic do duty that might better be reserved for that formidable polysyllable eleemosynary.

The allegorical figure of Charity here is a woman whose face bespeaks kindness and consideration. The warm humanity in her expression comes through even more effectively in the original drawing. She holds in her hand a heart aflame (a contrast to the allegorical figure for the sin of Envy who eats her heart out).

On the head of Charity stands a symbolic bird with two young. This is identified by Barnouw as the pelican "who feeds her starving young with her heart's blood." (The bird here in fact lacks the typical pelican beak, but its posture fully confirms this reading.) The pelican symbolized altruism.

Not aloof from the surrounding scene, Charity is holding the hand of a small child. Her contact with the children exemplifies the message of Jesus (Luke 9:48): "Whosoever shall receive this child in my name receiveth me." A garland, not readily visible in the print, crowns the head of charity—probably a wreath of olive which here symbolizes, not victory in competition, but peaceful love of one's neighbors.

The good works of charity are going on all around her. At left, foreground, the hungry are fed; at right the naked are clothed.

The half-starved eagerness of those who receive bread leaves no doubt as to their need for it. A house wall is removed at upper right, so we may see the visiting of the sick and infirm. In the house just to the left of this, a pair of pilgrims with their identifying staves are greeted hospitably. They will no doubt be lodged and fed before proceeding on their salutary journey.

In the far distance at the center, a burial takes place in consecrated ground next to the church. The coffin is lowered into the grave by two men, the only participants in the ceremony. Next to the open grave lies a sign or placard which will probably serve in lieu of a headstone or monument.

In the extreme upper left, before the wall of a prison, we may see a man and woman come to bring comfort even to the prisoners pent in the stocks. The visiting man shakes the prisoner's hand in a gesture of human fellowship.

Below the prison, drink is being given to the poor and crippled from great barrels. Most of them drink out of bowls. Because of the approach of a small boy from the right, we may trust that milk, or possibly beer—rather than wine—is dispensed here.

All the traditional "Seven Works of Compassion, or Charity" are represented here: (1) feeding the hungry, (2) giving drink to the thirsty, (3) clothing the naked, (4 & 5) visiting prisoners and the sick, (6) giving hospitality to the homeless, (7) burying the dead.

Near Bruegel's name in the lower right corner, two objects lie as if accidentally left there. One is a belt, another an empty bowl. In the corresponding part of the original drawing there is also a third object—a bundle of twigs, such as might be used for punishment. These objects, according to Stridbeck, had a relevant symbolism: the beggar's bowl—poverty; the belt—asceticism and self-deprivation; and the lash of twigs or branches—discipline, pain, suffering, etc. It is thus probably worth mention that the third object was left out by the engraver, and so is missing from the print.

Translation of Latin quotation: "Expect that what is befalling others will befall you; you will be aroused to render aid only if you make your own the feelings of the man who cries for help in the midst of adversity."

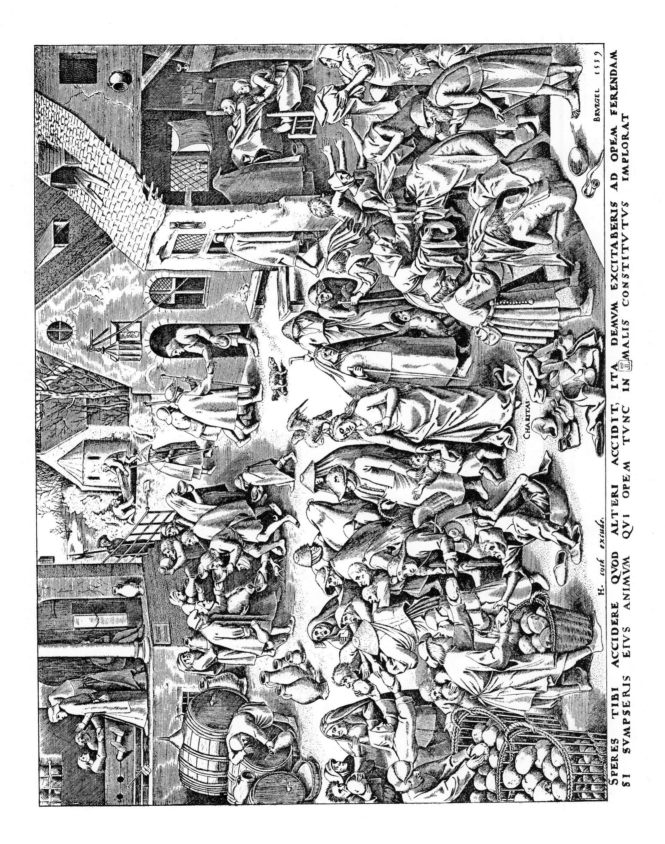

H. cock exiud.

CHARITAS

BRVEGEL 1559

SPERES TIBI ACCIDERE QVOD ALTERI ACCIDIT, ITA DEMVM EXCITABERIS AD OPEM FERENDAM
SI SVMPSERIS EIVS ANIMVM QVI OPEM TVNC IN MALIS CONSTITVTVS IMPLORAT

51. JUSTICE (*Justicia, La Justice, Gerechtigkeit, B.135, M.146*)

The original drawing, in the Royal Library, Brussels, is signed "Bruegel" and dated 1559.

This print is a social document as well as a work of art. It merits examination by sociologists, penologists, law enforcement authorities, and responsible citizens, whether or not they consider themselves art-lovers. Given the close study it deserves, it is likely to lead to shudders and revulsion, for to modern eyes this may appear a festival of sadism. To paraphrase Madame Rolland's outcry: "O Justice, what crimes are committed in thy name!"

This writer for some time considered it to be essentially a satire or travesty on what passed for justice in the Netherlands of the latter sixteenth century, but such an interpretation now seems oversimplified. The picture seems to be, rather, a serious summary, by means of allegory and representative incidents, of grim but not reprehensible social practices. Barnouw comments, "No age ever knew itself inhuman or cruel in administering justice." Such knowledge, and the protest it motivates, came always, and comes still, from a small, but saving, minority.

A further age may draw away in distaste from records of hanging, electrocution, and the gas chamber as perpetrated in the name of justice among us, some four centuries after Bruegel drew this allegory of Justice. (Unless, to be sure, the most monstrous bestiality of all—nuclear annihilation—does away with us and the future too.)

The Latin motto underneath sets the sober, sombre tone of the engraving: "The aim of law is either through punishment to correct him who is punished, or to improve the others by his example, or to protect the generality (society) by overcoming the evil."

The allegorical figure of Justice is a young woman with covered eyes, bearing in one hand a sword, in the other a pair of scales. She is not blind in the sense that a disgusted baseball fan intends when he accuses an umpire of blindness; her eyes are covered so that she shall judge without regard to the individual before her.

She stands on a block with a ring for shackling prisoners. A set of shackles lies below it.

At the left front, a prisoner is being put to the torture: he is stretched on a rack, and his feet are drawn out by a drum turned by the torturer at that end. Above him another executioner holds a flaming torch so that fiery pitch drops down on the victim's limbs. Adriaan Barnouw has written concerning executioners and judges all through this picture: "No one takes pleasure in the scene." Yet in the original drawings, this writer finds, the torch-bearer's face expresses a sort of brooding sadism, quite different from the effect in the engraving. (Again, an engraver's change which blunts the point and dulls the edge of more drastic effects in the working drawing.)

Two men pour water through a funnel into the mouth of the victim on the rack. Some critics see this as an act of mercy. The quantity of water and the swollen belly of the victim indicate rather that this is part of the notorious water torture.

By treatments of this sort the suspected criminal was induced to confess—that is, to testify against himself. Only those who had confessed were condemned to death. (Sometimes death terminated the torture, but this was regarded as "one of those things," rather than as evidence of a defect in the system.)

At farthest left stands a sixteenth-century "shorthand reporter," ready to take down the confession. The "examining magistrate" stands over him, holding upright a thorny stick. This is probably a symbol of his office rather than a tool which he uses to encourage the suspect to confess.

At the right front we see a solemn court scene. The magistrate there also holds a thorny stick. He is reading the sentence to be imposed on the convicted criminals who stand before his table. It will be death, for they have been given crucifixes to hold.

Court clerks note down everything in good legal order. (One recalls somehow the detailed, almost compulsive, record-keeping of the Nazis, large and small, in their programs of extermination of millions of men, women, and children. Everything neat, complete, and utterly final. Sadism, perhaps—but system, always. After all —*Ordnung muss sein!*)

In the middle distance at the left, the bearded executioner raises his sword while the condemned man kneels, bowing over a crucifix his head which will soon roll on the sand below. A priest at safe distance from blood pronounces a benediction.

Farther back, a criminal chained to a post is lashed with sharp bundles of branches. A goodly crowd is there as audience.

Somewhat to the right, a man is tortured by hanging, tied by the heels and wrists. Several well-dressed aristocrats, in fine cloaks and swords, look on.

Still farther right, inside an archway, a prisoner's right hand is being chopped off. Afterwards the same operation will be performed on another, who is being dragged to the butcher block by guards. This is probably a punishment for theft.

In the farther distance, against the sky, stand gallows, from which hang four corpses; also four of the horrible high wheels which Bruegel included in so many of his paintings and drawings of landscapes, based on what he saw in the Netherlands. Broken bodies of victims can be seen on three of them.

One concluding detail appears at the extreme upper left. In the words of Barnouw, it is "the Cross of Christ," which "rises above this scene of woe as a guarantee that justice thus administered has the sanction of the Supreme Judge. For its aim is not revenge but the improvement and protection of society."

A suitable commentary might be reserved for a writer like the Mark Twain of *Connecticut Yankee*, were such a one among us today.

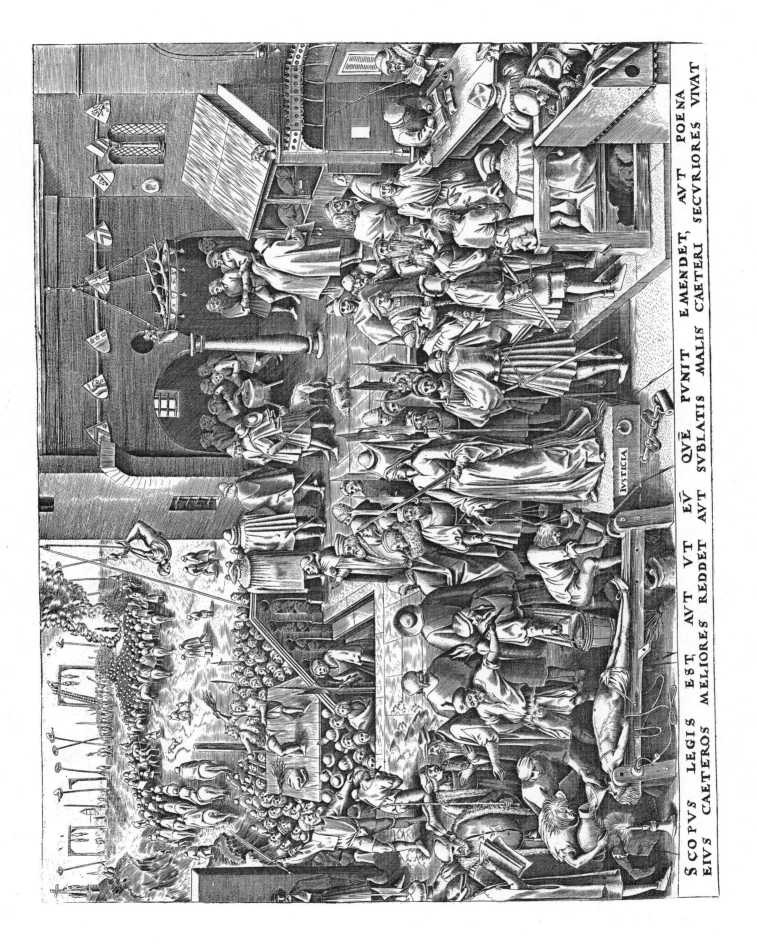

SCOPVS LEGIS EST, AVT VT EV̄ QVē PVNIT EMENDET, AVT POENA
EIVS CAETEROS MELIORES REDDET AVT SVBLATIS MALIS CAETERI SECVRIORES VIVAT

IVSTICIA

52. PRUDENCE *(Wisdom, Prudentia, La Prudence, Vorsicht, B.136, M.144)*

The original drawing, in the Royal Museum, Brussels, is signed "Brueghel" and dated 1559.

The original was quite likely one of the earliest finished of Bruegel's *Virtues* drawings, for it is the only one of the seven in which his signature is spelled with the "H." At about this time he went over to the simpler spelling "Bruegel," which he used thenceforward on all drawings and paintings signed by his own hand.

Prudence occupied a special place of honour. It was regarded as the first and most important among the four "cardinal" or non-theological virtues. Prudence, it should be understood, was not merely caution or circumspection; it was wisdom, good sense, the applied ability to distinguish between good and bad and to guide action accordingly. It was foresight in the service of virtue.

The Latin motto indicates something of the scope and special standing of Prudence: "If you wish to be prudent, think always of the future, and weigh all conceivable outcomes (contingencies)."

According to Coornhert, prudence was the prerequisite for a good life—that is, a life of goodness. This is what he had in mind when he wrote regarding wisdom: "Is there anything more worth men's striving than wisdom? . . . Wisdom is the sole mistress who can lead men to the right use of wealth, health, life itself, and also the other virtues; for without wisdom all other virtues are blind. . . . Thanks to wisdom, the wise man knows how to avoid the broad path of sin; it helps him to choose the right, straight way which leads to a virtuous life."

The allegorical figure of Prudence stands on, under, and next to objects symbolizing various kinds of such desirable wisdom: On her head she carries a sieve or colander; in her hand she holds a mirror; against her shoulder leans a long slender coffin. Each of these objects suggests a different aspect of prudence: the sieve or colander—the sifting out of good from evil, rejecting the bad, retaining that which makes for a life of virtue; the coffin—the inevitable death that awaits all men, in awareness of which they should live each day prudently; the mirror—self-knowledge.

A moral writer named Ripa, influential in the intellectual circles around Bruegel, wrote regarding the symbolism of the mirror: "Looking into a mirror represents learning to know one's self, for no one who is unaware of his own failings can judge soundly regarding his affairs."

Prudence stands on a ladder which lies on the ground. Nearby are scattered hooks and buckets. Obviously these are pieces of fire-fighting apparatus. And fire-fighting has a special symbolic meaning: for human passions are like conflagrations, raging and destroying; thus, the prudent person is one who controls or quenches the upflaring of passion before sinful action results.

In this connection another moral writer of the period, Poot, wrote: "Flame makes manifest that desire is a burning brand of the human heart and spirit which attacks immediately all in its way, if it has an appearance of good about it, just as natural fire consumes dry inflammables."

And so, in the lower left, a woman controls a fire by dousing it with water from a bucket.

The virtue of foresight or provision for the future, as an aspect of prudence, is illustrated at the lower right. Typical peasant women are preparing meats and other foods for storage. The great wooden tubs, when packed, will go into the cellar; thus plenty and well-being may prevail within the house despite winter's bitter cold.

Somewhat to the left of and behind the women, a man hoists bound twigs or branches into the barn to serve as fuel during the winter. Still farther to the left a man pours coins into a chest for safekeeping. Here, it seems, minted gold appears without the connotation of sin that we saw in the *Sins* series. This makes sense. Excessive desire to accumulate and hoard money and material things is a vice, Avarice. But precaution in protecting one's rightful possessions of money or goods is part of Prudence. Such was the view presented here by Bruegel, and such too was the view of leading theologians and ethical teachers, especially among the Protestant sects with Puritan direction.

Farther back of this group several men repair a house. Thus they prudently provide against its fall. It will be recalled that in one after another of the *Sins* subjects, degradation and moral downfall are suggested by showing sinners in shelters little better than rotten shacks or lean-to's. In view of the emphasis on cleanliness prevalent among the Dutch and Belgian people, it follows almost as a matter of course that order is Heaven's first law, cleanliness is next to (and even part of) godliness, while decay and disrepair are basically disreputable.

Still closer to the horizon a dike is repaired so that it may not crumble and let the ever-threatening sea inundate the land. On the other side of the stream—on which floats a fishing boat with sails prudently trimmed to catch the breeze—stands a church. Here Prudence may walk hand in hand with divine Providence.

At the left a man lies in bed seriously ill. Providently he has summoned a medical doctor and a cleric. The former examines the sick man's urine in a flask; probably the prognosis is poor. The cleric is taking the sick man's last will and testament, or possibly is administering to him a last sacrament. In either case, the sick man's action represents prudent conduct, for he has weighed the ultimate and final contingency—the certainty that awaits all mortals. And he is acting in accordance with what wisdom suggests.

One last detail—a delightful one—in the lower right corner. In a bowl of gruel or porridge the spoon stands up straight. Says Adriaan Barnouw, out of his great knowledge of the folkways and folksays of the Netherlands: "That is an allusion to a popular Dutch ditty expressive of one's joy in knowing his tomorrow secure." And such is the fruit of Prudence, in the sense suggested by this print.

Plate 52 is reproduced by permission of Mr. and Mrs. Jake Zeitlin, Los Angeles, California.

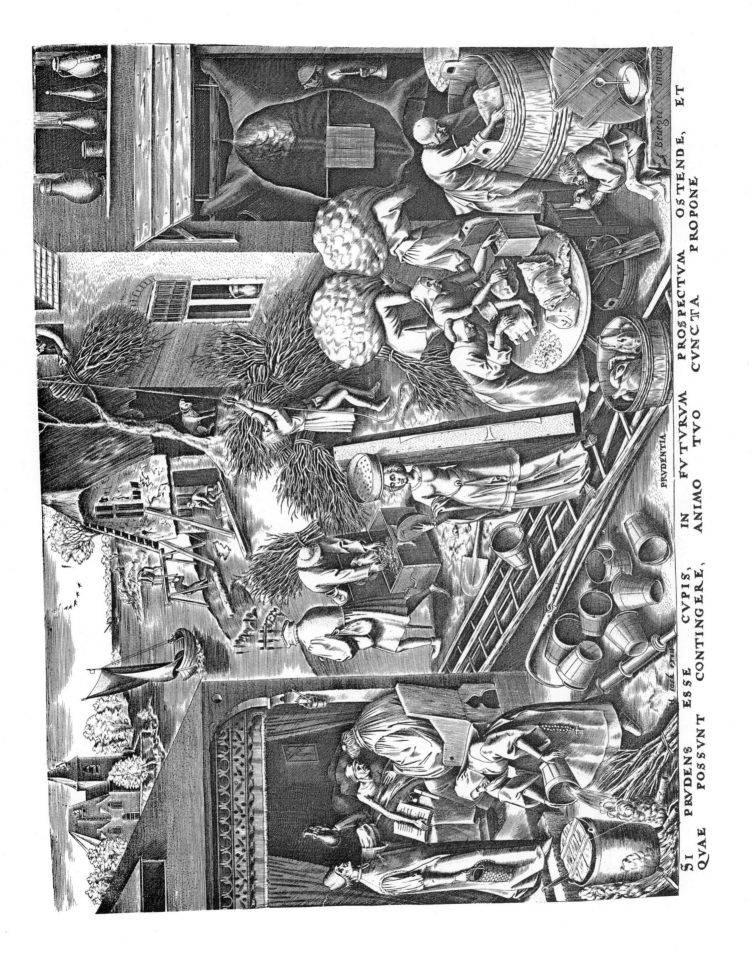

PRVDENTIA

SI PRVDENS ESSE CVPIS, IN FVTVRVM PROSPECTVM OSTENDE, ET
QVAE POSSVNT CONTINGERE, ANIMO TVO CVNCTA PROPONE

Bruegel Inuentor

53. FORTITUDE (Resoluteness, Steadfastness, Courage, Fortitudo, La Force, Seelenstärke, B.137, M.147)

The original drawing, in the Boymans Museum, Rotterdam, is signed "Bruegel" and dated 1560.

The drawings for this and the following engraving ("Temperance") date from 1560; those for the other five *Virtues* from the preceding year.

Here is the most agitated and tumultuous of the *Virtue* compositions. It is a raging battleground of the virtues against the vices; hence, it becomes the only *Virtue* print infested by diabolical and monstrous creatures. At the right in particular they seek to pour up from an abyss or pit, but they are beaten back by the swords of the stout soldiers of Fortitude.

The Fortitude Bruegel represents in this print is the virtue whereby men overcome vices. It is a positive, militant quality. It is by no means a mere omission of evil acts; neither is it rash or reckless bravado. It is the courageous facing and conquest of harmful passions and the sins to which they lead.

Though "Fortitude" is the accepted English rendering of the title, it might be expressed more accurately "Courage to Overcome Temptations." The connotations of the word fortitude as commonly used have come rather too close to the idea of endurance under misfortunes. The champions of fortitude here are more than unflinching; they are out in the field slaughtering the monsters of sin. A St. George piercing the dragon is closer to this Fortitude than a St. Sebastian, patient as he perishes, pierced by arrows.

Fortitude herself—the allegorical female figure—stands four-square on the neck of the dragon of evil. For good measure she holds an iron chain secured to a monster collar about his neck. The dragon's tail is clamped tight in a press at the left. He snarls, but is helpless. Thus Fortitude renders evil impotent.

On her head she balances an anvil—not to increase her pressure on the dragon, but to suggest the unflinching endurance with which the anvil bears up under many hammer blows. Thus the artist imparts both aspects of courage: "When you are the anvil, bear; when you are the hammer, strike!"

Only Fortitude, among the seven allegorical *Virtue* figures, has wings. Barnouw reads this as an indication that Fortitude must soar "above the passions." The column beside her betokens unmoving steadfastness.

Fortitude might repeat that old favourite elocution exercise in which the resolute maiden asserts: "This rock shall fly as soon as I!"—meaning fly as in "run away," rather than as in "bird."

Beasts symbolizing various vices are being slaughtered by the warriors of Fortitude. There is the toad of avarice, the peacock of pride, the dog of envy, the swine of gluttony, the ass of sloth, the monkey of lust or lechery.

Behind a wall at the rear stands a four-towered castle flying banners. The towers have man-like faces. Barnouw calls this "the citadel of Man" and reminds us that the "mouth and the eyes are the gate and the windows through which temptation may enter."

However, the walls are guarded by angels and by resolute human figures, one of whom carries a cross. The protectors stand alert and calm, ready for every onslaught.

Noteworthy are the numbers of soldiers, mounted and afoot, who are in action in the background. Veritable forests of spears are raised, or laid in rest as Fortitude's cavalry charge against the monstrous foes.

The organization of the military masses here is comparable to that which Bruegel used so effectively in two of his paintings on Bible subjects: "The Suicide of Saul" (1562) and "The Conversion of St. Paul on the Road to Damascus" (1567).

Other details worthy of mention include the war-shield on wheels manned by demons in the middle distance at the right. It carries a Rube Goldbergian mallet as weapon in its center. A similar shield has been overthrown by the cavalry charge in the center, and the monsters who manned the mallet are thrust through by the spears of the triumphant Fortitudians.

At the extreme upper right is the by now familiar symbol of the hollow egg or spherical shell. It seems to have served here as a sort of flying saucer, disgorging the forces of Sin, who now are being rounded up and sent "back where they came from" by the forces of Fortitude.

Translation of Latin caption: To conquer one's impulses, to restrain anger and the other vices and emotions: this is true fortitude.

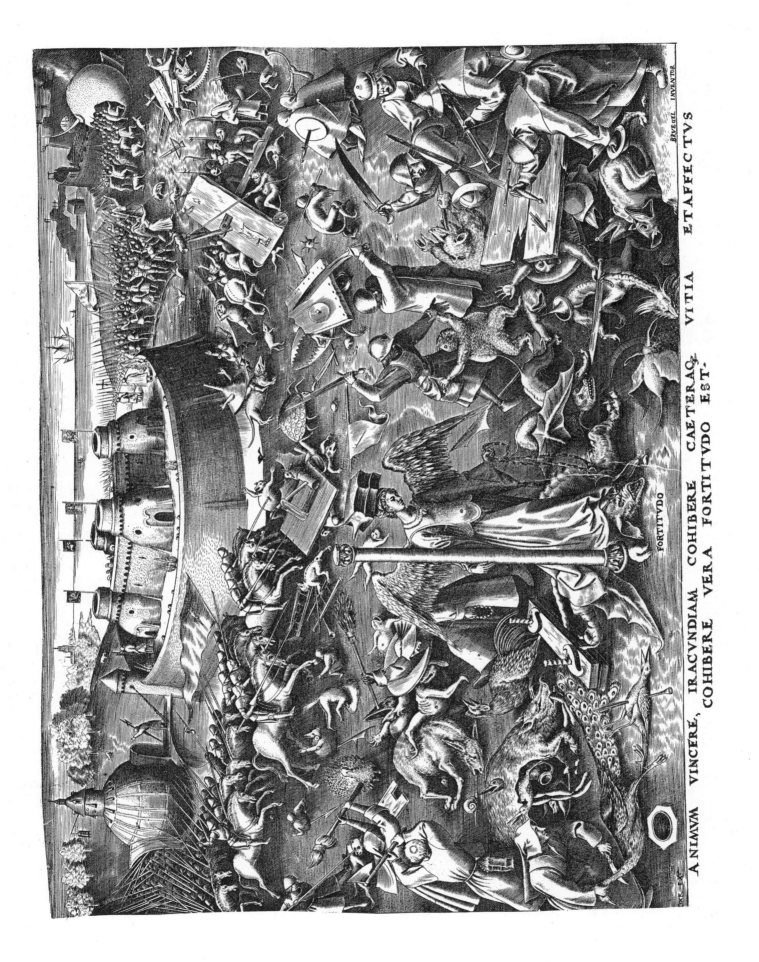

FORTITVDO

Bruegel INVENTOR

ANIMVM VINCERE, IRACVNDIAM COHIBERE CAETERAQ VITIA ETAFFECTVS
COHIBERE VERA FORTITVDO EST.

The original drawing, in the Boymans Museum, Rotterdam, is signed "Bruegel" and dated 1560.

An interesting minor discrepancy may be seen when the print here reproduced is compared with the original drawing. On the latter, the lettering on the skirt of the allegorical figure occurs reversed—that is to say, in mirror image—doubtless for the benefit of the engraver. But the spelling is Temperancia instead of Temperantia as corrected in the engraving.

Temperance herself stands tall and grave. She is burdened with an exceptional assortment of symbols. A clock balances on her head; it suggests that always "time's a-wasting." She carries a bit in her mouth, and she holds its bridle in one hand, thus indicating self-control and restraint. Her other hand holds a large pair of eyeglasses, instruments of vision. She stands on the blade of a windmill, man's device for harnessing the force of the wild, free wind to useful tasks.

Around her waist a live snake has been knotted as a belt. Stridbeck sees this as a possible symbol of the mastery of Temperance over the physical desires, associated especially with this part of the body.

As usual the Latin motto underneath offers insight into the ideas illustrated: "We must look to it that we do not give ourselves over to empty pleasures, extravagance, or lustful living; but also that we do not, because of miserly greed, live in filth and ignorance."

The picture as a whole shows that Temperance is not conceived primarily as an avoidance of Gluttony. Rather, this Temperance might be regarded as the opposite or antidote to Sloth. For around her are marshaled examples of man's useful, cultural, and—presumably—commendable activities. (Numerology is at work again; illustrating the moderating and beneficial rule of Temperance are the traditional *Seven* Liberal Arts.)

Beginning at the lower left and proceeding clockwise around the composition, we find groups representing: (1) Arithmetic, (2) Music, (3) Rhetoric (the stage, etc.), (4) Astronomy, (5) Geometry, (6) Dialectic, and (7) Grammar.

Nor did Bruegel forget the art to which he was dedicated. Just above the Arithmetic group he slipped in a painter at work before an easel, using brush, stick, and palette. As so often where we might hope to find something revealing the artist's own personality, we are blocked: this painter's face is turned from us.

In the Arithmetic group the arts of calculation are in action. Bills, interest, and foreign exchange are reckoned. A hatted figure cuts a property mark on a bellows. (Another branch of modern mathematics—geometry—was regarded as a separate discipline at that time, and so appears elsewhere in the picture.)

Music is pursued in an elegantly ornamented pavilion. Here are examples of (a) choral song, (b) a small orchestral ensemble, (c) an organ for religious instrumental music, (d) a lute for secular instrumental music. Various instruments lie on the ground before the choir.

Rhetoric comes next. This included the arts of eloquence and emotion-kindling expression. Here it takes the form of drama—serious, didactic drama, not just "show business." An audience stands watching actors on elevated boards. Apparently the play is

a moral allegory. Tolnay states that a young nobleman here plays the part of Hope and a lady plays Faith. At the right, the fool pokes his head around the corner, possibly representing the folly of the world. The flag above the stage, in any case, carries the symbol of the world turned upside down—an accepted expression for topsy-turvy, crazy, or even evil, human society.

Astronomy is displayed at the rear center. It includes measurement of the earth as well as the heavens. On a great globe of the earth, which seems to spin, a geographer measures latitude. Atop the globe itself stands the astronomer—or cosmologist. He applies his measure from earth to moon. The sun, complete with face, looks on from the left. The stars are spread on a dark curtain of sky. A cloud at right separates this group from Geometry.

The practitioners of Geometry make measurements of very different scale and intent. Architecture is involved here. Two workers with plumb line and dividers check a column. It must stand straight, not lean like that tower at Pisa. Below at left an artisan with a square trues a bas-relief block, as if readying it for cementing in place. Toward the right, cannon, cannonballs, and a crossbowman indicate ballistics, the bellicose branch of geometry.

On another elevation, somewhat closer, stand the five or six figures representing Dialectic, the art of logical disputation and development of ideas. A satirical slant has been pointed out here: the disputants are all talking at once. Another great Dutchman, Erasmus, had written of the dialecticians as a class of noisy fellows who will "fight to the knife about the Emperor's beard and in the heat of the battle will generally lose sight of the truth."

A plausible interpretation has been given by Römdahl. He finds that the five principal dialecticians here represent the five religious faiths. Thus, at the right in long robe and skullcap is the Catholic priest; just to his left is the bearded Jewish rabbi; and opposite stand three figures representing different creeds of the Protestant Reformation. While they carry on their polemic, the Bible stands unopened on the lectern at right. This typifies the standpoint of the "Libertine" or "Spiritualist" thinkers of Bruegel's era: true religion depended not on confessional rigidity or theological hairsplitting, but on individual study and application of the divine word contained in the Scriptures. Erasmus had written in his *Praise of Folly* concerning disputation that theologians who argued over non-essentials day and night never found a free moment for the Gospels or the Epistles of Paul.

Thus the dialectic group is basically a plea for religious tolerance, and a return to the basis of the Bible rather than creed and theological authority.

At the lower right sits the last group—Grammar, represented by a school where the ABC's are taught. The master has his switch handy to keep things in order. Comparisons are in order with the school in the print entitled "The Ass at School," reproduced on Plate 30.

A very common interpretation of this picture is that Bruegel is taking a negative attitude toward all of the arts considered, not merely the dialectic group.

Plate 54 is reproduced by permission of Mr. and Mrs. Jake Zeitlin, Los Angeles, California.

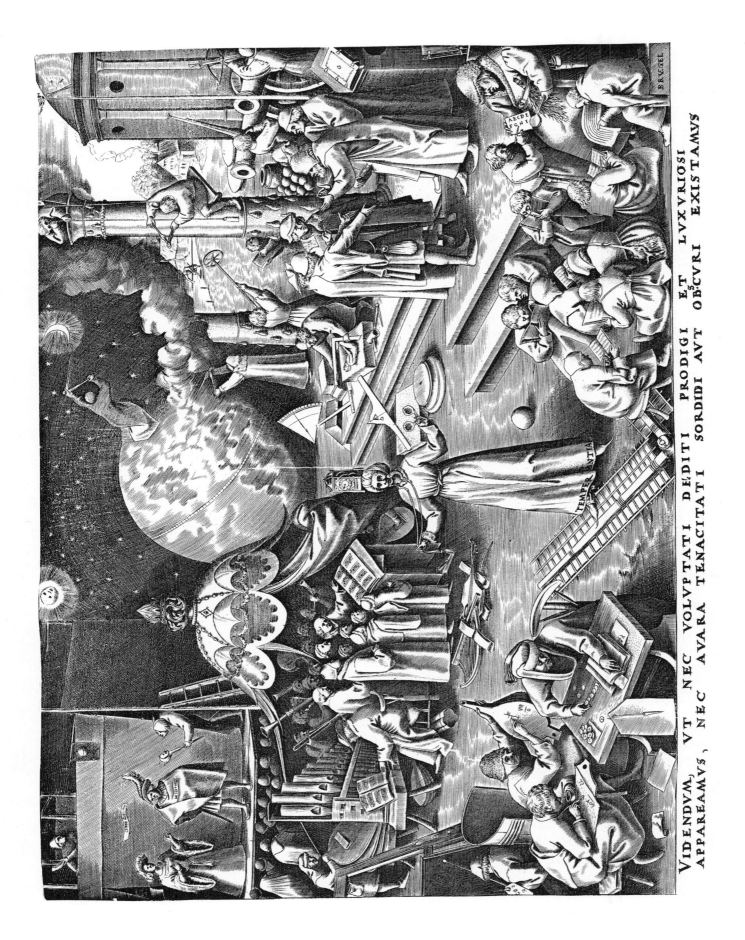

VIDENDVM, VT NEC VOLVPTATI DEDITI PRODIGI ET LVXVRIOSI
APPAREAMVS, NEC AVARA TENACITATI SORDIDI AVT OBSCVRI EXISTAMVS

The World of the

Apocrypha, Legends, and Lives of the Saints

and

The World of the Gospels

A single comment will introduce this final double section, each half comprising five reproductions.

The division into sub-sections here is a matter of distinction between literary sources rather than one of basic importance. Bruegel himself and most of his contemporaries hardly would have made much of such a distinction; for sacred stories from apocryphal and legendary sources, provided that they had general currency, were accorded esteem virtually on a par with that given to the canonical scriptures themselves.

Deeply concerned as he was with the human condition, Bruegel sought and found sacred material to meet his emotional and ethical needs without drawing fine distinctions between what was canonical and what apocryphal. The "Age of Reason" still lay long in the future, and "higher criticism" of Biblical sources had barely begun. Thus his treatment of the apocryphal miraculous death of Mary, mother of Jesus, is no less tender, reverent, and luminous than his treatment of the gospel incident of "Jesus and the Woman Taken in Adultery."

With Bruegel, as with many an artist before him, material from the widely-disseminated *Golden Legend* of Jacobus de Voragine provided impetus for drawings and paintings certain to appeal to a wide audience. As a source, the *Golden Legend* ranked close to the Good Book itself.

The ten engravings in this double section may be grouped in

another way, which affords a different kind of comparison. Thus we might consider all those in which the infernal and fantastic elements invade the domain of the sacred and saintly central figures or vice versa. This group would include "The Descent into Limbo," "St. James and the Magician Hermogenes," with its companion piece, "The Fall of the Magician," and "The Last Judgment." The remaining group, devoid of demons, includes: "The Death of the Virgin," "Jesus and the Woman Taken in Adultery," "The Resurrection," "Jesus and the Disciples on the Road to Emmaus," and "The Parable of the Good Shepherd."

The first three of the second group can be considered a distinct as well as distinctive subgroup. Those three engravings are all based on monochrome black-and-white—"grisaille"—paintings or wash drawings, rather than on pen and ink drawings designed with a deliberate view to subsequent engraving on copper plates. The grisaille originals, marked by their mastery of light and shadow, are among the noblest, most sensitive and appealing of all the works of Bruegel. Philippe Galle, the engraver, who executed "The Death of the Virgin" and probably also "The Resurrection," unfolded a remarkable technical skill, in keeping with the requirements of the subject matter. Perret, who engraved the third, was not far behind.

Perhaps the most important insight for all that follows is the

fact pointed out by Adriaan Barnouw: "It is clear from these engravings that Brueghel knew the scriptures intimately."

This knowledge and absorbed interest is exemplified also in his paintings, among which many of the greatest are directly drawn from Biblical subjects.

Thus we find from Old Testament sources the painting known as "The Suicide of Saul" (1562) and the two versions of "The Tower of Babel" (one assigned to the year 1563, the other perhaps a decade earlier).

From New Testament sources a far larger number remain to us: no fewer than ten, including such extraordinary and haunting works as "The Sermon of St. John the Baptist" (1566); two versions of "The Adoration of the Kings"—one from 1564, and a 1567 work in which surrounding snow is an important element; as well as several works in which Bruegel combined his Biblical interpretation with noteworthy approaches to a problem that deeply fascinated him: the representation of large numbers of people in motion. One such is known variously as "Jesus Carrying the Cross," or "The Procession to Calvary" (1564). Another is "The Conversion of St. Paul on the Road to Damascus" (1567).

Biblical and sacred figures are introduced, as we have seen, to serve as subordinate elements in some Bruegel landscape compositions. Thus we have seen Mary Magdalene repenting, St. Jerome studying in the desert, etc.

Further, in compositions whose subject is not specifically scriptural—such as "The Temptation of St. Anthony," reproduced as Plate 59—we encounter implications and allusions which can be solved satisfactorily only in the light of Biblical quotations. A *full* reading of Bruegel's many meanings can hardly be attained today, and even a *fair* approach to such reading requires considerable familiarity with proverbs prevalent in Bruegel's day and with the Scriptures, which formed so basic a part of the cultural background of artist and audience alike.

Doubtless, among Bruegel's lost drawings and paintings were many other Biblical subjects. Even on the basis of the work that has survived these 400 years, it can be said that among great Netherlands artists, the two most deeply devoted to the Bible were Bruegel—and that later genius, Rembrandt.

The original drawing, in the Albertina, Vienna, is dated 1561 by a hand not Bruegel's. The engraving, by van der Heyden, was published by Jerome Cock soon after 1561.

Bruegel's infernal fantasies are memorable in this engraving. There are significant similarities to the series of *Sins*. However, if those were set in psychological hells, this one is situated in Hell itself—or at least in its entry-way and anteroom.

The literary background is quite definite. In Bruegel's time it was also well known and commonly read. The action comes from an apocryphal work known sometimes as *The Gospel of Nicodemus*, sometimes as *The Acts of Pontius Pilate*. Somehow, to that work, which may stem from as late as the fourth century, a second part from about the second century came to be attached; it is this part, known sometimes as "The Descent into Hell," or again as "The Harrowing of Hell," that provides the present melodrama.

The story is that of Jesus, after the resurrection, going down into Hell itself for the predetermined purpose of liberating and removing the patriarchs of old. These were the saints and holy men of the Old Testament, obviously undeserving of an eternal lingering in darkness and discomfort, or worse, simply because they were born on earth too soon.

In Bruegel's conception here, Jesus enters Hell as the divine and invincible liberator. His power and glory are symbolized as he hovers inside a great bubble or cell of radiance, insulated from the foul infernal horrors. With him are nine angelic musicians, performing praises and exultations; one sings from music, the rest are instrumentalists.

Jesus is tall, majestic, supernaturally elongated. Yet despite his triumphant divinity he is still the newly risen or newly descended crucified one who had been laid in the tomb. He wears only a loin-cloth and cloak. His feet are unshod. Nail holes mark his foot and hands. His body is marred and gashed.

At the left, the saints and patriarchs pour out of gaping Hell-mouth, their arms extended in hosannahs and thanks. The ever-lasting gates have been literally lifted up and flung aside. They are unhinged. One of the gates serves, in fact, as a kind of platform or gangplank permitting the liberated patriarchs to walk safely over the sharp teeth projecting from the lower jaw of the Hell-monster.

Hell-head itself resembles to some degree an awful fish, but its eyebrow and tonsure also suggest a monk. At the right, between the Hell-head and the divine bubble, a strange curved dividing wall has been partly torn away in the upheaval. A great hole gapes in the forehead of Hell itself. Inside, on a floating plate or shield, sits "Satan the prince." In fear or rage he clutches at his crown. His hind legs have hands, and his tail mingles male and female genital suggestions. Around him in the darkness several monsters grin and grimace.

Above, on the tonsured dome of Hell-head, crawls a loathsome horror, all head and arms. One hand holds a wineglass, the other a piece of fruit. Tolnay identifies this creature as Lewdness, as indicated by the revolting pustules on the chin and the bestial self-indulgence of the features.

The stinking pit or floor of Hell is the foreground. In this arena, foul monsters and perversions writhe and gyrate. Among them are delirious nightmares of ill-assorted anatomy, merging organs of beasts, birds, and fish. In rage and frenzy they snarl and snap. A giant mussel or clam has clamped about the head of a knight-like figure in armor, just under Hell-mouth.

Almost in the center, a semi-human tailed creature has stabbed a knife through his own back. A strip of flesh clasps his wrist.

This Hell has inmates other than the patriarchs and saints whose liberation is under way. Sinners ineligible for this release continue, and will continue, to suffer. Back of the divine bubble we see a great wheel turning. Long spikes on its rim pierce the bodies of helpless sinners. The wheel turns endlessly, carrying them to a chute at right, which tumbles them into the seething caldron. There we see cooking a dozen or more sinners, with suggestions of more in the murk behind. Below them smokes the fire. Most likely to their scalding torture is added the torment of knowing that not now or ever will be for them the divine release which the patriarchs are about to enjoy.

In an enormous pot behind the wheel lurks a gigantic "peeping Tom," too dim to be seen clearly. Tolnay declares that Bruegel placed him here to serve as "a spectator who robs the proportions of the foreground scenes of their reality and degrades them to a dwarfish puppet play." This interpretation, however, seems unconvincing. Bruegel does not appear to downgrade or minimize the merit of the patriarchs and prophets pouring from Hell.

At upper right, an ornate knightly helmet—often a symbol of sin or corruption—is combined with metal wheels. It forms a peculiar infernal velocipede—or a veloci-hand, for it is turned by hand rather than foot power. Inside the helmet is a demon; he has pierced a fish with an upraised sword. He makes as if to strike—but vainly—at the King of Glory.

Over the sacred cell projects a small roof. A fishy monstrosity draped over it blows his fiery breath against the divine bubble. It has no effect. Below and to the right of the bubble, a fish monster glides along in the foetid atmosphere, its arms clutching a basket of birds on its back. A maternal monster seeks a new refuge for her little ones.

Just right of this refugee group, a broken sinner hangs helpless through a projecting ladder. A reptile demon emerges from a trap-door and yanks at his hair.

In the upper left corner, supported and pierced at once by a hollow tree, is another of the egg-like structures which serve to symbolize sin or to imprison sinners. It appears here as a kind of tree-top trap. It is partly split open and a demon's arms are clutching the edges as if trying to pull them together before the inmates can escape. From the left of this awful "egg" projects a strange leg, in a direction which proves it cannot be part of the demon's anatomy. And finally, if this picture is turned so that the present left side of the egg becomes the top, the structure is revealed as a great helmet with projecting, spiked chin guard. Helmets of this kind were fairly common in Bruegel's day. Furthermore, this helmet is also a monstrous face with round staring eyes and ghastly grin.

The Latin quotation inscribed below is from Psalms, 24: 7: "Lift up your heads, O ye gates; and be ye lift up, ye everlasting doors; and the King of glory shall come in."

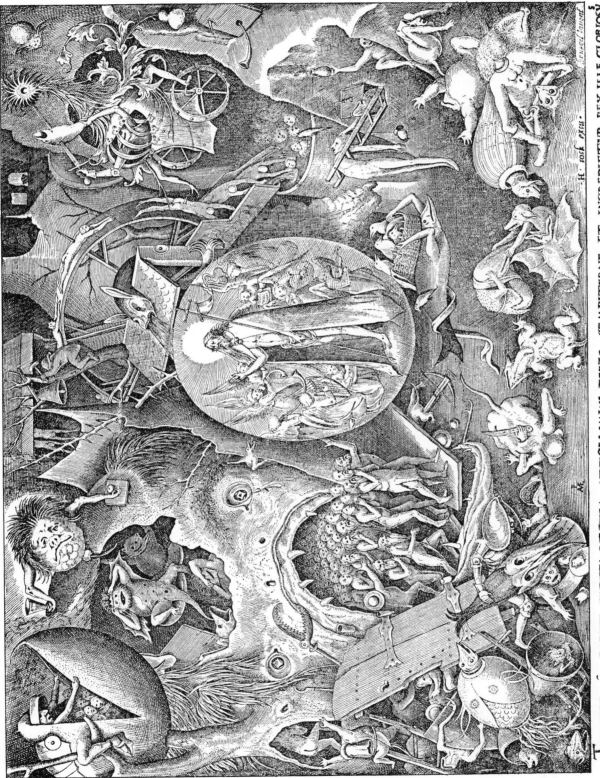

TOLLITE Ô PORTE, CAPITA VESTEA ATTOLLIMINI FORES SEMPITERNE ET INGREDIETVR REX ILLE GLORIOSV

56. THE DEATH OF THE VIRGIN (Death of Mary, Mother of Jesus, Mort de la Vierge, B.116)

The original grisaille oil painting, now in Upton House (National Trust), Banbury, England, is assigned approximately to the year 1564. The engraving is by Philippe Galle.

The painting, in the monochrome black-and-white which Bruegel preferred for his most personal expressions, is believed by Grossmann and others to have been done for the artist's friend, the eminent geographer Abraham Ortelius. Presumably it was presented about 1564; and ten years later, five years after Bruegel's death, Ortelius had it engraved by Galle for presentation to other friends.

The names of Bruegel and Galle appear in the decorative panel at lower left; that of Ortelius at the right. A dozen lines of Latin poetry are inscribed between.

The original grisaille paintings of both this picture and "The Resurrection" show, according to Ebria Feinblatt, "effects of light and dark all but unique" in the body of Bruegel's work. No treatise on abstruse niceties of "chiaroscuro" is required to draw attention here to the remarkable handling of illumination. The best of Rembrandt may be referred to for parallels.

The main source of light appears to be the figure of the dying Mary herself, rather than the taper she holds. Other and lesser light sources are the two candles over the door at rear center, the fire on the hearth before which a cat sleeps, and a small lamp that stands amid dishes and utensils on the table at front center.

The scene here does not derive from the New Testament, but from an apocryphal book, sometimes known as "The Discourse of St. John the Divine Concerning the Falling Asleep of the Holy Mother of God." (An English translation from the original Greek is given in M. R. James, *The Apocryphal New Testament*.)

The story probably reached Bruegel in a re-telling contained in one of the most popular works of the fourteenth, fifteenth and early sixteenth centuries—*The Golden Legend* or *Legenda Aurea* of Jacobus de Voragine. This thirteenth-century assemblage of legends and lives of the saints and sacred figures has been called "an encyclopedic volume" which deals "in attractive style with the saints of all times and places—their deeds, sufferings, and miracles." (For its story of the death of Mary, done into English, see F. S. Ellis's edition of *The Golden Legend, or Lives of the Saints as Englished by William Caxton*, London, 1900, Vol. IV, p. 324 ff.)

St. John, teller of the story, is shown in the engraving seated, apparently asleep, at lower left. The miraculous assemblage of disciples and saints around the bed is seen by him in a dream, or trance.

Identification of individual figures around the bed is not essential for appreciation of the engraving; however, among those mentioned in the apocryphal work are "Peter from Rome, Thomas out of the inmost Indies, James from Jerusalem." Also: "Andrew the brother of Peter, and Philip, Luke and Simon the Canaanite, and Thaddaeus, who had fallen asleep [had died], were raised up by the Holy Ghost."

Also, "Mark, who was yet alive, came . . . from Alexandria with the rest."

During a rather lengthy narrative, various arrivals tell how they came miraculously to be brought to Mary's bedside. One example is the testimony of Bartholomew: "I was preaching in the country of Thebes, and lo, the Holy Ghost said to me, 'The mother of thy Lord maketh her departure: go therefore to salute her at Bethlehem.' And lo, a cloud of light caught me up and brought me."

The "cloud of light" is several times mentioned. Light, in fact, is emphasized again and again. Thus Mary says to the apostles around her: "Cast on incense, for Christ cometh with a host of angels."

And as the miraculous company prayed, "there appeared innumerable multitudes of angels, and the Lord [Jesus] riding upon the Cherubim in great power. And lo, an appearance of light going before him and lighting upon the holy virgin because of the coming of her only-begotten Son."

Ultimately the apostles take up the bed and bear it to Gethsemane. Various miracles take place en route; and in some versions of the apocryphal story a paragraph is included stating that as the apostles "went forth from the city of Jerusalem bearing the bed, suddenly twelve clouds of light caught them up, together with the body of our lady, and translated them into paradise."

"The Assumption" is described in quite different ways in various other Greek, Latin, and Syrian versions. Doubtless the "golden" touch of the pen of the author of the *Golden Legend* did much to soften for subsequent centuries, even for the time of Bruegel himself, some of the crudities and contradictions.

Nearly forty figures are gathered about the bed of the dying Mary in this memorable engraving. Their faces express deep tenderness and concern. The furnishings of the room, as well as the garments of Mary and the woman who adjusts her pillow, are typical of Bruegel's own time and clime. We are, in fact, within a dignified and comfortable Flemish chamber. A curtained canopy shelters the bed. The ceiling is beamed. Panelling and wood carving enrich the interior.

Over the fireplace stands a religious image—a sword-bearing saint or archangel. The chair in the foreground and the nearby table have triangular or tripod leg supports.

A man in monastic garb kneels by the bed at lower right. His left hand holds a bell, and his robe is caught up by a cord from which hangs what seems to be a part of a rosary.

A work such as this dates no more than do human tenderness, human grief, or human hopes. Faith, not historical fidelity, is here in focus.

Translation of Latin caption: Virgin, when you sought the secure realms of your son, what great joys filled your breast! What had been sweeter to you than to migrate from the prison of the earth to the lofty temples of the longed-for heavens? And when you left the holy band whose support you had been, what sadness sprang up in you; how sad and also how joyful as they watched you going was that pious group of yours and your son's! What pleased them more than for you to reign, what was so sad as to do without your face? This picture painted by an artful hand shows the happy bearing of sadness on the faces of the just.

Plate 56 is reproduced by permission of the Metropolitan Museum of Art, New York City (Dick Fund).

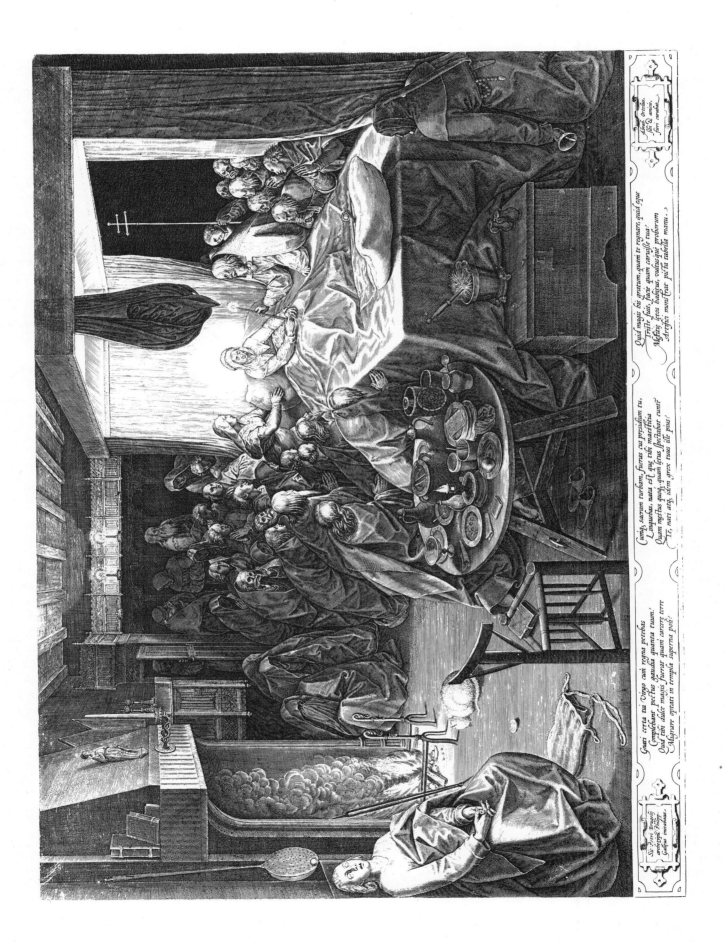

Quai certa tui Virgo cum regna petebas Cumq; sacram turbam, fueras cui præsidium tu, Quid magis his gratum, quam te regnare, quid æque
Complectant pectus gaudia quanta tuum! Linquebas, natu es' quç tibi mæstißia Triste fuit, facie quam caruiße tua?
Quid tibi dulce magis fuerat quam carcere terræ Quam mæstus quoq; quam seruus ſpectabor euntē Mæstiç seruos habçras, cultuaque proborum
Migrare optati in templa superna poli? Te, mari atq; idem grex tuus ille pius? Arreptci mon'rar pictá tabella manu.

57. ST. JAMES AND THE MAGICIAN HERMOGENES *(Saint Jacques et le Magicien Hermogène, B.117)*

This was published by Cock, with the date 1565 at the lower right. The engraver appears to have been Pieter van der Heyden; he certainly engraved the "sequel" print which follows.

Again the legend illustrated comes from—or through—*The Golden Legend* by Jacobus de Voragine.

The St. James shown here is traceable to one of the Apostles—James, son of Zebedee. This James has been identified as the elder brother of the apostle John. His designation as "St. James of Compostella" arose because his body, following his martyrdom, supposedly reached Santiago (in the Spanish province of Galicia). There was built the pilgrims' shrine known throughout the Catholic world as the shrine of St. James of Compostella. It has been called "the most favoured devotional resort" of the Middle Ages. By the twelfth century it was held in such high esteem that a pilgrimage there was looked upon as no less efficacious than a pilgrimage to Jerusalem or Rome itself.

St. James and Spain seem to have been associated first by a work in which the late seventh-century writer Aldhem tells of James' preaching in that country. About 200 years later appeared an account by Notker Balbulus of the transfer of the relics of James to Spain. Devout Catholics in that land were convinced of the authenticity of the story, and their conviction gained credence far outside Spain itself.

This James—also known as James "the Greater" to distinguish him from that other apostle, James "the Less"—was important enough to be mentioned in a bull issued by Pope Leo XIII in 1884, declaring that the remains interred at Compostella were authentic. (Scholars today, other than some Spanish Catholics, seriously question, when they do not positively deny, such authenticity.)

St. James traditionally was depicted as a pilgrim, just as he is here, where Bruegel has given him the garb worn by the pilgrims who flocked to his Compostella shrine: the cape, the staff, the wrist-fastened water bottle (just below his extended right hand), and the case hung from the girdle. In fact the legend asserted that Jesus himself had presented James with the long staff. The shape of the hat, too, was traditional.

The event here shown supposedly took place in Judea where James had gone to preach the gospel of Jesus. According to the legend, the Pharisees among the Jews there sought to refute or discredit him by enlisting the aid of Hermogenes, a magician. Magic and witchcraft thus opposed the saint's miraculous powers.

Hermogenes sent his apprentice magician, Philetus, to expose James as a fraud, but Philetus himself became converted. Then Hermogenes summoned his demons to seize James and bring him and Philetus, both in shackles, before him.

The demons, however, when they came to James could only cry out for mercy, for, as they said, "Have pity on us! Behold, we burn before our time!"

James invoked divine aid to release the demons. On his instructions they fetched Hermogenes (instead of James and Philetus) and brought him bound before James, asking that James put their former master in their power so they might take revenge for the insults to James and their own "burnings."

James asked why they did not seize Philetus, and the demons answered that they were unable to touch "so much as an ant which is in your chamber."

James rejected the idea of vengeance, saying to Philetus, "Let us follow the example of Christ who taught that we should return good for evil." Philetus, whom Hermogenes had bound, was given the privilege of freeing his former master.

Hermogenes then went to fetch his books on magic and brought them for burning to James, who ordered him to throw them into the sea instead. Finally, the ex-magician prostrated himself before the Apostle, saying, "Receive as a penitent him whom you have succored, even when he envied and slandered you."

Thus the tale in *The Golden Legend* exemplified the golden virtue of forgiveness. And Barnouw in his *The Fantasy of Pieter Brueghel* stressed this as the element which must have appealed particularly to Bruegel.

However, closer study of the print reveals a different story. This is not a parallel to the magnanimous statement of another magician, Prospero of Shakespeare's *Tempest*, who, in abjuring finally his black arts, said, "Forgiveness is the word to all." The picture here is rather prelude to punishments, brazen and brutal, inflicted on the magician, as the following engraving will show.

The scene here is, in fact, the magician's studio of surreptitious sorcery. James has been brought by magic before the magician, not vice versa. The Latin caption declares: "Saint James by devilish arts is placed before the magician."

Hermogenes, surrounded by his monsters and misshapen devils, sits at left, hunched over the book of spells which, presumably, has helped him bring in the Saint. The Saint, however, shows no fear, even amid all this black-magic vileness and viciousness. Of the two, Hermogenes appears the more uneasy. Perhaps he even then senses what is soon to follow. . . .

Meanwhile, all Hell has broken loose in the chamber. The cast of an entire Walpurgisnacht or *Night on Bald Mountain* is swarming and milling about the place. Naked witches dangle their breasts as they fly astride dragons and a billy goat above. A real Hallowe'en broomstick witch is flying up the chimney at the right (or possibly she is coming down). Another is at the peak of the chimney hood, top right.

A diabolical toad seeks to outstare a cat on the hearth. A hole has broken through into the room's subconscious—the cellar below. Sinister monsters huddle there.

The sun-faced horror with upraised arms just behind Hermogenes is the twin of Satan the prince, as seen in Plate 55 in the "Descent into Limbo" print.

Such is the nature of this fantastic confrontation between saint and sorcerer. It is significant that most spectators today undoubtedly find the demonic sideshow much more interesting than the quiet strength of the Saint. Perhaps Bruegel's audience did too.

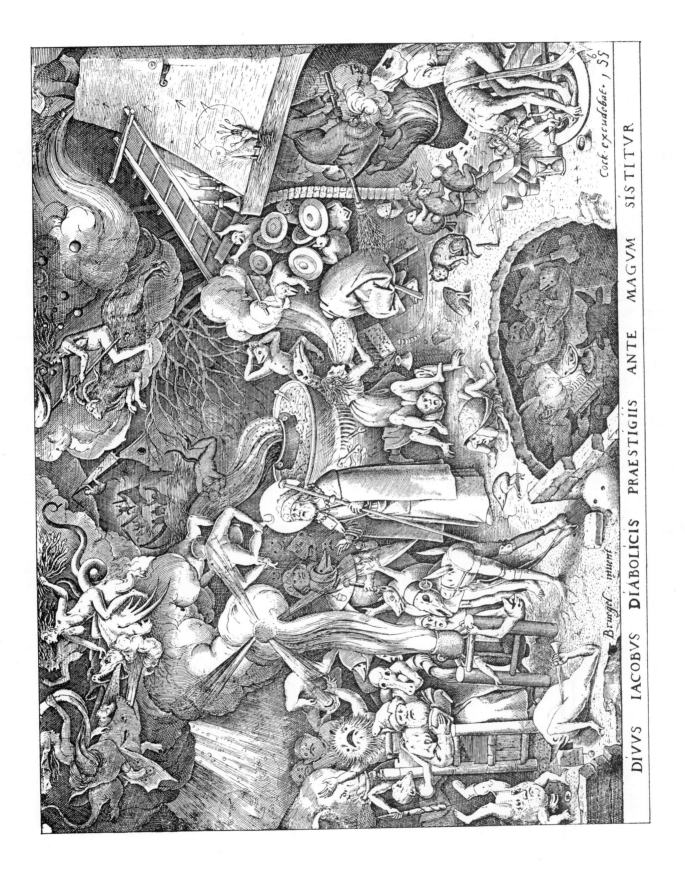

Bruegel inuent Cock excudebat. 1 55
6

DIVVS IACOBVS DIABOLICIS PRAESTIGIIS ANTE MAGVM SISTITVR

58. THE FALL OF THE MAGICIAN (*The Overthrow of the Magician, La Chute du Magicien, B.118, M.150*)

The original drawing, in the Rijksmuseum, Amsterdam, is signed "Bruegel" and dated MD<u>XL</u>IIII, an error for MD<u>L</u>XIIII (1564). The engraving by van der Heyden dates from the following year, 1565.

Here is the sequel to the previous scene.

The reversal has taken place, as indicated by the Latin caption: "God granted the Saint's prayer that the magician should be torn apart by the demons."

His fall is in full swing now. Recognizably the same as in the previous engraving are the magician and his chair, now topsy-turvy. The Saint, too, is essentially the same: hat, halo, staff, hand gesture, and general posture.

Differences are obvious among the demons, some of whom take part in the gruesome "come-downance" administered to their erstwhile dictator. The remainder are, as it were, otherwise occupied. Comparing this "after" with the "before" picture, one may feel the demons to be protean, transient, melting incessantly from one horrible guise to another.

Yet the ensemble suggests the presence of an underlying new idea. So it has seemed to at least two of the most thoughtful and resourceful of previous Bruegel commentators. Though their proposed interpretations differ, both discern here more than just an illustration for an old legend, folktale, or sacred melodrama in the enduring tradition of "the good guy licks the bad guy."

(1) Adriaan Barnouw finds it to be an allegory for the idea that "The make believe kermis scene of Vanity Fair, this world of human folly, will be overthrown by its own vices, which are but agents of God's will."

(2) Tolnay, on the other hand, finds this to be "a satire on the abuses of the Inquisition" and a hidden argument for Bruegel's own "religious-universalist theism which stands above the battle of the sects."

In support of the latter interpretation, we note the ecclesiastics looking on approvingly from the door behind St. James at right. Tolnay calls them "blind figures, outwardly holy, . . . who witness the murder of their fellow man with solemn seriousness, as if they were seeing a holy act."

Hermogenes, falling upside down here, is quite certainly being "done in." It is obviously the end for him. Tolnay believes that in this picture the demons are merely unthinking instruments of the Saint, who commands them to wreak vengeance against the heretic (the role here represented by Hermogenes, while St. James is an Inquisitor).

As a precaution, Tolnay suggests, Bruegel disguised the event as a theatrical scene. (Hence the jugglers, performers, acrobats, and carnival characters, especially at the left, and the sideshow announcement hanging like a flag from the back wall, left of center.)

It may be noted that dimly through the window, just to the left of that flagstaff, appear several faces of typical Flemish townspeople looking on, as if in amusement.

On the table at the lower left a headless body lies; the severed head is on the plate. Is this only a conjurer's trick? Just below, more mutilation—a balloon-like monster has thrust a knife through one hand and a peg through its tongue.

The gigantic staring figure at the table to the left is perhaps playing the old carnival shell game—with three balls and three cups. She (?) balances the egg of folly or sin atop her (?) head. The tail of a diving reptile monster extends in front of one nostril. More self-mutilation appears in the monkey-like monster just to her (?) left.

The show in progress here is surely one which, in Barnouw's words, "caters to the evil appetites of man and unchains in him the demons by which he is possessed." That would be true also were the veiled theme a satire on the excesses of the Inquisition, which was at that time working up to its later rigors and terrors.

For an almost contemporary statement of the anti-Inquisition viewpoint which he finds here, Tolnay quotes from a Coornhert work dated 1579: "The word 'heresy' is nowhere found in the Holy Scriptures. Christ had severe words against the Pharisees, but does he demand their death? He does not desire the death of the sinner but the death of the sin. He says to his apostles that they will have persecutions to endure. He does not say that they are to be persecutors."

Such was the voice of the exponent of "Libertinism" or "Spiritualism," the ethical thinker whose ideas were so often illustrated, as we have seen previously, by Bruegel's graphic works.

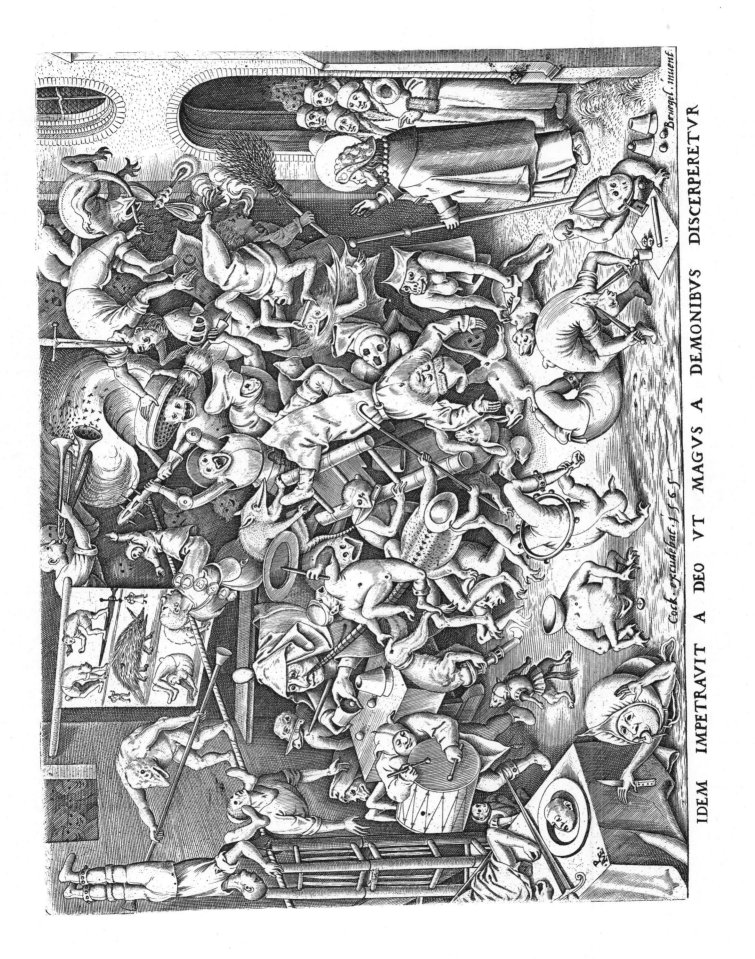

Bruegel. invent.

Cock. excudebat. 1565

IDEM IMPETRAVIT A DEO VT MAGVS A DEMONIBVS DISCERPERETVR

The original drawing, in the Ashmolean Museum, Oxford, England, is signed "Brueggel" and dated 1556, but by a hand probably not that of Bruegel. The engraving, which bears the same date in the lower left corner, was published by Cock. The engraver probably was ván der Heyden.

Together with the "Big Fish Eat Little Fish" (reproduced as Plate 29), this is, as Ebria Feinblatt points out, "Bruegel's earliest Bosch-type composition." Individual elements appear here which are derived from Bosch, and, in some cases, used again elsewhere by Bruegel. A pair of these are juxtaposed near the bottom, just left of center: on a floating barrel sits a fat figure tilting against the man-jug on the shore; this is similar to the fat figure representing Carnival in Bruegel's 1559 painting "The Combat between Carnival and Lent." The man-jug here is believed to be a lineal descendant of a similar monster in the Bosch altarpiece of the same name, "The Temptation of St. Anthony," in Lisbon, Portugal.

An unusual relationship is revealed when the original drawing and this engraving are compared: the latter is *not* a reverse or mirror-image of the former. They "run in the same direction." Also, because the original has some "continuous tone" brushwork supplementing the line drawing, the engraver's technique differs in the corresponding areas—notably, according to Miss Feinblatt, in the garments worn by St. Anthony at the lower right, and in the scarf bound around the gigantic floating head.

The story of St. Anthony of Thebes, founder of Christian monasticism, inspired many drawings and paintings. He lived during the latter half of the third and first half of the fourth centuries, some 900 years before the other famous St. Anthony, of Padua.

The earlier Anthony was born in Middle Egypt. When about twenty he began to live as an ascetic. After fifteen years he became a solitary also, existing alone on a mountain near the Nile for a number of years. Later he directed the monastic organization of monks, ascetics like himself.

In succeeding generations his fame was associated chiefly with his heroic resistance to the temptations and devilish lures that were sent to assail him. These were not restricted to images of seductive females and fleshly delights. According to Athanasius there were at first also alluring thoughts of domestic duties and satisfactions as contrasted with his bitter trials. When the lures of family joys and fornication did not defeat him, the devil tried to get at him through ambition, taking the guise of figures who acknowledged that Anthony had bested them. The devil also assailed him in the guise of wild animals, soldiers, women, and what not. Sometimes the Evil One attacked the Saint and thrashed him sorely.

Below the engraving appears a line (verse 19) from Psalm 34 of David (the engraved attribution to Psalm 33 gives the Vulgate numbering): "Many are the afflictions of the righteous: but the Lord delivereth him out of them all."

Another reference to David, the Psalmist, is pointed out by Barnouw. Within the hollow tree to the right of the Saint sits David himself singing assurance and courage to him. The song, this fine scholar says, is Psalm 11, especially that part which declares (in the following quotation, the writer has combined desirable elements out of the King James version and the Masoretic Text of 1917, Jewish Publication Society of America):

> In the Lord I have taken refuge;
> How say ye to my soul:
> 'Flee as a bird to your mountain'?
> For, lo, the wicked bend the bow,
> They have made ready their arrow upon the string
> That they may shoot in darkness at the upright in
> heart.

Sure enough, as Barnouw points out, the archer is in the crotch of the tree above, aiming his arrow toward the holy man's upright heart.

Though the quoted psalm applies admirably, the present writer has doubts about identifying the lute player in the hollow tree with David. Hollow trees—in fact anything unusually hollow—usually represent abodes of sin or sterile corruption in Bruegel's fantasy.

In its drastic criticism of the condition of both Church and State, this may well be the most "outspoken" of Bruegel's graphic works. Corruption and decay beset both the state (the one-eyed head below) and the Church (the rotting fish above). The cross on the flag flying from the tree through the fish's mouth is notably clearer in the print than in the original drawing. That flag is actually a Papal bull, as the twin seals indicate.

The huge head below is foundering. Two men in the lower jaw bail, but cannot keep it afloat. A column of smoke appears in place of the tongue (suggesting some sort of political hot air?). No wonder the fisherman in the rowboat wildly calls for help.

The head of the great fish above, says Barnouw, represents "the papacy, the source of the corruption within the body of the Church." Within that body men fight and murder. Demons gather like birds of prey. Yet, says the same scholar, the promise of "new life" for the Church is suggested by the tree growing through the mouth of the fish. (We note, however, that the tree is leafless, and seemingly lifeless.) A local church, at right, is ablaze.

Amidst conflict and confusion, the enemy draws near. At left center an Oriental-looking dome on the water disgorges a multitude of men. These are identified with the Turks, recurring threat to Christian Europe.

St. Anthony here represents saintly strength, a special case of the sin-resisting fortitude previously shown in the *Virtue* series. As he reads his sacred book, he is neither cast down nor distracted—not even by a purse which spills coins provocatively near his feet. He disregards also the knife with its suggestion of violence, or possibly of food to slice. For nearer to him is the skull, that ever-present reminder of mortality. The Saint's heart is attuned only to the life beyond. The degradations and dangers of the world around do not touch him.

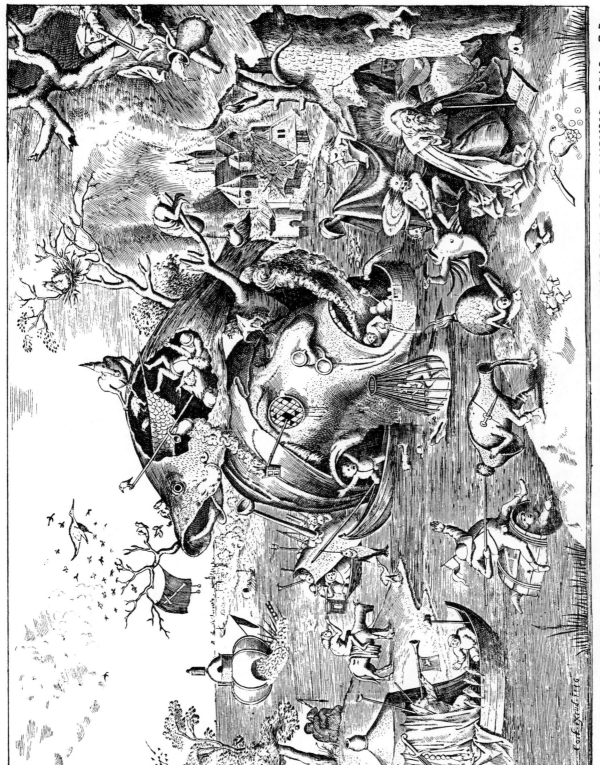

MVLTÆ TRIBVLATIONES IVSTORVM, DE OMNIBVS IIS LIBERABIT EOS DOMINVS. PSAL·33·

Next to Bruegel's name at the lower left is the date, 1565, of the original, a grisaille painting now in the Antoine Seilern collection in London. This engraving was executed by Pieter Perret in 1579, ten years after Bruegel's death.

Grave, unpretentious, and haunting is this work, and obviously —to use a much-abused word—sincere. In manner and mood it manifests the special place it held, according to a plausible anecdote, in the heart of its creator. It is said that Bruegel retained it as a personal possession and that it was still among his artistic effects at the time of his death.

The Latin line below gives the quotation from John 8:7: "He that is without sin among you, let him first cast a stone at her." Jesus is pictured tracing with his finger the corresponding words in Flemish.

The essentials of the incident as told in the King James version of the Bible are as follows:

Jesus . . . came . . . into the temple, and all the people came unto him; and he . . . taught them. And the scribes and Pharisees brought unto him a woman taken in adultery; and . . . they say unto him, Master, this woman was taken in adultery, in the very act. Now Moses in the law commanded us, that such should be stoned: but what sayest thou?

. . . Jesus stooped down, and with his finger wrote on the ground, as though he heard them not. So when they continued asking him, he . . . said unto them, He that is without sin among you, let him first cast a stone at her. And again he stooped down and wrote. . . .

And they which heard it, being convicted by their own conscience, went out one by one, beginning at the eldest, even unto the last: and Jesus was left alone, and the woman standing. . . .

When Jesus had lifted up himself, and saw none but the woman, he said unto her, Woman, where are those thine accusers? hath no man condemned thee?

She said, No man, Lord.

And Jesus said unto her, Neither do I condemn thee: go, and sin no more.

Perhaps the highest praise for this print is to say that it conveys understanding and sympathy for an utterance whose ethical beauty and deep humanity are unfading.

The poignance and significance of the moment are underscored in light. Jesus' figure stands out as if illuminated. The whiteness of his robe is even more striking in the original grisaille painting, as reproduced in the Stridbeck volume (Plate 86).

Bruegel's use of light to symbolize divine power and sanctity has been mentioned in connection with "The Death of the Virgin." Tolnay has discussed the use of light in Bruegel's paintings (see his article, page 123, in *Jahrbuch der Kunsthistorischen Sammlung in Wien*, neue Folge, 1934).

From hip to neck, Jesus' robe forms an area of stark white. It points in the direction of the composition's emphasized diagonal, running from lower left to upper right.

The faces or garments of principal figures round about are illuminated as if reflecting this radiance. This applies especially to the two disciples who stand closest to the left edge of the picture, among the group of some eight disciples; and to the attentively watching figures of principal scribes and Pharisees in the group at the right. It applies above all to the figure of the adulterous woman herself. The grisaille original appears even more strikingly than the print to make the figure of Jesus the source of light.

In the shadow are the people "convicted by their own conscience" who have turned to the right or left to leave the scene. Workers, soldiers, old people, children are among them. A total of some thirty individuals are seen wholly or in part, and possibly a dozen more are suggested faintly in the farthest background.

Two stones lie unflung on the ground just below the butt end of the spear carried by the backward-glancing soldier.

Comparison of the original grisaille with this print shows "small" but important differences in facial expression. In the grisaille the adulteress looks grateful, affected, and involved; in the print, more placid and aloof. In the grisaille the backward-glancing soldier, his mouth somewhat open, seems to feel greater pain and chagrin.

In other respects the engraving remarkably recreates fine details of delineation in the painting. In both, for example, the face of the scribe or Pharisee "spokesman" shows a slight smile, partly ingratiating, partly smug, as if he were expecting to catch Jesus in the trap of his question. In both, also, the faces of the apostles on the other side indicate a fine mingling of concern, confidence, and pride in their master.

The painting, as might be expected, seems more sensitive, subtle, and humanly expressive. After all, Bruegel may have had, and probably did have, "something to say" about fine points of many of the engravings made from his originals while he was alive. This could not apply to the print reproduced here.

Three states of the plate are known for this subject. In the first state no publisher's name appears; in the second the words "Antverpiae apud Petrum de Jode" appear in the center (below the Latin quotation from the Gospel); in the third those words have been removed, and inside the picture, directly under Jesus' printing on the ground is added the new publisher's identification: "Visscher excudit." Another addition in the third state is the initial "P." placed ahead of the name Bruegel at the lower left. Still another, minor but interesting, involves Jesus' printing on the ground: in the second state the letter "I" in the first word "DIE" shows a needless diagonal which makes it look like an italic "V." In the third state this is corrected, so that the "I" has become exceptionally heavy, and much of the shading behind and below the word has been obliterated.

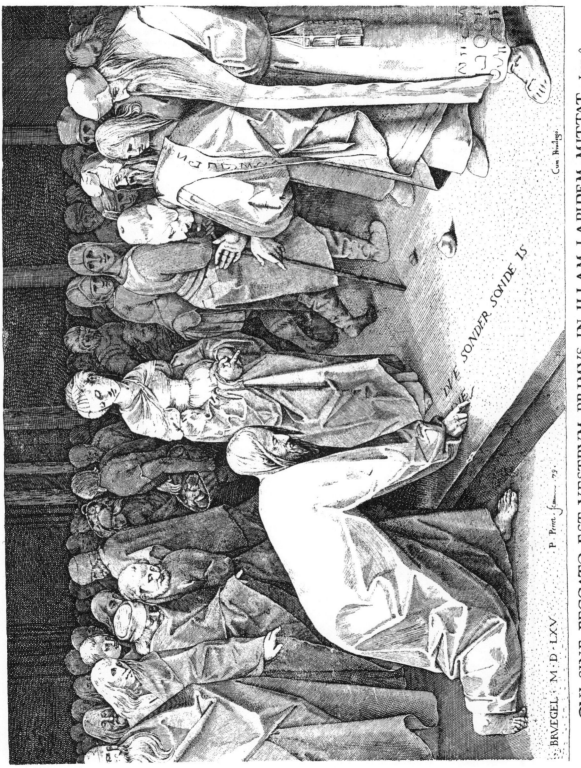

61. THE RESURRECTION (La Résurrection du Christ, B.114)

The engraver of this imposing and important work is not known positively; however, he seems to have been Philippe Galle, the same who engraved "The Death of the Virgin" (seen as Plate 56).

The originals of both of these remarkable engravings were executed in monochrome—that is, they were continuous tone gray-scale pictures, known in art jargon as grisaille. The later (1564) original, however, was painted in oils, whereas this one (c. 1562) was executed in ink or wash, with both brush and pen as the artist's tools of application. Grossmann speaks of it as being done "mainly with the brush to which only a little pen work is added."

This original grisaille is in the great Boymans Museum in Rotterdam. Its attribution to Bruegel has been disputed by Tolnay, but upheld by Cohen, Friedländer, and Grossmann. The weight of authority seems to place it securely within the body of Bruegel's works.

Pictorial details show that the artist here has based his picture primarily on the simpler version of the two first synoptic gospels, notably on that gospel attributed to Mark which according to Ernest Sutherland Bates "was unquestionably used by the authors of *Matthew* and *Luke* and was thus the earliest of the four."

In Mark 16:1–7, "Mary Magdalene and Mary the mother of James, and Salome, had bought sweet spices that they might come and anoint" the body of Jesus.

And very early in the morning the first day of the week they came unto the sepulchre at the rising of the sun. And they said among themselves, "Who shall roll us away the stone from the door of the sepulchre?" And when they looked, they saw that the stone was rolled away: for it was very great. And entering into the sepulchre they saw a young man sitting on the right side, clothed in a long white garment; and they were affrighted.

And he saith unto them, "Be not affrighted: ye seek Jesus of Nazareth, which was crucified: he is risen; he is not here: behold the place where they laid him. But go your way, tell his disciples . . ."

The version of Matthew (28:1–8) has supplied the picture's "angel of the Lord" and its group of soldiers, guards or "keepers" who in fear of the angel "did shake." However, the "great earthquake" mentioned in Matthew is nowhere suggested in the print.

The presence at the scene of the risen Jesus, bearing cross and banner and radiating light, is symbolical rather than an illustration of anything stated in the gospel story. Nothing there suggests that Jesus appeared to either of the two Marys when they were at the tomb. Accordingly, in this print, they, their companions, and the guards, awake and asleep, are all unaware of his presence.

The drawing of Jesus' face here conforms rather closely with his features as depicted in other prints after Bruegel originals. Jesus' bodily proportions are excessively elongated. This was characteristic especially of Bruegel's early delineation of sacred, saintly or angelic figures, as exemplified in paintings such as the "Fall of the Rebel Angels" (1562), etc. The elongation spelled sanctity; similarly—as we have seen—squat, low figures signify ignorance, evil or sin. This use of elongation is comparable to that which is so striking in El Greco's paintings of sacred subjects.

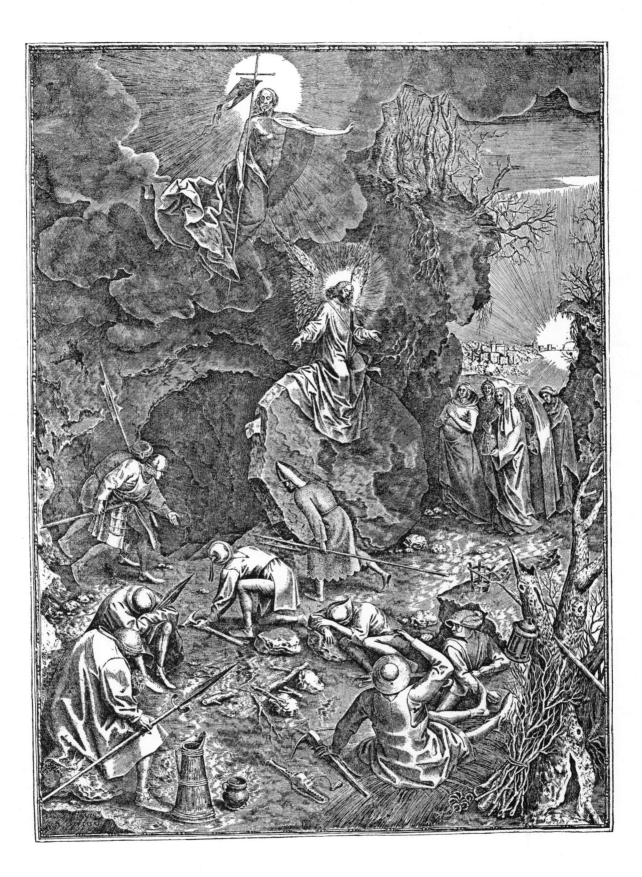

62. JESUS AND THE DISCIPLES ON THE ROAD TO EMMAUS (Jésus et les disciples sur le chemin d'Emmaus, B.113)

This is another engraving by Philippe Galle. The date, 1571, appears below Jesus' shoe. Two states of the plate are known. The second was issued by Philippe Galle's son, Theodore.

(Since this is one of the engravings executed after Bruegel's death, he could have had no influence on the engraver's work. According to the rigid criteria of what constitutes a "fine print," direct influence or supervision of the artist in the preparation and printing of the plate or block is essential. Such considerations seem of little importance here, however.)

Some dim suggestion as to a possible date for a lost Bruegel original may be gained from the fact that a similarity has been pointed out between (a) the three figures here, and (b) a walking trio of peasant women in Bruegel's 1565 painting "The Haymakers" (also known as "Hay-Making" and "July").

In that painting, too, the three figures walk side by side in stride, the face of the middle figure being turned toward us. However, the likeness seems too tenuous and far-fetched to support any substantial conclusions.

Fritz Grossmann says of this print that it "seems to render only part of an elaborate composition, which in its complete form provided the basis for a painting by Peter Brueghel the Younger."

Marked similarity exists between the features of Jesus seen fullface in this print and in profile in "Jesus and the Woman Taken in Adultery," reproduced as Plate 60. There is the same parting of the long hair in the middle, the same downturned moustache and short beard, the same rather heavy eyes with downcast lids dominating a slender face. The features of the two disciples, in comparison, here appear earthbound, rugged, almost coarse.

The incident illustrated is reported in two of the four synoptic Gospels. It took place at a time later than the Resurrection.

From Mark 16:12–13: "After that he appeared in another form unto two of them as they walked, and went into the country. And they went and told it unto the residue: neither believed they them."

From Luke 24:13–28: "And, behold, two of them [apostles] went that same day to a village called Emmaus, which was from Jerusalem about threescore furlongs. And they talked together . . . And it came to pass that while they communed . . . Jesus himself drew near and went with them. But their eyes were holden that they should not know him. And he said unto them, 'What manner of communications are these that ye have one to another, as ye walk, and are sad?'

"And the one of them, whose name was Cleopas, answering said unto him, 'Art thou only a stranger in Jerusalem, and hast not known the things which are come to pass there in these days?'"

They tell the story of the crucifixion, the entombment, and the finding of the empty tomb. . . .

"Then he said to them, 'O fools, and slow of heart to believe all that the prophets have spoken: Ought not Christ to have suffered these things and entered into his glory?'

"And beginning at Moses and all the prophets, he expounded unto them in all the scriptures the things concerning himself. And they drew nigh unto the village [of Emmaus] . . ."

Jesus' expression of face and gesture can readily be coordinated with that text.

All three figures wear pilgrim's garb of Bruegel's time. Each carries the pilgrim's staff. The prevalent tradition of religious art in France and the Netherlands was to represent the three on the road to Emmaus in the garb of pilgrims, though the Gospels said nothing specific to that effect.

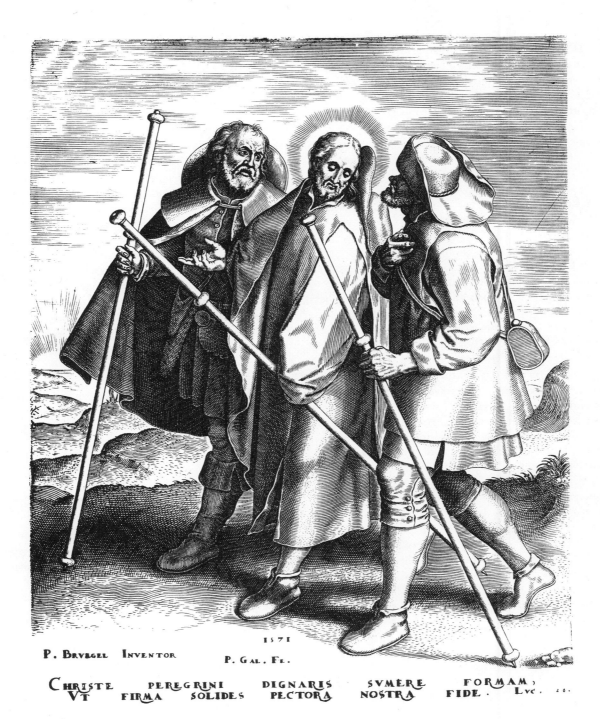

1571

P. BRVEGEL INVENTOR P. GAL. FE.

CHRISTE PEREGRINI DIGNARIS SVMERE FORMAM,
VT FIRMA SOLIDES PECTORA NOSTRA FIDE. LVC. 22.

63. THE PARABLE OF THE GOOD SHEPHERD *(La Parabole du Bon Pasteur, B.122)*

The engraver is Philippe Galle, and the date 1565.

Here Bruegel interprets and extends Jesus' parable from John 10:1–16. In somewhat less archaic language than that of the Authorized Version, the relevant portions of the parable follow:

"He who does not enter by the door into the sheep-fold but climbs up some other way, is a thief and a robber. But he who enters in by the door is the shepherd of the sheep. . . .

"And when he puts forth his own sheep he goes before them, and the sheep will follow him for they know his voice. And they will not follow a stranger, but will flee from him, for they do not know the voice of strangers. . . .

"I am the door of the sheep. . . . If any man enter in by me he shall be saved, and shall go in and out, and shall find pasture. . . . I am the good shepherd."

Jesus, as the Good Shepherd, stands in the door of the allegorical sheepfold. He carries a ewe, and other sheep look up to him in confidence. On both sides and above, thieves and robbers break into the fold seeking to steal the sheep. They come, at the left, with pickaxe, with lantern, with sword. They come, at the right, with ladder and with knife. They break in through walls and thatched roof. Nearly a dozen figures are engaged in this breaking and entering. At the lower right of the doorway, one of the thieves has leaned his axe. Its blade serves as a panel for the initials of the engraver, Galle.

In the upper left and right corners in triangular spaces above the roof are shown related episodes of sheep-tending. At the left, the shepherd defends his flock with a spear against an attacking wolf. At right, the unfaithful shepherd runs from his flock, and they fall prey to the wolves.

The engraving refers to verses 11–14 in this chapter of John, in which Jesus says: ". . . the good shepherd gives his life for his sheep. But he who is a hireling and not the shepherd, whose own the sheep are not, sees the wolf coming and leaves the sheep and flees, and the wolf catches them and scatters the sheep. . . . I am the good shepherd and know my sheep, and am known of mine."

The Biblical citation is inscribed above the door.

In comparison with other engravings based on the good shepherd parable of the same period, Ebria Feinblatt finds that "Bruegel took over the theme and general iconographic intent; but gave it a more prevalent import, extending the sense of ungodliness to all classes of society."

Class differences are apparent from the dress and features of the thieves breaking into the sheepfold here.

Bruegel used the parable of the "Unfaithful Shepherd" in painting also. Two such paintings have survived, the better of which is in the John G. Johnson collection in Philadelphia. Some scholars believe that both paintings are good copies of a lost original by Bruegel; others believe that at least one is the original, though so repainted and done over by hands other than Bruegel that it can no longer be considered an "original" in the strict sense. However, there is no reason to doubt that the conception and design, as well as all important details, are Bruegel's. The simple, concentrated, and powerful arrangement of landscape and the emotional central figure suggest in fact the later Bruegel rather than the earlier artist who tended toward more crowded and "simultaneous" canvases, lacking subordination.

The unfaithful shepherd is shown running in full flight. He carries his shepherd's staff in his hand, and is just passing a milestone placed cryptically but somehow significantly at the side of the path. The landscape behind is flat and bare. Looking back over his shoulder this pastoral deserter can see that the ravening wolf is already killing a sheep, while the rest of the flock is scattered.

It has been suggested that this picture may have represented a cryptic commentary on the action of Margaret of Parma. She had been the Netherlands regent for the Spanish Emperor, Philip; but after Philip sent the bloody Duke of Alva in 1567 to stamp out heresy (Protestantism) and dissent, she quit her post. Alva became dictator, and within half a dozen years completely transformed the country for the worse.

Bruegel died early in the period of the Alva terror, but not too early to have experienced, and painted such a commentary on, the flight of Regent Margaret from her proper sheep, the people of Spain's Netherlands possession. The date of the engraving is, however, too early for assuming any such political meaning here.

Translation of Latin inscriptions: (*On the lintel:*) John 10: I am the door of the sheep. (*Bottom:*) Stable your flocks safely here, O men, come to my roof; while I am shepherd, the door is always open. Why are you breaking through the walls and roof? That is the way of wolves and thieves, whom my sheepfold shuns.

EGO SVM OSTIVM OVIVM · Iohn. 10.

BRVEGEL · INVEN ·

HIC TVTO STABVLATE VIRI, SVCCEDITE TECTIS; QVID LATERA, AVT CVLMEN PERVMPITIS? ISTA LVPORVM
ME PASTORE OVIVM, IANVA LAXA PATET ATQVE FVRVM LEX EST, QVOS MEA CAVLA FVGIT

64. THE LAST JUDGMENT *(Le Jugement dernier, B.121, M.137)*

The original drawing, in the Albertina Museum, Vienna, is signed "brueghel" and dated 1558. This engraving, also dated 1558, is by van der Heyden, and in many ways is typical of his engraving of Bruegel's original drawings.

Verses below in Latin and Flemish set the tone for this, an "hour of decision" or "moment of truth" subject. A free equivalent of the Flemish and the Latin:

> Come, all who're by my Father blessed,
> To the eternal realm up higher;
> But down, all you who are accursed,
> Down into everlasting fire!

Jesus hovers here in his role of final judge over men. A rainbow supports him. His feet rest upon a globe, emblem of the world. On one side floats the sword of judgment, on the other the branch of glory.

The last trumpets are here blown by two pairs of angels. On the left one pair—perhaps including Gabriel—sound the summons for the blessed. These throng in a massed column up the hill, toward "the eternal realm up higher."

But on the right—here the side of the damned—the two flying trumpeters hover on strangely insect-like wings, not on the orthodox feathery pinions of their opposite numbers. The lower of the two right-hand angels, in fact, displays claw-like appendages instead of feet, as if infernal influences had altered angelic anatomy. This trumpeter is all curved—wings, "legs," general posture, even trumpet. Perhaps it is a "fallen" angel.

Saints and patriarchs watch from billowy clouds at the upper right and left. Their hands are clasped in adoration. Some of these doubtless are to be understood as "Old Testament" Fathers who long before had been liberated from Hell, or Limbo, as previously shown.

Graves have opened in the foreground of the engraving. The dead arise, entire, obedient to the trumpeted summons. They come up with clasped hands. Demons assist in uncovering coffins, as if eager to get at those who will be condemned to everlasting torment in Hell.

Many monsters fill the foreground. Others harry the lines of the damned and herd them into the gaping Hell-mouth at the middle right. Certain monsters, in fact, seem to pursue the rear guard of the blessed, somewhat left of the point under the judging Jesus. However, angelic escorts carrying tall crosses safely shepherd the blessed up toward the everlasting bliss which is in store for them.

Hell—head itself looms like a monstrous Leviathan or whale. It resembles sea creatures we have seen in earlier engravings from the *Ship* series. On the brow of Hell—head is perched a strange and rather jaunty hat, while on the tip of its nose is perched a cosy little demon.

The demonic crew at the center carry torch, hook, and ladder. No doubt these refer to the hell-fires raging below.

Less than twenty years before the execution of this engraving, Michelangelo completed the greatest and most terrible of all Last Judgments: his enormous masterpiece in the Sistine Chapel. Bruegel studied and worked in Rome during his Italian journey (1552–1553). It is tempting, and not too far-fetched, to suppose that he saw the Michelangelo "Last Judgment," then completed some nine years.

Between the vast painting and the small drawing for engraving, exists an abyss of difference deeper than that of medium and size. It is a deep diversity of concept. Michelangelo's Jesus is the omnipotent and angry magistrate, judge, and muscular executioner in one. In righteous rage he repudiates the sinners, hurling them down to unspeakable horrors. It is a spectacle to inspire waking nightmares even in a twentieth-century spectator.

Far different is the central figure of the Saviour drawn by Bruegel here. His face is serene, his gestures neither imperious nor threatening. Jesus considers and assents to the necessary outcome here, but he does not revel in it, nor does he seem to resent the damned. He is compassionate, not enraged. This is by no means a God of vengeance.

And the action below, in spite of fantastic fiends, is not likely to convey a feeling of terror today. It is, after all, a medieval sort of mingling of what we "moderns" have come to think of as opposites. Here, the sinner's downfall and the clown's pratfall are set side by side. The ghastly and the grotesque are interwoven. Tragedy goes hand in hand with gross crudity, awfulness with awkwardness. And even the theology of final things, eschatology, is not far distant from scatology.

It does not seem likely that print purchasers in Bruegel's day were severely shocked or depressed by such presentations of the "shape of things to come" as this engraving offers. They were quite familiar with "morality" plays, passions, and masques in which Hell, damnation, the Day of Judgment, and the Devil himself were all sources of slapstick and gross guffaws, as well as edification and uplift. At each carnival or kermess, stage directors and designers did their utmost to create Hell-mouth sets more gruesome and teeth-chattering than anything previously achieved. The more horrendous and convincing, the better. Infernal evidences and direct diabolical intervention were normal, if not actually essential, for any popular passion play during the Middle Ages and long afterward.

Barnouw surmises that Bruegel himself may have designed elaborate Hell-mouth settings for passions and moralities in his time, for, after all, "no one could create a gaping hell monster more suggestively."

Truly, no one could—and it is not the least of Bruegel's many merits that the same hand which gave us "Jesus and the Woman Taken in Adultery" could also create this "Last Judgment," as well as all the other wonderful records of his graphic worlds.

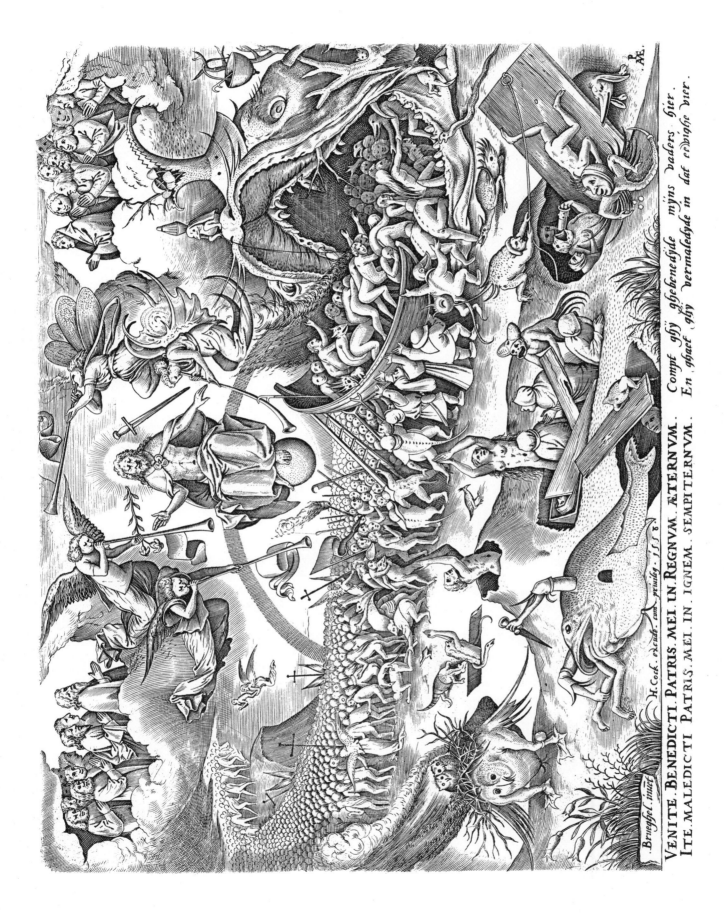

Bruegfel. inuet. H. Cock. excudé. cum priuileg. 1558.

VENITE. BENEDICTI. PATRIS. MEI. IN. REGNVM. ÆTERNVM. Compt ghij ghebenedijde mijns vaders hier.
ITE. MALEDICTI. PATRIS. MEI. IN. IGNEM. SEMPITERNVM. En ghaet ghij vermaledijde in dat eewighe vier.